**50 YEARS
OF WILDLIFE
PHOTOGRAPHER
OF THE YEAR**

50 YEARS OF WILDLIFE PHOTOGRAPHER OF THE YEAR

HOW WILDLIFE PHOTOGRAPHY BECAME ART

ROSAMUND KIDMAN COX

PUBLISHED BY THE NATURAL HISTORY MUSEUM, LONDON

Blue ice and penguins

This is possibly the most magnificent blue iceberg ever photographed, shot from a ship off the South Sandwich Islands in Antarctica. To see such a cathedral of ancient ice, calved from the base of a glacier, would be enough, but to have a tight little group of Adélie penguins to set the scale and a prion perfectly positioned overhead is a gift. To catch the moment and frame it perfectly reveals skill, in this case, of a photographer in love with ice. The resulting picture won her the main award.

Cherry Alexander UK 1995

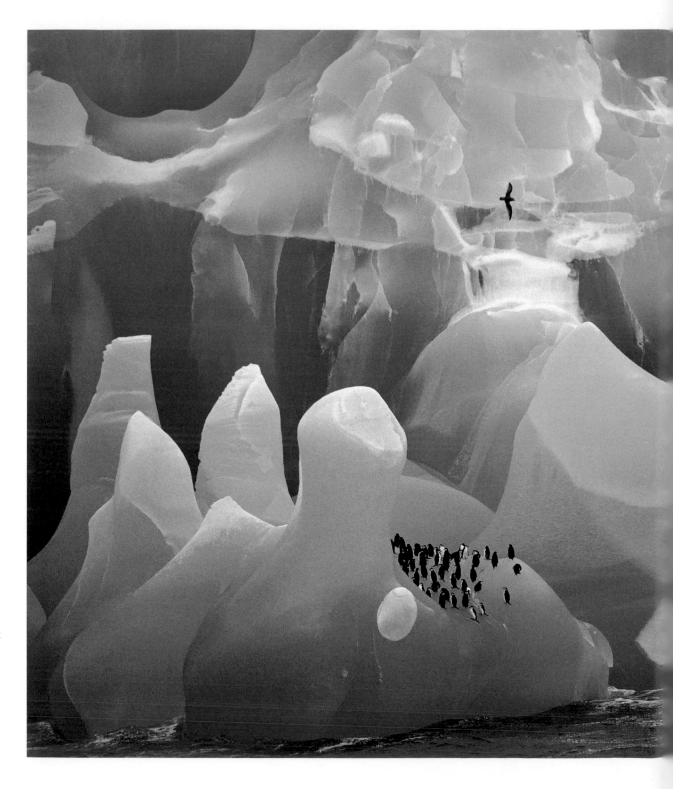

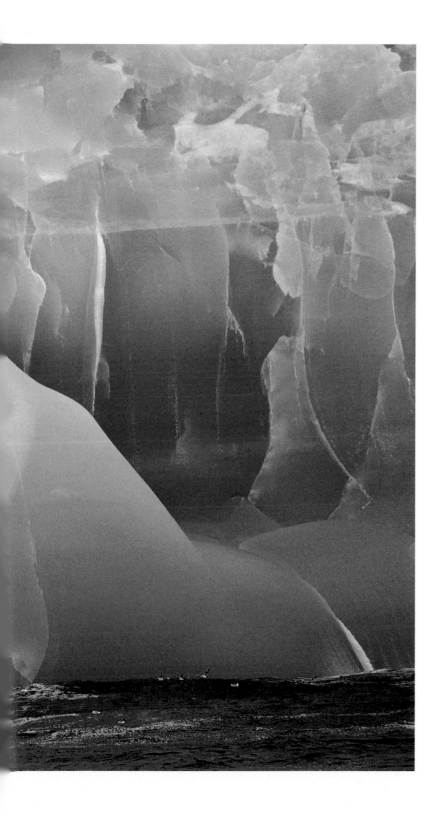

Contents

Putting it all in context

This book has been produced to mark 50 years of the Wildlife Photographer of the Year competition and as a celebration of wildlife photography itself. Its intention is also to show that wildlife photography is an art that deserves a place in art history.

Nature has been a subject of photography since photography began. Yet because a certain understanding of natural history is required to capture pictures of wildlife, and so many photographers of wildlife are also naturalists or even biologists, a divide developed between this branch of photography and the photographic mainstream. When narrowed down to fine-art photography, that divide has been crossed by only a few professionals. Yet it can be argued that many wildlife images straddle the boundary between documentary and fine art, especially as those classifications so often depend on how images are presented and in what context.

The competition itself has grown from modest beginnings in the 1960s – when entries tended to be just records of nature – into a showcase of the work of the world's leading wildlife photographers and a display of different ways of seeing nature. The 160 or so prize-winning and commended images in this book represent 50 years of different times, styles and specialisms. The chronology is within the sections. Every picture dated before 2004 was shot as a transparency (slide) or print (rather than a digital file). And in some cases their reproduction here is from old prints or duplicate slides. But the aesthetic qualities of the pictures remain as high now as they were then.

Some of the images are by top professionals, others by photographers early in their careers and yet others by non-professionals. What all of these artists share is a passion for their subjects and an emotional link that shines through their work. Some of the pictures are pure documentary – photojournalism at its best. Others are creative interpretations. All of them are remarkable – the product of experience, knowledge, patience, skill and aesthetic instinct.

The rewards given to pictures in this competition have over the decades been important for photographers, for both reputations and careers. The time has come now for wildlife photography to receive due recognition by the art world and be given its place in the world's international photographic art collections.

Stories in white

The choreography for this highly original composition was reliant on the behaviour of the whooper swans, though the choice of the final arrangement was, of course, the photographer's. The swans congregate each winter on Lake Kussharo in Hokkaido, Japan, migrating from much colder Siberia and Mongolia. Hot springs keep part of the lake ice free, but the frozen area is perfect for socializing. What the photographer looked for was an arrangement of poses on the ice arena. Here two swans are courting, their necks forming a perfect heart, two are bonding with a mirrored dance display, and three are taking off in diagonal succession. Retaining the rear of the first flying swan, rather than cropping it off, was deliberate – the final element of the flight path – to both break out of and at the same time emphasize the frame.

Jan Vermeer The Netherlands 2007

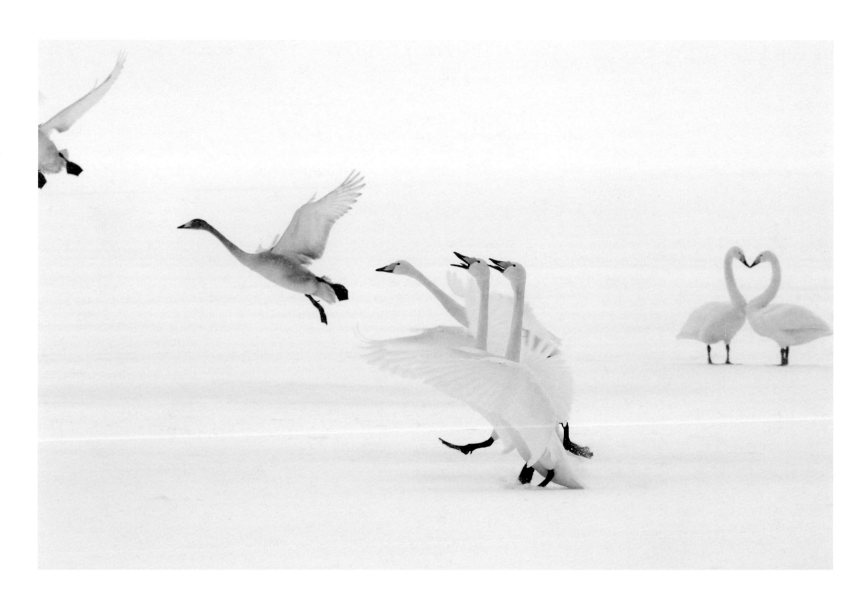

In the beginning . . .

The first pictures we know about are of nature, in particular of animals, painted on cave walls in Spain and France and dating from nearly 40,000 years ago. Ever since then, art in its various trends and styles has incorporated representations of nature.

THE DARKENED ROOM AND LIGHT AS PAINT

For most of those 40,000 years, the only way to create a picture was by applying a marker, typically a paintbrush, to a surface. But as early as the fifth century BC in China, another way was discovered. If you drilled a hole in a wall of a certain kind of room which was darkened, a well-lit scene outside that hole would be projected onto a wall or other flat surface inside. This phenomenon eventually came to be known as 'camera obscura', Latin for 'dark room'. And the way of capturing the projected image, which was accurate, if upside-down, was to trace it.

But this was still essentially a system involving hand and marker. The ambition, almost from the discovery of the camera obscura effect, was to use light itself to etch an image – to paint with light, to create photo-graphy. Not until the nineteenth century was it finally accomplished, by chief among others, the Englishman William Henry Fox Talbot and Frenchmen Joseph Nicéphore Niépce and his collaborator Louis-Jacques-Mandé Daguerre. Others had already reduced the camera – the darkened 'room' – to a portable box with a lens and viewing screen, and Fox Talbot added, to the inside 'wall', chemically sensitized paper. In 1834 he achieved 'the art of photogenic drawing', which he announced in January 1839 in response to Daguerre's own. A botanist, as well as an astronomer and mathematician, many of Fox Talbot's earliest images were of nature – plants and outdoor scenes.

FINDING PHOTOGRAPHY'S CANVAS

Daguerre, also with box-form cameras and more sophisticated lenses (better to focus and to concentrate the light), used the more durable silvered copper plates to make his images. The daguerreotype was a one-off positive that couldn't be reproduced, while Fox Talbot's processes – photogenic drawing and calotype, which he announced in 1841 as its successor – produced a negative that could produce many positives. This was the basis of modern photography. The calotype cut exposure times to a few seconds, and through the discovery of his friend Sir John Herschel, Fox Talbot introduced a permanent fixer, 'hypo', to photography and went on to patent a process of photographic engraving. In 1844 he published the world's first photographically illustrated book – *The Pencil of Nature*.

It was for his tree studies that the Frenchman Gustave Le Gray improved on Fox Talbot's paper-negative process by waxing the paper beforehand, preserving more detail in the negative. He also made the first constructive use of the double exposure, for seascapes, in particular. Le Gray was also among the first acclaimed photographic fine artists.

Despite the existence of paper processing, the glass negative became predominant. Glass gave a better surface for the sensitive photographic emulsion of the wet-collodion process invented by the British artist Frederick Scott Archer in 1851. The 'wet-plate' gave sharp negatives and, later, emulsions more sensitive than the daguerreotype or calotype. The trade-off was the need to develop a photograph while the emulsion was still damp. Photographers working in the field had to carry portable darkrooms with them, along with the chemicals, their camera and heavy glass plates. Exposure times were still counted in seconds. So pictures were mainly limited to stationary subjects: plants, landscapes and domestic animals – or dead animals, stuffed and posed. And this, ironically, led to new levels in landscape artistry and a golden age of atmospheric pictures. Roger Fenton, founder in 1853 of what would become the Royal Photographic Society (RPS), cited contemporary landscape photography as proof that an art form had arrived that could equal painting as an evocative means of expression.

1839, William Henry Fox Talbot: Buckler fern

The first 'photogenic drawing' – a lasting impression of a fern frond, one of many examples made to show 'the inimitable beauty of the pictures of nature's painting which the glass lens of the Camera throws upon the paper in its focus'. It was made by placing the frond on sensitized paper (coated with salt and brushed with a solution of silver nitrate), covering it with a piece of glass and placing it in the sun. Where the paper wasn't exposed, it remained light. Further darkening was prevented with another coat of salt.

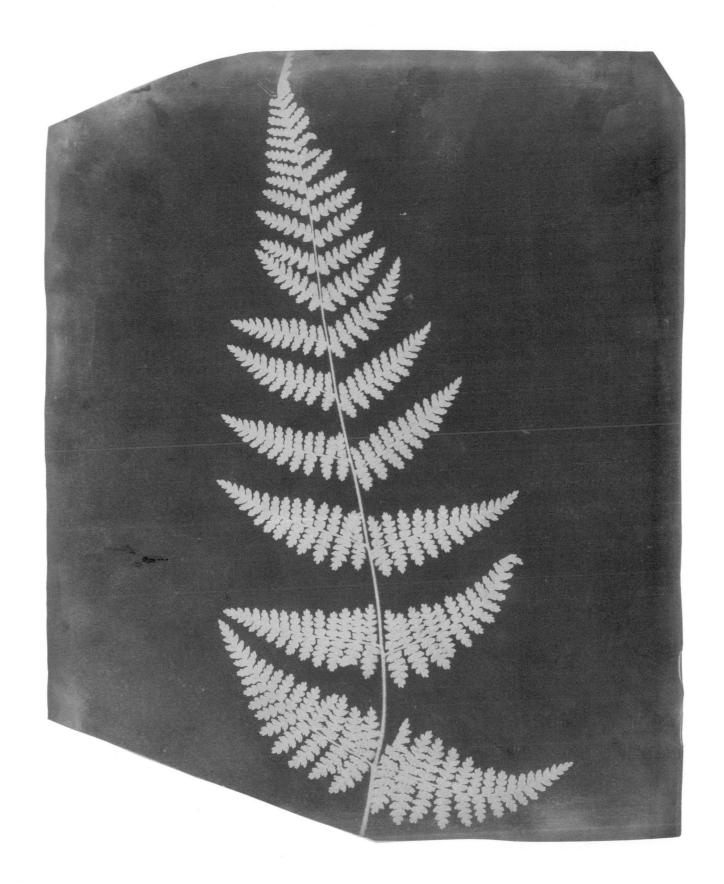

CAMERAS AS PIONEERS

Perfectly suited to the new art form was a new world. Just as landscape photography was taking off, the North American railways were opening access to the wildernesses of the West. Photographs of these places not only produced a huge variety of new aesthetic experiences but also brought the West to the attention of people who would never otherwise have seen any of it – the public of the eastern states and of Europe. And photography did as much for the new landscapes as vice versa. Carleton Watkins' pictures of California's Yosemite Valley, taken in 1861, helped persuade President Abraham Lincoln to grant the valley official protection. And it was William Henry Jackson's photographs of Yellowstone, produced in 1872, that persuaded President Ulysses S Grant to declare the region America's, and the world's, first national park.

Of course the photographers who were active in the 1860s and 70s were still lugging around their portable darkrooms, but from the late 1870s they were largely unshackled. Dry plates which matched the sensitivity of collodion had been introduced. These could be exposed and developed later, and it opened the field to a lot of people, many of them painters, who hadn't been able to handle the heavy-duty aspect of photography. Among these was Andrew P Hill, whose 1899 photographs of California's ancient giant redwoods saved many of them from destruction and resulted in the establishment of Big Basin Redwoods State Park.

FINALLY CAPTURING ANIMALS

While photographs of plants and landscapes were becoming increasingly sophisticated, those of wild animals – because of their annoying habits of hiding and, worse, moving – were all but non-existent. But zoo animals would sometimes stay still for a while. One of the earliest animal pictures is of lion cubs, taken by Fox Talbot's cousin John Dillwyn Llewelyn at Bristol Zoo in 1854. And among the the most famous, taken in the 1860s by Frederick York and Frank Hayes, are of the Zoological Society of London's quagga, portraits of the last of its species (see page 13). The first true wildlife photograph may well be one taken

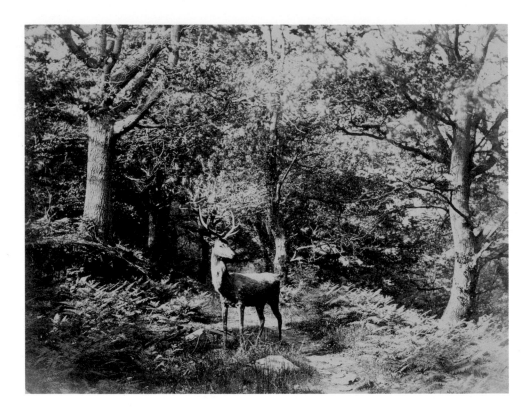

in 1870 by the American Charles A Hewins – of a live, wild stork on its nest. Remarkable also were the photographs brought back to Britain shortly after, in 1876, by HMS *Challenger*, following a four-year scientific oceanic expedition. The pictures of nesting penguins and albatrosses were true wildlife shots, taken by one of the ship's official photographers, Caleb Newbold.

But alongside more sensitive emulsions and better optics, the real wildlife breakthrough came with shutters allowing shorter exposures. It was the invention of a fast shutter by German Ottomar Anschütz that made it possible to photograph moving animals. In 1884 he took the first sequence of wild birds, white storks.

Others who in the 1880s and 1890s took portraits of moving animals were the Englishman Eadweard Muybridge, starting with a series of a horse in motion, and the Frenchman Étienne Jules Marey.

1852, John Dillwyn Llewelyn:
Deer in woodland

A stuffed red deer stag, picturesquely arranged in woodland on the Llewelyn estate in Wales – a staged portrait resembling the painter E H Landseer's famous 1851 *Monarch of the Glen*. It was a paper positive made with a paper negative – Fox Talbot's calotype process. Llewelyn was skilled at such outdoor still-life compositions, requiring very long exposures, not possible with live subjects.

1856–59, Gustave Le Gray:
The Great Wave, Sète

One of a series of dramatic seascapes, produced by printing two glass negatives on a single sheet of paper – one exposed for the sea and the other for the sky. It brought Le Gray international fame as a photographic artist.

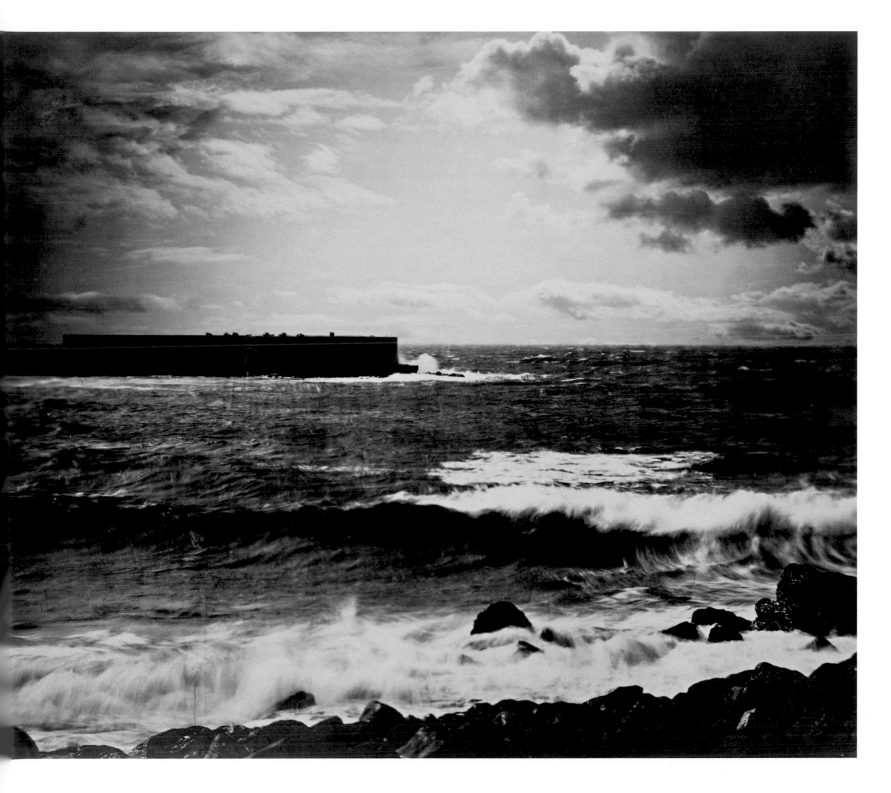

ART MEETS SCIENCE

By the end of the century, as photography became more manageable and its take-up more widespread, the first philosophical split had appeared. This was between the scientific photographers who saw the medium as a way of revealing the truth, and those who wanted to develop photography as a fine art.

The biggest transformation, though, was to come with the introduction of celluloid film as a base for emulsion. It was the catalyst for mass amateur photography and heralded the hand-held camera, epitomized by the Kodak camera of 1880 and Brownie cameras of 1900. By the turn of the century more than a million box cameras had been sold. It was the beginning of the age of the snapshot. But the difference in the quality of the prints meant that naturalists and artists would continue to use glass plates for decades to come.

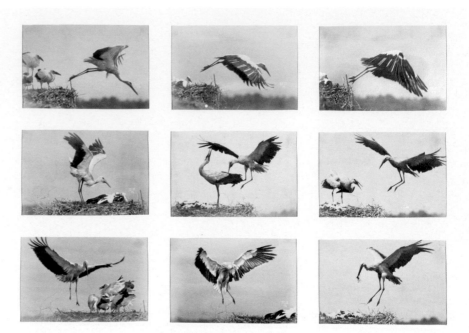

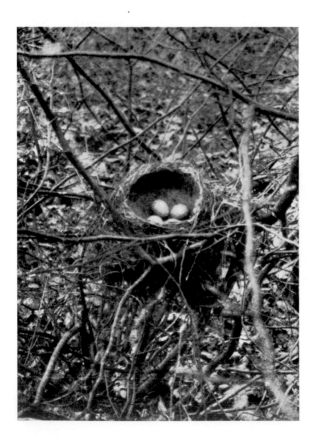

The rise of the naturalist photographer was also under way. Landscapes had been an important part of art photography, and the study of plants and animals was similarly important to science. So nature photography, as a form of its own, drew from both sides of the art-science split. It would even become a staple of the Kodak camera, since nature was always there to be photographed by anyone with an interest in it.

SNAPSHOTS OF LANDMARKS

As the nineteenth century ended and the twentieth began, nature photography, like photography in general, surged, with new developments almost every year. The following are some of the more notable landmarks.

1888 British photographer Benjamin Wyles starts to photograph seabirds, including gulls in flight, and goes on to publish an article on seabirds in 1892. The professional photographer and naturalist Reginald B Lodge starts photographing birds in about 1890, and in 1895, using

1884, Ottomar Anschütz: White storks

The first action shots of wild birds – white storks flying to the nest – taken by Ottomar Anschütz using the latest dry-plate photography, with a camera of his own design incorporating a fast shutter.

1892, Cherry Kearton: Song thrush nest

One of the first pictures of the nest of a wild bird. It led to the publication of the first natural history book to be illustrated with photographs taken in the wild – *British Birds' Nests*, by naturalist brothers Cherry and Richard Kearton.

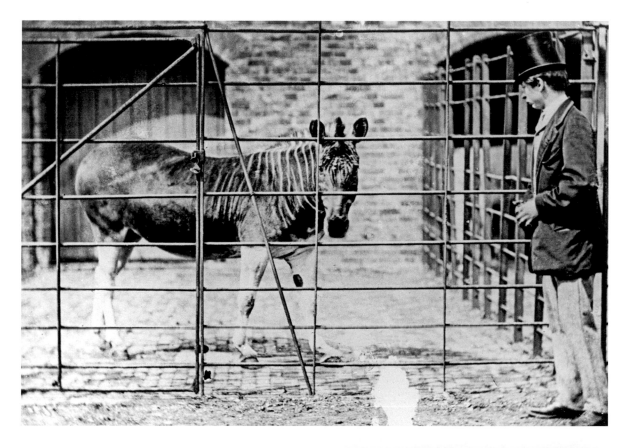

1864, Frank Hayes:
Quagga

The passive and presumably extremely still quagga in the London Zoological Society's menagerie. Though not stuffed, she might as well have been, as when she died, her species had already died out in the wild – hunted to extinction. It was one of several examples of early photography capturing the last of a species.

1895, Reginald B Lodge:
Lapwing

One of the earliest pictures of a wild animal and certainly the first in the UK to be taken remotely, using a trip-wire placed over the lapwing's eggs. Reginald Lodge started taking pictures of birds at the same time as the Keartons, possibly earlier. A naturalist with an artist's eye (his brother was a famous painter), he composed his pictures with care. He also invented an electric shutter that could be activated by a bird's foot.

1896, George Shiras:
White-tailed doe and her fawns

One of the first night shots, taken with flash in Michigan, USA, by the pioneer of remote flashlight photography. The trip-wire triggered the camera when the deer stood on it. George Shiras's pictures were the first wildlife ones to be published by *National Geographic*.

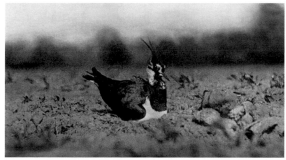

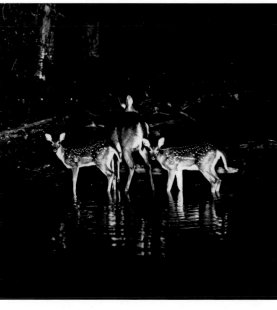

a trip-wire to release the shutter, takes a shot of a lapwing on its eggs. That year, he receives the Royal Photographic Society's first medal for natural history.

1888 *National Geographic* magazine is founded, promising 'absolute accuracy' and 'beautiful, instructive and artistic illustrations'. It isn't until 1906, though, that it publishes

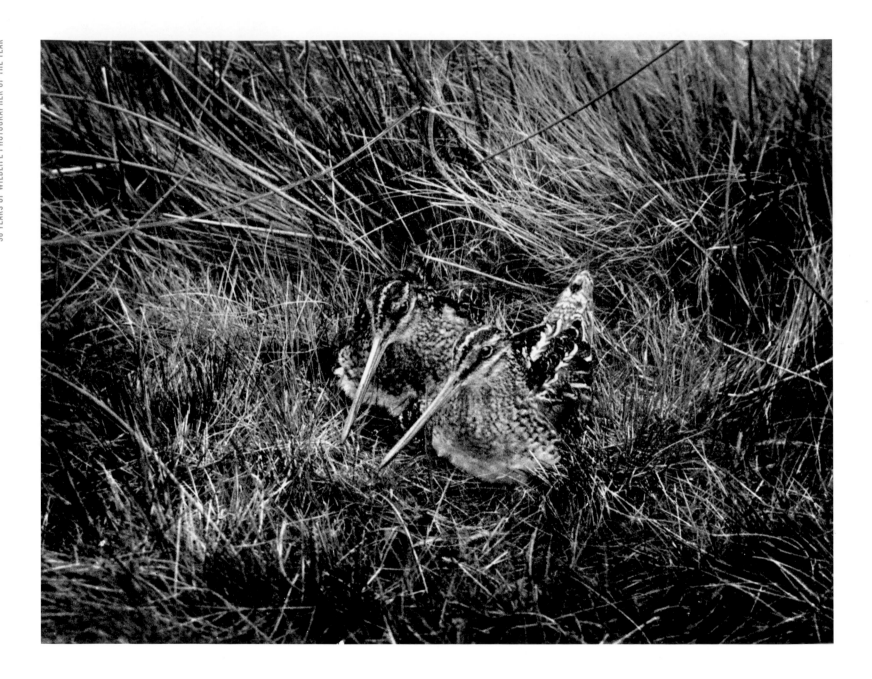

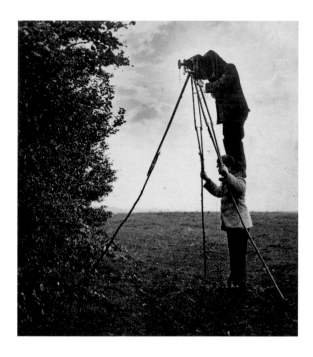

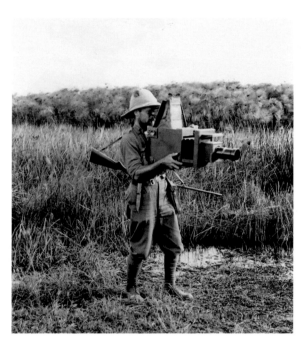

1907, Cherry (and Richard) Kearton: Snipes covering young

'One cold May morning I quite accidentally came upon the two chicks… I erected a hiding tent… and speedily exposed a number of plates upon their mother in the act of brooding them. Presently a long bill was nervously thrust through the rushes behind the crouching bird and instantly disappeared again. This was repeated at intervals of about a minute for quite a while, then the head of the male appeared, and finally he came forth into the open with a small piece of food… This was given to one of the chicks, and afterwards male and female each brooded a member of their small family, and I photographed them in the act.'

1900, Richard and Cherry Kearton using a home-made tripod

The two pioneering brothers (here, Cherry standing on Richard's shoulders to photograph a nest) did more than anyone else to encourage an interest in nature photography, through their many influential publications, their entertaining presentations and their international travels. Cherry went on to become a pioneering film-maker.

1909, Arthur Radclyffe Dugmore and camera, Kenya

Dugmore, a professional photographer and wildlife artist, posing with his extremely heavy reflex camera. He used the camera and its new telephoto lens, to take daylight pictures on his first African expedition. He went on to use trip-wires for night photography.

any wildlife photographs – pictures of deer taken in 1896 by George Shiras, using a remote-control flashlight and trip-wires.

1895 British brothers Richard and Cherry Kearton publish the first photographic nature book, *British Birds' Nests: How, when and where to find and identify them*, championing photography as 'the handmaiden of science in the field'. Richard invents the photographic hide. They are the first people to earn a living as nature photographers, and they publish more than 30 books, including, in 1898, *Wild Life at Home: How to study and photograph it*, which becomes a bible for generations of photographers.

1902 Irish-American Arthur Radclyffe Dugmore publishes *Nature and the Camera: How to photograph live birds and their nests; animals, wild and tame; reptiles; insects; fish and other aquatic forms; flowers, trees and fungi*, proclaiming in it, 'As a means of studying nature in most of its many forms, there is, perhaps, nothing better than the camera.' In time, he promotes the concept of photographic big-game hunting, declaring that hunting with the camera is more exciting than hunting with the gun.

1904 The German Carl G Schillings publishes *In Wildest Africa*, having used flashlight and trip-wires to take a series of spectacular shots of big, wild East African animals, causing a sensation. In 1910, he publishes *Camera Adventures in the African Wilds*.

1909 The Nature Photography Society (NPS) is launched, catering for all natural history subjects. In 1912, at the NPS's first exhibition, 95 per cent of the pictures have been taken out of doors.

1910-1913 The British Antarctica Expedition led by Captain Robert Falcon Scott includes the professional photographer Herbert G Ponting, already famous for his outdoor photographs. He produces a record of Antarctic wildlife that's recognized as special not just because of its subjects but also its artistry, made famous through his book *The Great White South*.

1913 *Wild Life*, the first nature-photography magazine is launched in the UK by Douglas English, author of *Photography for Naturalists*. Contributors include

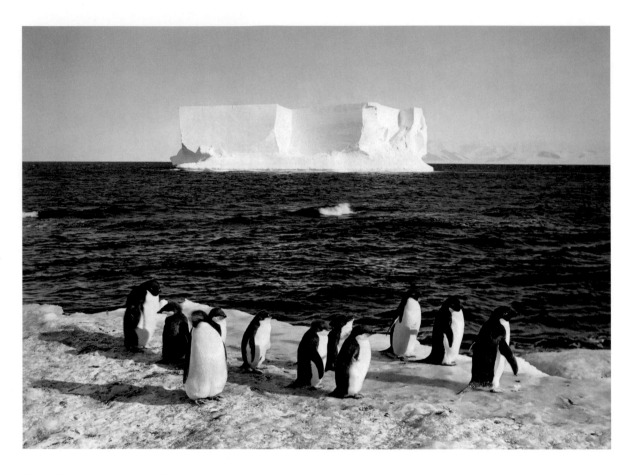

1911, Herbert Ponting:
Penguins and a berg at Cape Royd

One of a series of pictures of Adélie penguins. Ponting was one of the most famous outdoor photographers of his time, and was chosen by Captain Robert Falcon Scott for his 1910-13 expedition to Antarctica as a camera-artist, to make a record of Antarctic wildlife. Taking with him the latest film cameras and equipment, Ponting returned from his leg of the expedition with unforgettable pictures that received international praise. Scott and his South Pole team never returned.

1945, Ansel Adams:
Mount Williamson, Sierra Nevada,
from Manzanar, California

A classic landscape by one of the most influential American fine-art photographers of his time. His black and white landscapes were distinguished by the quality of the light and by his printing. Ansel Adams believed in 'pure' photography – creativity through framing, light and selection of the moment.

Emma Turner, one of the first British women to become a dedicated nature photographer.

1913 Inspired by the Kearton brothers and the flash photographs of Carl G Schillings, Frederick Walter Champion (page 18) goes to India with the aim of photographing tigers in the wild. His pictures – taken from elephant-back, by flash and by trip-wire – provide a record of Indian wildlife that, in the 1920s, help in the campaign for conservation of both habitats and species. Likewise, the photographs coming out of Africa in the 1920s and 1930s prove vital for conservation campaigning.

1927 The first underwater colour picture is published. Underwater photography began in 1893 with French marine zoologist Louis Boutan, who developed all sorts of contraptions to try to take photographs, including a lighting-explosion system. The focus was on developing a housing for a camera rather than an underwater camera. Continuing Boutan's work, Etienne Peau took probably the first in-situ shot, in 1907, of a spider crab. But it was American fish biologist William Longley, with Charles Martin from *National Geographic*'s Photo Lab, who made the first colour photographs of moving fish in the sea, published in the magazine in 1927. Dr Longley had already experimented with glass-plate photography, but there was never enough light. This time he used a faster solution for the plate and a raft of explosives on the surface. Unsurprisingly, no one followed their technique, and underwater colour images had to wait for Kodak fast-colour film, the first commercial flashbulbs in the 1930s and the modern aqualung of the 1940s.

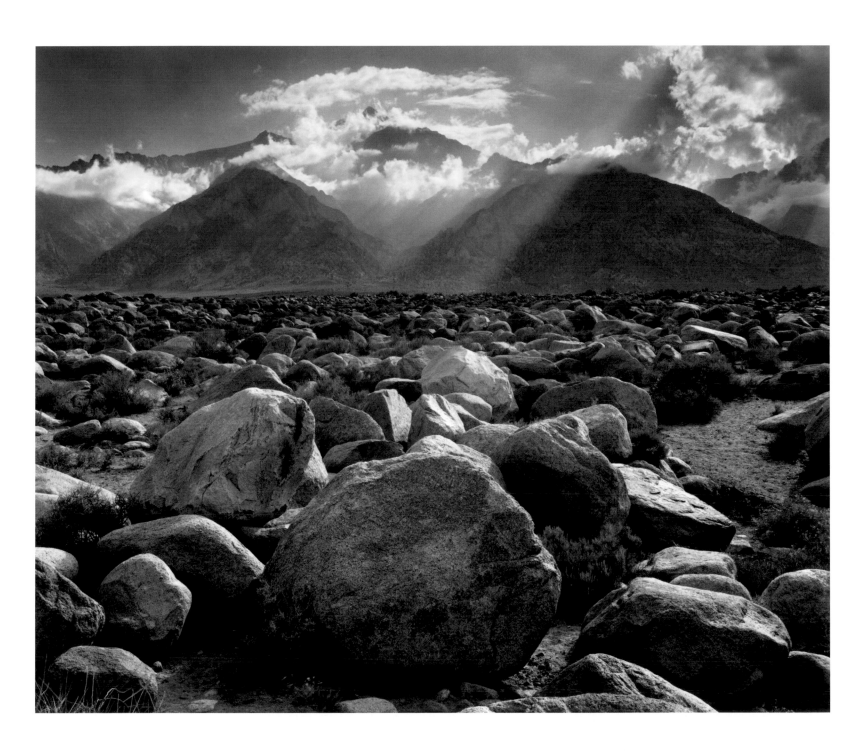

ABSTRACT ART AND CREATIVE PHOTOGRAPHY

The rapid rise of photography, which in less than 30 years had progressed from an arcane, often awkward, chemical process to an established scientific and artistic tool, had an effect on painting. Photography could create in a flash a record of the visual world, freeing painters to develop new forms, such as abstract expressionism and modernism. Photography, in turn, could adapt a certain creativity to its visual documentation. This became known as creative realism, and among its proponents was the American landscape photographer Ansel Adams. He emphasized the importance of the photographer's choice as 'selector', framing the area that the camera could capture in sharp detail, and he and others championed creativity in the selection of aspects of form in nature.

COURTING COLOUR

Adams' legacy was a series of famous landscape images that led to the creation of more national parks. His environmental successor was Eliot Porter (see page 20), whose colour images from the 1940s included wildlife as well as landscape. They were made using Kodak's new dye-transfer process, with its rich colour, and moved away from the grand vista towards a more intimate view of the natural landscape. Most European wildlife photographers, though, continued to work in black and white, mainly for its resolution and creative darkroom possibilities but also because colour negative film was expensive

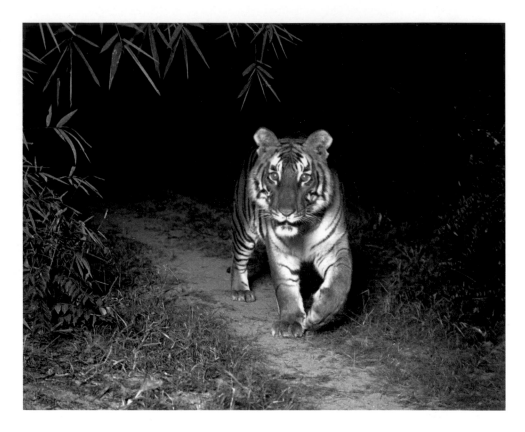

and difficult to process, and most publications continued to print in black and white. Much of the work in Britain remained traditional and still featured birds at the nest (birdwatching being the most popular natural history hobby), and almost all the photographers regarded themselves as naturalists first and foremost. Practitioners included C W R Knight, a specialist in treetop bird photography, Seton Gordon, famous for his golden eagles, and Eric Hosking, who was to become one of the most well-known bird photographers of the twentieth century.

THE FLASH REVOLUTION

Two breakthroughs came with the production of the smaller-format single-lens reflex camera in the 1920s, in particular the Leica, and in the 1930s, the first commercial flashbulbs, replacing magnesium flash powder. Kodak colour film also arrived in the 1930s. The photographer Eric Hosking turned professional in 1929, and until at least the 1960s, he was the only person in Britain to earn a living from nature photography.

1926, Frederick Walter Champion: Tiger on a jungle path

The first picture of a truly wild tiger, taken by the tiger touching a trip wire. The positioning of the wire, camera and lighting had to be just right to both create and compose such a picture.

1948, Eric Hosking with his high-speed flash equipment

Eric sitting in the frame of his bird hide to reveal all the equipment that was necessary at that time to photograph birds in flight using high-speed flash.

1938, Eric Hosking:
The tawny owl that robbed me
of an eye

This picture of a tawny owl was taken
using the new revolutionary (for wildlife
photography) Sashalite flashbulb, at
1/75th of a second, with a Sanderson
field camera and a Serrac 8.5-inch lens.
In the dark, Eric had to rely on sound to
know when the owl had landed, then open
the shutter, fire the flashbulb and close
the shutter, there being no synchronized
link. The same owl later attacked him
when he was climbing into his hide in the
dark. The fact he hadn't realized the owl
was back at its nest cost him his left eye.
But the publicity that resulted also gave
him overnight fame.

It was the flashbulb that enabled him to take his famous pictures of owls, but it still had to be operated by hand in the dark. When a portable high-speed flash came on the market in 1945, Hosking had it modified so it was operated by an automatic shutter trip, resulting in sharp flight images. In 1947 *National Geographic* published high-speed flash pictures of hummingbirds by the flash's inventor, Harold E Edgerton, who in 1937 had also designed the first successful underwater camera. He became widely known for his flash photography, and, in 1953, designed the first deep-sea electronic flash.

THE FILM REVOLUTION

What started the growth in wildlife photography in colour was the arrival of slide film in the 1950s – Ektachrome in 1959 and Kodachrome II in 1961, which was reliable and increasingly affordable. By the mid-1960s, when the Wildlife Photographer of the Year competition was launched, colour wildlife images were ubiquitous. From 1974, Kodachrome 64 took over as the wildlife photographer's general slide film of choice.

Compared to negative film, there were drawbacks with transparencies. You were stuck with what you shot – there was no artistic freedom through processing. You couldn't make good prints from slides, other than through expensive processes such as Cibachrome, and slide duplication was not perfect. Also, the film had to be sent away for processing. So you couldn't see the results for weeks and certainly couldn't learn from any mistakes in time to adjust shooting in the field. But it was cheap enough, and it reproduced well enough and resulted in a collection of images that remains remarkable today. At the same time new long-focus lenses increased the possibility of photographing the behaviour of shy animals. Indeed, technology was about to transform the ability of photographers to create pictures of nature.

In 1965 *Animals* magazine (forerunner of *BBC Wildlife*) launched the Wildlife Photographer of the Year competition. Its annual galleries of pictures would chart the technological development of the medium over the next 50 years and the growth of nature photography as a genre, not to mention the genre with which photography began.

OPPOSITE PAGE
1963, Eliot Porter:
Forest floor detail from the road
between Blue Ridge and Newcomb

A close-up of a forest meadow in the
Adirondack Park, New York State, USA –
one of a series taken as part of a
campaign against opening up the park
to development. It's a typical Eliot Porter
mosaic composition of subtle shapes and
colours, light and shade, using Kodak's
new dye-transfer colour-print process.
An environmental artist, Porter set a
standard and style of colour landscape
photography that inspired a generation.

1945, Eric Hosking:
Hobby

This shot of a hobby nesting in an
old crow's nest was taken using early
Kodachrome colour film, with a
quarter-plate Sanderson camera.
To be eye level with the nest required
the erection of a 19.5-metre-high
(64-foot) pylon hide opposite the tree.
The drawback of Kodak colour film was
that it had to be sent away for printing,
with no later adjustments of colour or
tone possible, and so the amount of
light was all important.

The rise of the competition

It was possibly the most influential nature photograph ever taken, and it wasn't taken on the Earth. It was taken on the Moon, and it was of the Earth. The picture was, of course, the famous 'Blue Marble', from the 1968 *Apollo 8* mission, and it gave people, for the first time ever, an all-in-one look at the place where they and all the rest of nature lived.

That picture was the crowning image from a pivotal decade in public attitudes towards nature. There had been the *Silent Spring* awakening to the threats of environmental poisons and pollution and a new widespread awareness of a need for nature conservation, that meant saving whole habitats. International conservation organizations such as the World Wildlife Fund were established and regular nature programmes began to appear on television, including some that touched on conservation.

Among the early television nature series was the BBC's *Travellers' Tales: Armand and Michaela on safari*, presented by Armand and Michaela Denis in 1958. Britain's first colour nature magazine, *Animals* (which became *BBC Wildlife)*, established in 1963 and covering conservation issues, was fronted by the same couple. It set out to make the most of the growth of wildlife photography, running an international competition for wildlife photographers in its first year. Then in 1965 it launched the Wildlife Photographer of the Year competition. The competition's purpose, it stated, was 'to encourage the work of wildlife photographers and enhance the prestige of wildlife photography' and added 'in the hope that ultimately the awards will benefit the animals themselves, by creating greater public interest in them and in that all-important topic – conservation'.

In those days, there were few professional wildlife photographers, but there were skilled amateurs – knowledgeable about wildlife, masters of their cameras and in love with their subject. Given the limited outlets for their images, the magazine and its competition would provide a platform and an incentive. It also marked the rise of nature photography in full colour, requesting that all entries be colour transparencies.

THE FIRST COMPETITION

The first judging panel included the artist and conservationist Peter Scott and Britain's only professional wildlife photographer, Eric Hosking. Both had strong views about conservation, which the competition would continue to champion, with an ethical stance that would harden over the years. Peter Scott designed a gold medal for the overall winner – the Wildlife Photographer of the Year – to be presented by David Attenborough, and silver medals for both an overseas winner and a British one in each of three categories, Birds, Mammals and All Other Animals. The quest the competition now set out on was to find 'that extra quality that turns a good photograph into a great one'. Over the next 50 years, the competition would grow in parallel with the growth in photography.

In its first year, there were 361 entries, many of them from overseas. Twenty years later there were more than 12,000. Fifty years later, there were more than 40,000. Over that time it has helped move wildlife photography away from specimen collecting and towards aesthetics and emotion, message and meaning. Its archive of pictures can also be seen as a record of wildlife photography over the past half-century.

1980s – THE TRANSFORMATION

The biggest changes occurred in the 1980s, both in technology and in the competition itself, which transformed into the event as we know it today. In 1981, the magazine (by then *Wildlife* and shortly to become *BBC Wildlife*) enlarged the competition with six categories, including an environmental and an urban category, ran a new linked competition for young photographers and an exhibition of winning and commended pictures, which went on show that year in London's Mall Galleries. Then in 1984, *BBC Wildlife* joined forces with the Natural History Museum, London, found its first competition sponsor,

Prudential Assurance, and brought in a conservation partner, the Fauna and Flora Preservation Society (now Fauna and Flora International) for the next few years.

It relaunched with 11 categories, including ones for underwater and landscape photography. There were 12,000 entries from 24 countries and more than 100 pictures in the exhibition, which ran for two and a half months at the Natural History Museum. The museum also hosted the awards – an international gathering of all the winners, with prizes presented by the good and the great in the wildlife world, including Sir Peter Scott, David Attenborough, Gerald Durrell, Virginia McKenna and David Bellamy.

In the following years, the exhibition would also start to tour overseas. In 1988, entrants from the USA swept the board. In 1989, the Scandinavians and northern Europeans entered in force. New Zealand and Australia began to take the touring exhibition in the 1990s, resulting in more Antipodean

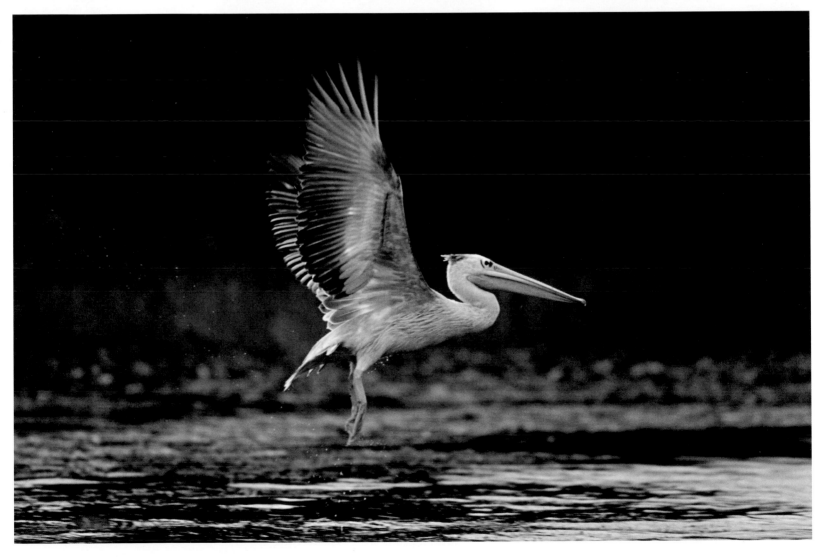

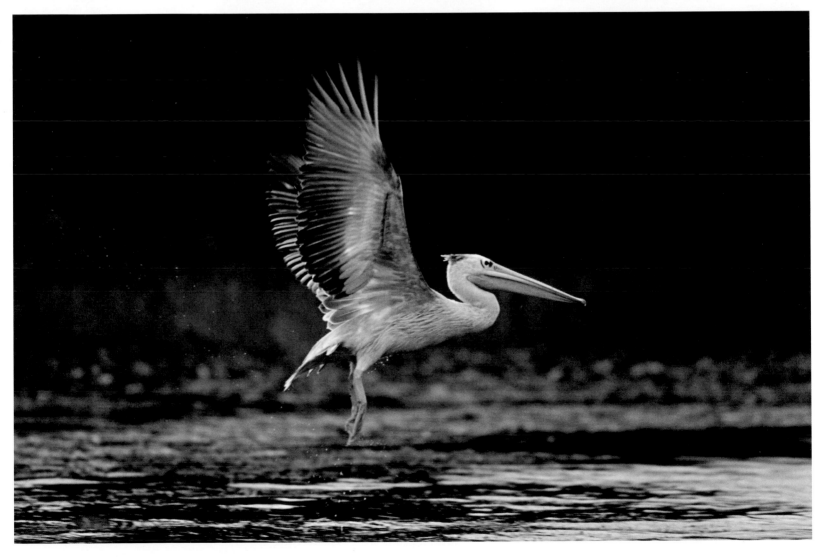

entries, and in 1993, a partnership with a Japanese magazine brought the competition and exhibition to Japan. The result was a growing international collection of images, which not only wowed the public but also introduced photographers in different countries to each other's styles and innovations.

In the 1990s the reach of the competition grew, helped by the 12-year sponsorship of British Gas (later BG), which took the exhibition to places as far afield as India, Kazakhstan, Trinidad and Brazil. The portfolio yearbooks, first published in 1991, displaying all the winning and commended entries, have become another vehicle for inspiration.

Eric Hosking remained a judge for many years, and when he died in 1991, the Eric Hosking Award was created for a portfolio of work by a photographer at the start of his or her career, to encourage talent. And when Gerald Durrell, another supporter of the competition, died in 1995, the Gerald Durrell Award for endangered species was created – emphasizing the competition's conservation aims.

Year by year the competition grew gradually, in parallel with the growth in numbers of wildlife photographers. But the major growth was to come with the arrival of digital photography. At first, the prohibitive cost of the cameras meant that only a few professionals, including underwater photographers, made use of the new technology, and in 2004, the first year the competition invited digital entries, an underwater photographer won the main award. But by 2009, all entries were digital, and the number of entries passed the 40,000 mark.

Today the competition remains the most prestigious of its kind, attracting entries from the top professionals from all over the world. Its reach remains international, and the number of people who see its annual gallery of pictures is in excess of six million. Though the competition has come a long way in half a century, it is only one supporting influence in the very much longer way that nature imagery itself has come – from cave paintings to the whole Earth.

1979: Eric Hosking presenting the Wildlife Photographer of the Year Award to David Cayless, UK.

1979 Wildlife Photographer of the Year, David Cayless: The crossing

A river-crossing of migrating wildebeest, accompanied by zebras in the Masai Mara, Kenya. At that time, the Mara was not the tourist honeypot it is today, and the picture was one of the first to be published of the massing of wildebeest. It was taken with an Olympus OM2 with a 300mm lens, using Kodachrome 64, which was by then the preferred transparency film.

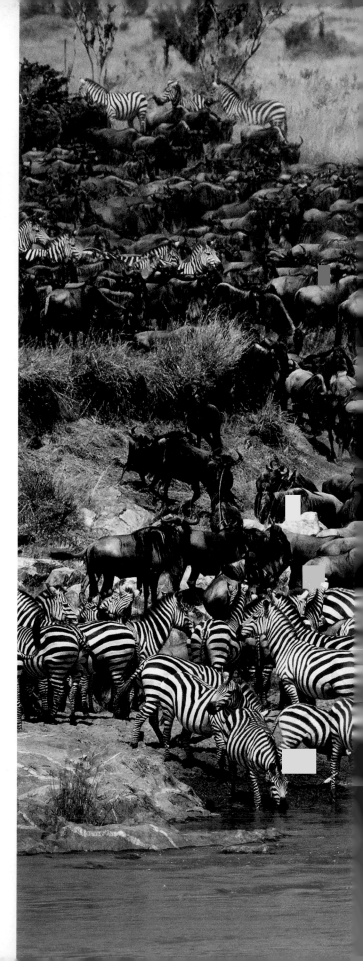

The art of seeing

A camera takes a picture, but it's the photographer who chooses the composition and offers the image as an artistic creation, and it is that act of selection that is the main part of the art. Photography of nature requires craft – planning, knowledge and the application of technique – but for a picture to be seen as more than a crafted record of a subject or scene requires a composition that connects with the viewer's emotions and imagination. It is those compositions that the judges of the competition search for. And it is the test of time that reveals whether or not their choices have been right.

The best pictures last, allowing us to look and look again with pleasure. Sometimes there is an intention that a picture should express something, make a statement. Sometimes a picture is obviously innovative. Other times it has a quiet appeal, and it is the little things and not the obvious ones that make it work. But a winning picture is always original.

What is fascinating when looking at the gallery of pictures as a whole is that so many of the older film images (20 or so years before the arrival of digital) are still among the very best. Often it's not a matter of sharpness or depth of field – rather depth of feeling. If submitted into the Wildlife Photographer of the Year competition today, many of them would still win top awards. Indeed, some of those unforgettable pictures have influenced a generation. The shame is that they are not yet included in the historic collections of photographic art.

Tern over the magical slough

It was midday when the photographer took the picture, and the wind was blowing, as it often does in North Dakota, near the US border with Canada, bending the reeds and washing the algae into sunlit, sparkling rafts. The scene was beautiful, but the sun was directly overhead, which photographically meant harsh light that would probably flatten and bleed the colours. So the photographer just watched from the car and ate his lunch. But when a sooty tern started playing the wind back and forth, he had to take a shot. He didn't think he had a chance of capturing the beauty of the scene, and so it was weeks before he looked at his slides – and there it was. Magic.

Jim Brandenburg USA 1988

Flights of colour

The impact of this picture was the result of the decision to let movement paint it, producing wing-splashes of translucent colour. It was a surprising and original image for its time, and an award-winner. It was also one of the first pictures of such a scene. For the red-and-green macaws, the focus was the riverbank, where they would gather every morning to mine clay. Groups of them would take turns to fly down and grab beakfuls, swallowed to neutralize toxins in the seeds they eat. The picture was taken in Manu National Park, Peru, from the opposite riverbank and a hide that the photographer would enter before dawn so that he wouldn't be seen by the ever-watchful macaws.

André Bärtschi Liechtenstein 1992

Shrimp

It's a powerful composition that hasn't been bettered in 20 years. The power of the picture is in the viewpoint, portraying the anemone as a great fortress, with the tiny shrimp as the surprise, peeping out of the gloom. The concept has been executed with careful illumination, the artificial light of the flash softened by use of a reflector, adding polish to the anemone and glow to the shrimp, and leaving mystery in the background. The picture also hints at the relationship between the two Red Sea creatures. The shrimp performs cleaning duties, and the anemone provides food, a home and defence in the form of its umbrella of stinging tentacles.

Jeff Rotman USA 1991

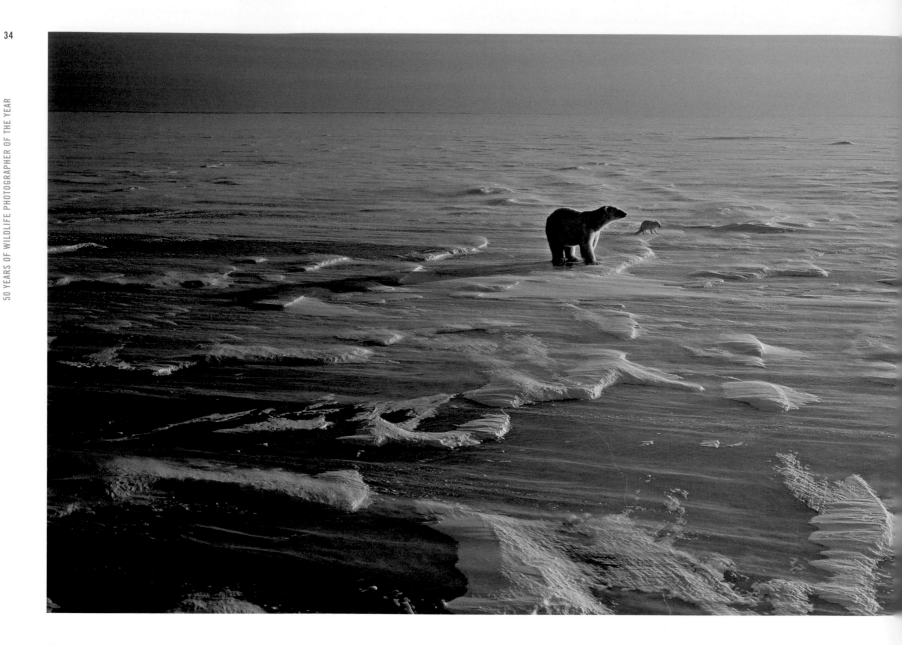

Great bear, little fox

This is another extraordinary picture that, 20 years on, remains unequalled. It has both intimacy and grandeur – the opener to a story of survival. The panoramic view creates the feel of a vast ice wilderness, stretching to the horizon. It shows Hudson Bay, frozen at the onset of winter – hunting ground for polar bears. The bear and the little Arctic fox stand looking towards the setting sun, as if about to begin their journey. The bear will hunt seals on the ice, and its little follower will grab scraps from the dining table. This was the first panoramic picture not only to win the main award but also to be entered in the competition. It took 10 years and some 80,000 frames to achieve what remains one of the photographer's most treasured images.

Thomas D Mangelsen USA 1994

Down to eye level

One of the most important stylistic developments was something so simple that, today, it seems strange wildlife photographers didn't adopt it much earlier. But that, of course, was probably because of the restrictions of heavy cameras and sturdy tripods and of convention and different aims. This is the eye-level perspective, adopted automatically when the subject is a human, usually standing up, but when the subject is a wild animal, it can mean getting right down on the ground. When the viewer is no longer looking down but is eye to eye, the link that's made can be an emotional one, certainly a respectful one, and if the camera can actually be looking up, sometimes even a reverential one.

One of the first proponents of an intimate eye-to-eye view, and in the early 1980s certainly the first professional to adopt it as almost a signature style, was the influential Dutch photographer Frans Lanting. It can be seen in much of his work in the competition, and certainly in the pictures in his 1991 award-winning portfolio.

Shooting big wild animals lying prone on the ground creates a dramatic effect but can obviously have its dangers, and solutions include attaching the camera to a pole, lowering it to ground level and leaving it there, using remote technology to fire the shutter from a distance.

Today, the fashion in hides is to create them below ground level, allowing the photographer to sit comfortably while being eye to eye with the birds or mammals, often attracted to an artificial water source. Many of the winning Wildlife Photographer of the Year pictures have been taken from such hides. With birds and smaller animals, the eye-to-eye approach can be startling and revealing, giving a whole new perspective on familiar subjects.

Impalas in unison

By lying flat on the ground, the photographer was able to frame the picture to concentrate on the natural symmetry of the impalas, their graceful poses mirrored by their reflections. They are alert, ears cocked, but obviously unaware of the human, who has been lying long enough beside the waterhole to become part of the landscape. The low light of evening was also what Frans Lanting had been waiting for, casting a gentle golden glow over the forms of the drinkers.

Frans Lanting USA 1991

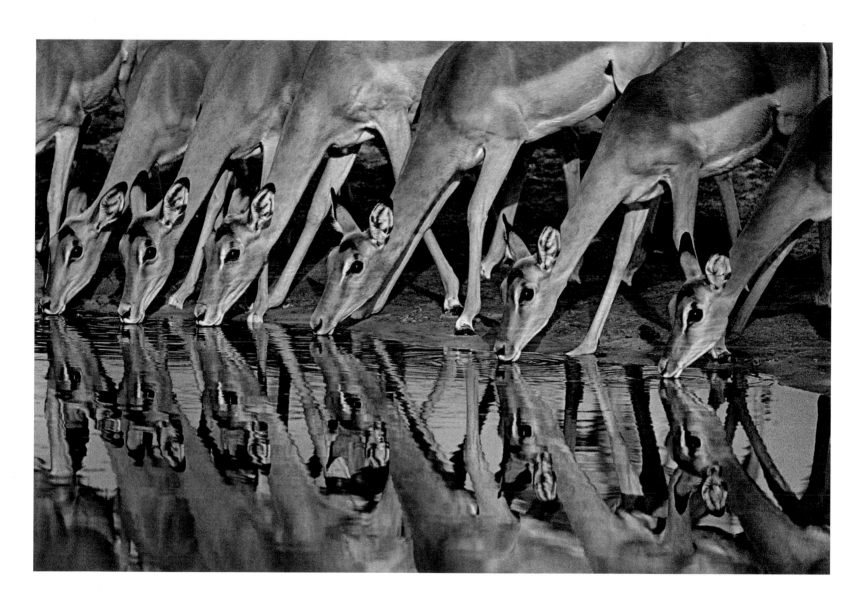

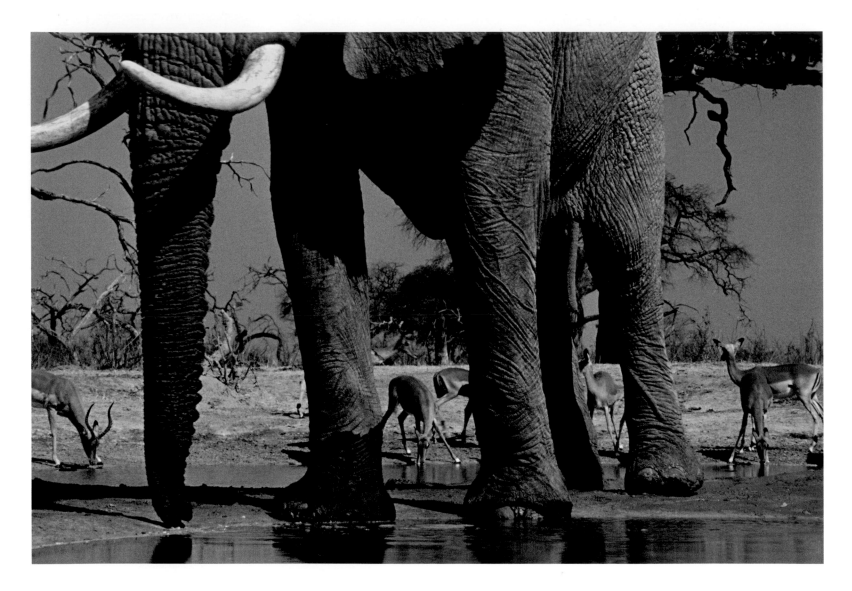

At the feet of an elephant

It's a classic ground-level perspective, used to create a sense of the great size of
African elephants – a viewpoint that has become part of the repertoire of wildlife
photography. In reality, the impalas are not as small relative to the elephant as they
appear, the illusion resulting from the use of a long lens. Adding to the effect is
the dramatic crop – a novel composition device at the time – concentrating our view
on the contrast between the solid, gnarled tree-trunk forms of the elephant's legs
and the delicate, miniature gazelles on the sunlit stage behind.

Frans Lanting USA 1991

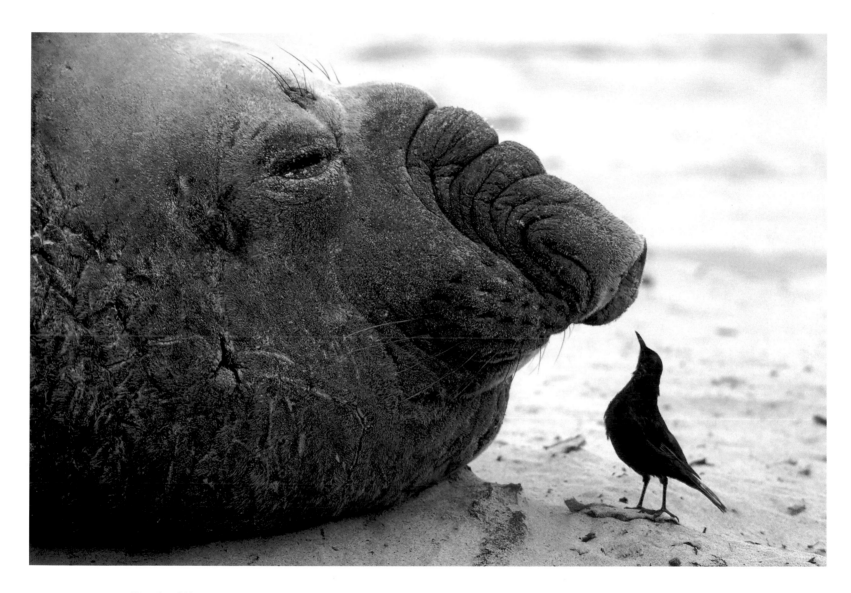

Attractive pickings

The only way to photograph such a cameo scene was to adopt the pose of an elephant seal and lie flat on the beach. The inquisitive little tussock-bird hopping around the southern elephant seal on the Falkland Islands could have been looking for flies. But the likelihood is that it was about to pluck mucus from the nasal cavities of the resting male or to pick at a scab or two and feed on the blood — regularly available after males have been fighting. Avoiding a more literal illustration, the photographer has chosen a tonally muted, amusing angle on a fascinating bit of behaviour.

Fritz Pölking Germany 1991

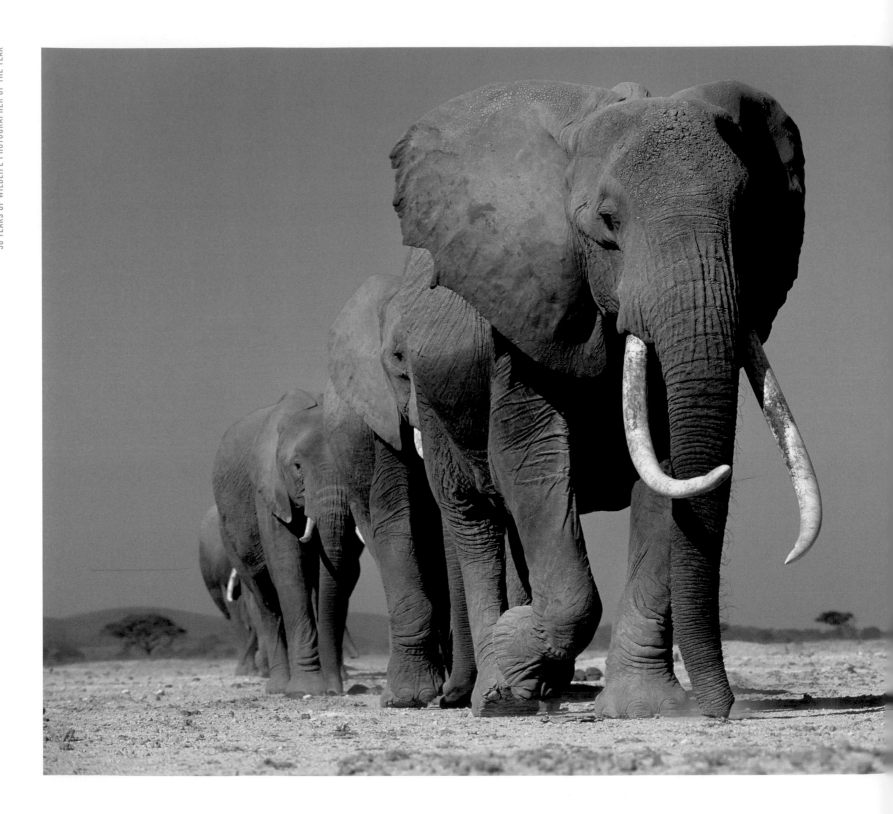

Procession

The grandeur of these giants is made physical both by the perspective and the proximity, a cloudless sky providing the perfect backdrop. That it was possible to take such a shot from a prone position was because the elephants were very familiar with both the photographer and his Land Rover, since he had been photographing and filming them for a number of years. Their own habits were also well known, the elephants of Kenya's Amboseli National Park being the best studied population in the world. Here the matriarch Jezebel leads the JA family on their daily pilgrimage across the flat alkaline pan to the central swamps to bathe and drink. Her unmistakable tusks form the central focus of the piece. Nearly 60, she died shortly before her portrait was awarded its prize.

Martyn Colbeck UK 1993

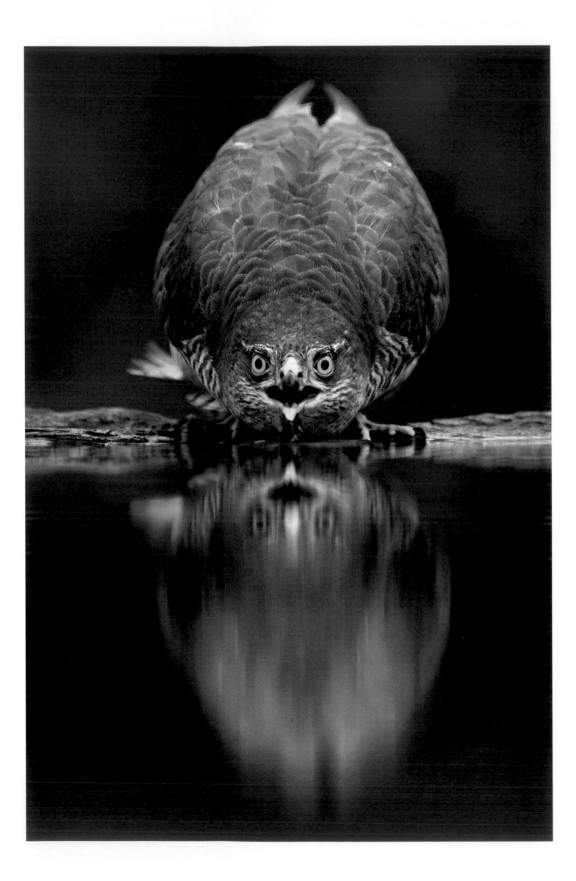

Pool hawk

Such an intimate eye-to-eye view was made possible through ingenuity and planning. It was taken from a hide built down into the ground so the photographer could sit at eye level with the pool that he had dug close to his home in Hungary. To allow an unobstructed view without any visitors to the pool being scared away by movement inside the hide, he used a one-way mirror to look out through. Woodland surrounded the pool, and so eventually a sparrowhawk started to visit. The photographer focused on the hawk in advance of it bending down to drink, waited for the moment it lifted its head and took the perfect head-on portrait.

Bence Máté Hungary 2007

Pester power

Everything is right with this picture – the colours, the setting, the angle of the birds and the focus of attention, and it all comes together because of the eye-level view. At 14, Mateusz Piesiak knew his stuff – he'd watched birds since he was six and photographed them since he was 11, and had studied the work of other photographers. So it was second nature to lie down on the wet sand and follow the American oystercatchers with his lens. The young one was pestering its parents as they foraged on the beach, begging for food. In the shot, it's about to win a morsel of shellfish. The picture would go on to win Mateusz the Young Wildlife Photographer of the Year Award.

Mateusz Piesiak Poland 2011

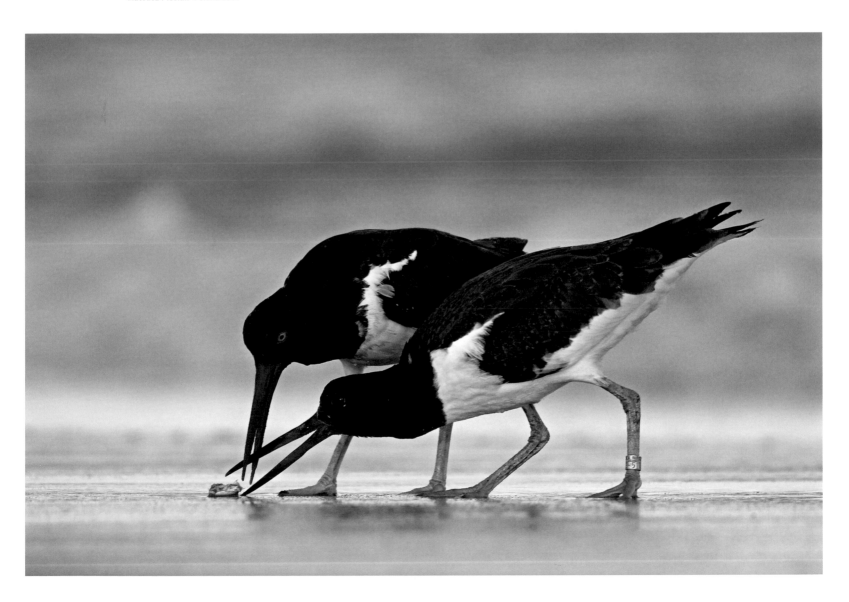

A sense of place

Creating a picture where the wild subject is glimpsed as just part of its environment is something that many photographers now aspire to, conveying atmosphere as well as a sense of place. But it wasn't always so.

Though the early photographers took pictures of natural environments, these were usually of grand vistas in the style of the great Victorian landscape painters. The technical limitations of lenses and film speed meant it was impossible to put animals – at least living ones that might move – into such scenes. So the first pictures of plants and animals were static portraits. To shoot pictures of truly wild animals, you had to be a first-class naturalist as well as a wizard photographic technician. The art therefore tended to be in the skill of capture rather than the aesthetics of atmosphere.

With the advent of new lenses, SLR cameras and faster film, more creativity in the photography of nature became possible, and communicating the impression of a place, with an animal glimpsed as part of it, became the challenge. The compositions were often created with feeling, as an encapsulation of the photographer's sense of the moment as well as the place. As the naturalist and broadcaster David Attenborough commented on such pictures, 'A tiny speck that is an eagle in the swirling mists of a northern forest can reveal its character and that of the place in an almost mystical way.'

One way to both set a scene and convey a message, almost as painters did in past centuries, is to use a wide-angle lens, creating a composition that focuses on the subject but also places it against a backdrop of its environment and the foreground of its setting. Skilled use of a wide-angle is what has created the most memorable of underwater pictures and is now one of the favourite tools of land-based nature photographers.

Chamois lookout

There's something almost quizzical about the expression of this chamois, as if he's surprised at what he's seen in the alpine valley below. Indeed, the setting is what makes the picture. Carefully composed, taken in Abruzzo National Park, Italy – the photographer's favourite location – it shows an Apennine chamois, a threatened subspecies, poised at the edge of his mountain home, overlooking the human-populated Sangro Valley below. There is a message here, about both the animal's home and the threats facing it. Today, hunting chamois is illegal, and numbers are stable, but the population is restricted by competition with livestock for space and food.

Angelo Gandolfi Italy 1987

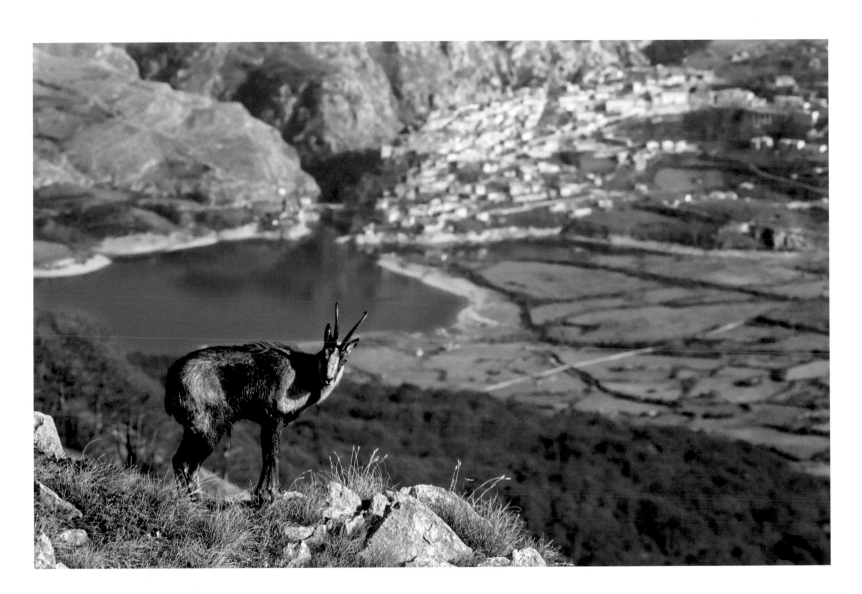

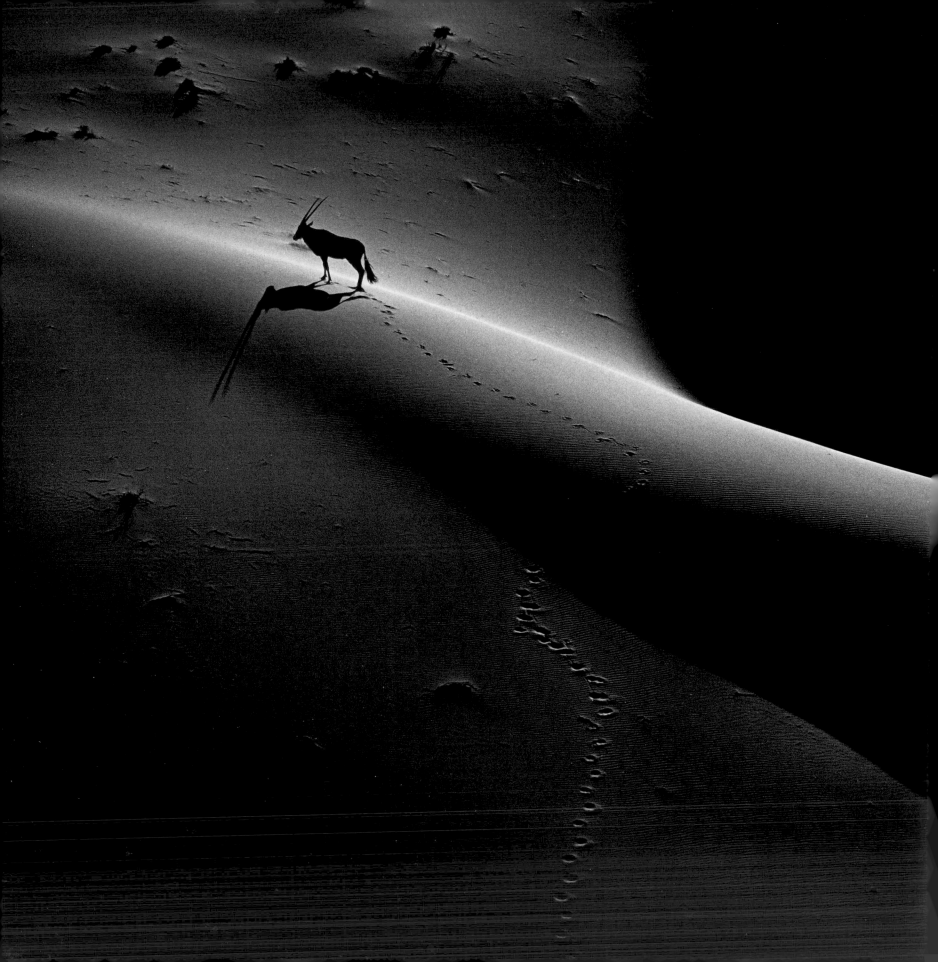

Dune oryx

So often a special image is a matter of luck, but to catch that luck, you have to be in the right place at the right time. In this case, the photographer had visualized the picture before he went to Namibia – an oryx, small in its vast desert environment, against a sunlit stage – but he knew the chances of all the elements coming together at the same time were remote. Not only were oryx difficult to find in the desert, there was still a war going on, which he was supposed to be there to cover. He still sees it as a miracle that it all came together, at sunset, on the third week of the quest – the great sand-dune stage, the angled lighting and the beast itself. It remains a magical shot, deserving of the competition's grand award.

Jim Brandenburg USA 1988

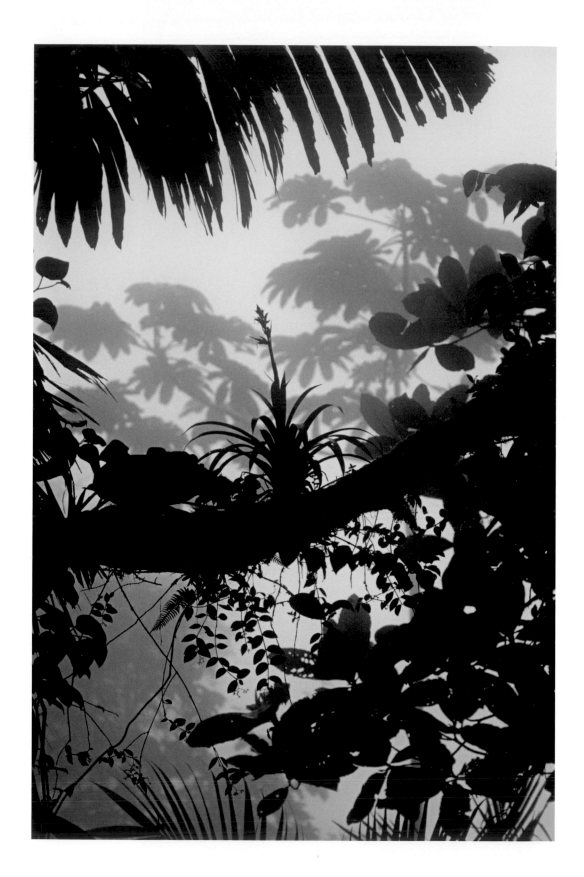

Bromeliad in the cloud forest

This is a cloud forest composition, designed to conjure up the feel of being in a magical high-altitude forest where hummingbirds feed and sloths hang and the air drips with moisture. It's a simple but skilful composition by a photographer fascinated by the beauty of tropical forests. The centrepiece is a bromeliad – an epiphyte, which uses other plants as its support and drinks water from the air. It is surrounded by a diversity of life, signified by the many leaf shapes and sizes. Palms frame it top and bottom, tendrils of climbers reach in from the sides, and the serrated leaves of a cecropia tree, favourite food of sloths, form the backdrop. Here, in Venezuela's Henri Pittier National Park, the mist that bathes the forest condenses from the warm air that sweeps up the mountains from the Caribbean Sea below.

Brian Rogers UK 1985

Testing the depth

Storm clouds create the grey palate of this cold Greenland landscape – a region
visited by comparatively few wildlife photographers. Casting ripples on the meltwater
on a windless evening, the Arctic fox is delicately testing the water's depth as it
makes its way across the ice to a nesting tern colony on an offshore island beach.
It's spring, and the fox is moulting into its summer coat, but a shortage of lemmings
has meant that it emerged from the starvation of winter to lean times and was
more intent on hunting for chicks than paying any attention to human followers.

Jean-Louis Klein & Marie-Luce Hubert France 1994

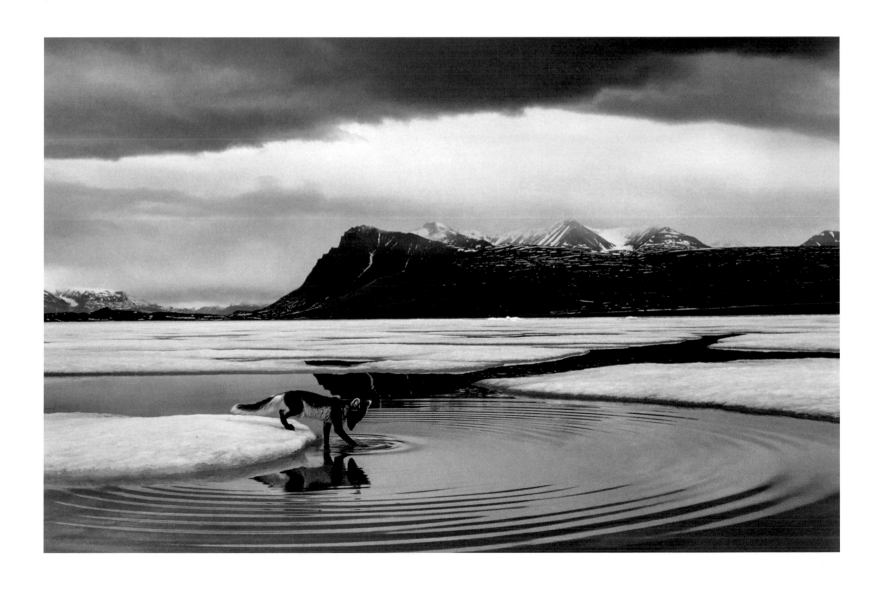

Moose at sunset

This magnificent canvas has merged the great tower of clouds and sunset sky with the flooded river plain into one great vista. It's also caught a moment of movement – of the fast-changing colours, the rolling clouds and the moose itself, listening intently to the sound of a distant car. The picture was taken in the early evening in late summer in Yellowstone National Park, Wyoming, after a massive thunderstorm, when the river has flooded over the valley plain. The photographer is a long-time winter keeper in the park, intimate with the landscape and tuned to the weather. This is one of his favourite places, and after the storm, he had stationed himself on a bluff overlooking the valley to watch the changing light. He knew a moose might come to feed in the river, but for it to pause in the pool of reflected sky was a gift from the heavens.

Steven Fuller USA 1984

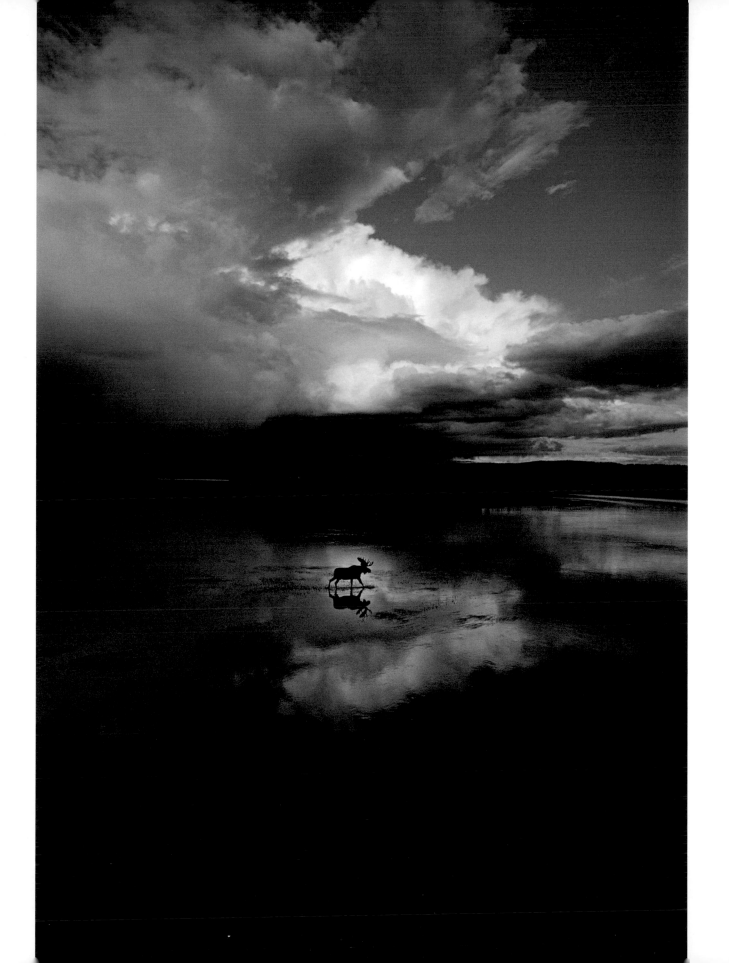

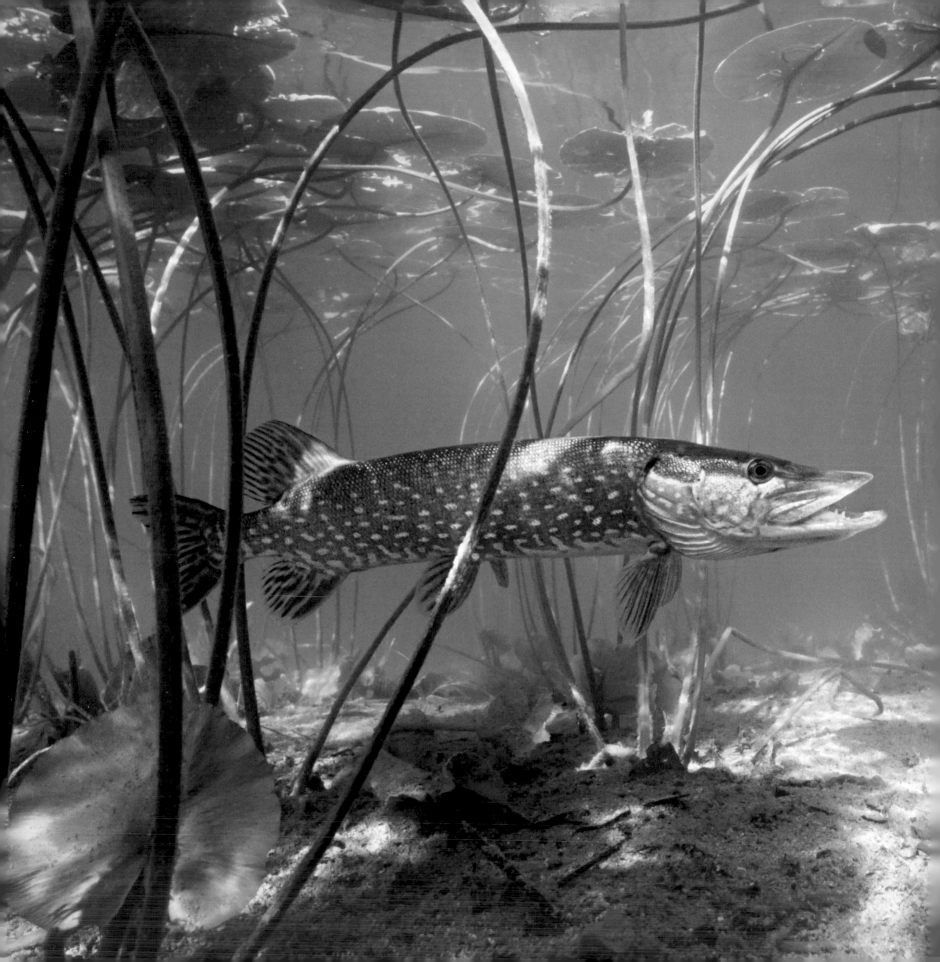

Pike heaven

To see a freshwater landscape with such clarity is rare. The beauty of the scene comes from the dappled light filtering down from overhead, picking out the curves of the swaying lily stems and painting the sand with leaf shadows. It's this interplay between water and light that inspires the photographer, whose landscapes are discovered mainly by snorkelling in the rivers and lakes of the Jura region of France. This scene is from a crystal-clear creek in Lake Ilay, where the water is filtered through the surrounding limestone hills. The surprise was finding a predator among the grove of lily stems. The pike stayed motionless except for the occasional ripple of its fins, and remained so even when the photographer had to return to the bank to change film. It was perfectly relaxed in its camouflage colours and at home in its environment.

Michel Loup France 2005

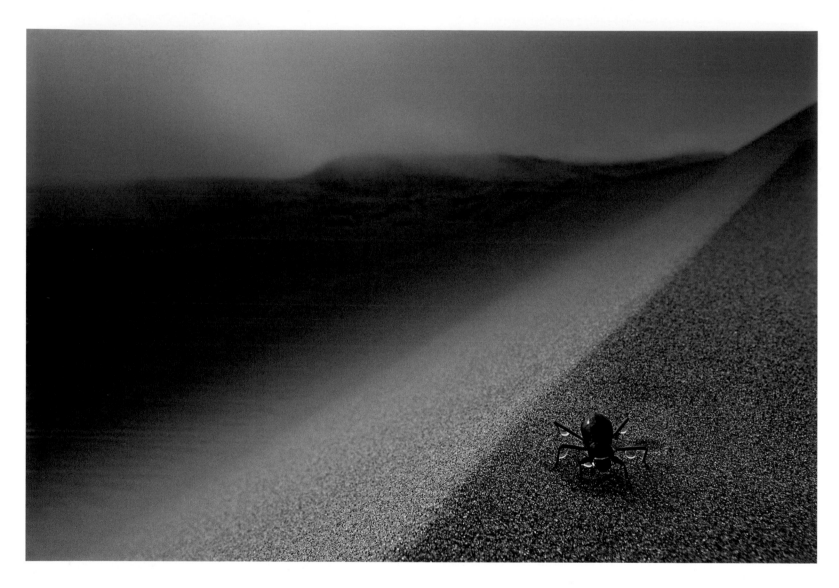

Dune beetle at dawn

Many people have photographed this extraordinary desert insect, a tenebrionid beetle, but few have created a composition that illustrates exactly how it survives in its extreme environment. Setting up at dawn on a high sand dune where he knew a beetle would want to be and knowing exactly the angle he wanted, the photographer waited for the arrival of the performer. In one third of the picture, the sea mist can be seen rolling in over the dunes. In the middle third is a great expanse of sand, catching the dawn light. And in the foreground is the beetle, its body turned to face into the wind so that the mist can condense on its back and legs, ready to do a handstand to allow the droplets to run into its mouth.

Olivier Grunewald France 2003

Sinuousness

It's hard to think of a more perfect setting for a grass snake then this beautiful stream in Lombardy, Italy. The snake is relaxed but alert, at home in its environment, watching for potential prey, possibly frogs. Its colours and coils are echoed in the wet smooth stones and the sinuous roots, and the use of a long exposure to blur the running water and convey the impression of movement emphasizes its stillness. The photographer returned to the location three years later to find that the stream had changed course and the waterfall had gone, and that his image was the only evidence that the magical spot had ever existed.

Marco Colombo Italy 2011

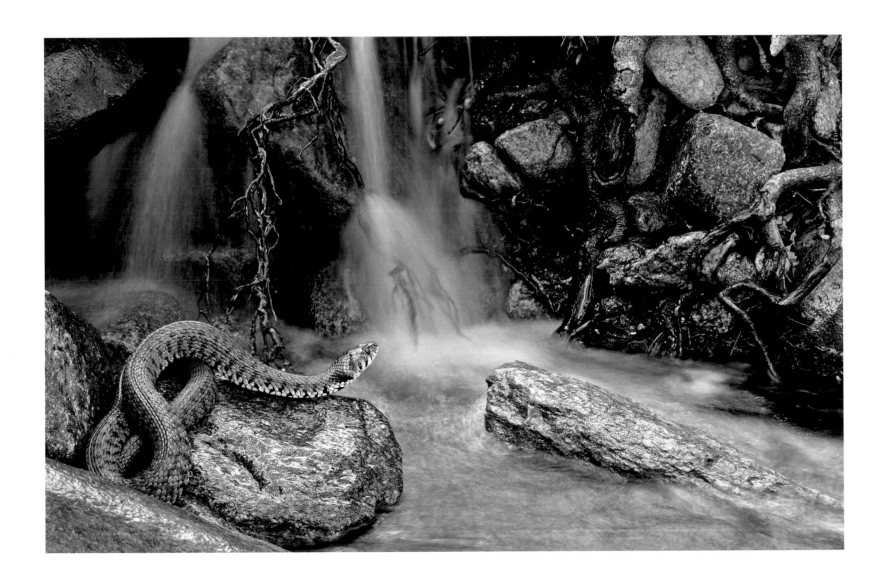

And then there was light

For the first 20 years of the competition – in the 1960s and 70s – without today's lenses and fast shutter speeds, the challenge was so often how to get enough light onto a subject and illuminate the detail, especially difficult when movement was involved. But with the advent of improved and faster film, ever-more creative nature photography became possible.

What the competition revealed through its international annual collections was how different nationalities were using light in different ways, reflecting both a tendency to prefer the levels of light they were intimate with but also cultural trends. So, for example, photographers from southern Europe, the southern states of America or Africa tended to relish rich, warm light. And photographers from northern Europe loved to play with the evocative subtleties of low, seasonal light. It was the pictures by Scandinavian photographers towards the end of the 1980s that showed how low light can create mood and drama – a style that was to influence photographers in other countries – especially when the subject is portrayed as small within its environment, which is what the Scandinavians also tended to do.

Light is what creates a sense of mood and place. Landscape photographers often know best how and when to use it – how light filters through mist, sparkles off rain, washes over landforms, rim-lights formations or picks out detail. They know that shooting into the light can create a spiritual quality, that a cloak of darkness can imply mystery, that holding back on detail and showing a glimpse of a scene can create the sense of being there. This is also what the Scandinavians did. But skilful use of artificial light can not only enhance the colour and detail, but like stage lighting, can add drama, which is what so many of the best underwater photographers have perfected with the use of strobes.

Today, the gallery of winning and commended photographs from the competition can be seen worldwide through the internet. But in the 1980s, the showcase comprised the magazine, then the travelling exhibitions and the international press coverage, to be joined in the 1990s by the first portfolio books. This was a time when there were relatively few photographic display books, and publications in one country weren't always available in another. So the influence of the competition in that 15- to 20-year period, displaying an international range of styles and ways of seeing, was significant in the development of fledgling nature photographers – those who would become the winners of the next decades.

Golden diver

This award-winning shot was a planned and perfected product of 20 years of observation of red-throated divers on the lakes around the photographer's home in Finland. Knowing exactly where a particular pair would be at the end of the day, he positioned his hide specifically so he could take a portrait of a red-throated diver burnished with the last rays of the summer sun, framed and presented as an icon of the wilderness. The low light filtering through the forest behind and reflecting off the mirror-still dark water created the ripple effect on the velvet-smooth neck of the bird, which held its pose long enough to allow a slow exposure.

Jouni Ruuskanen Finland 1989

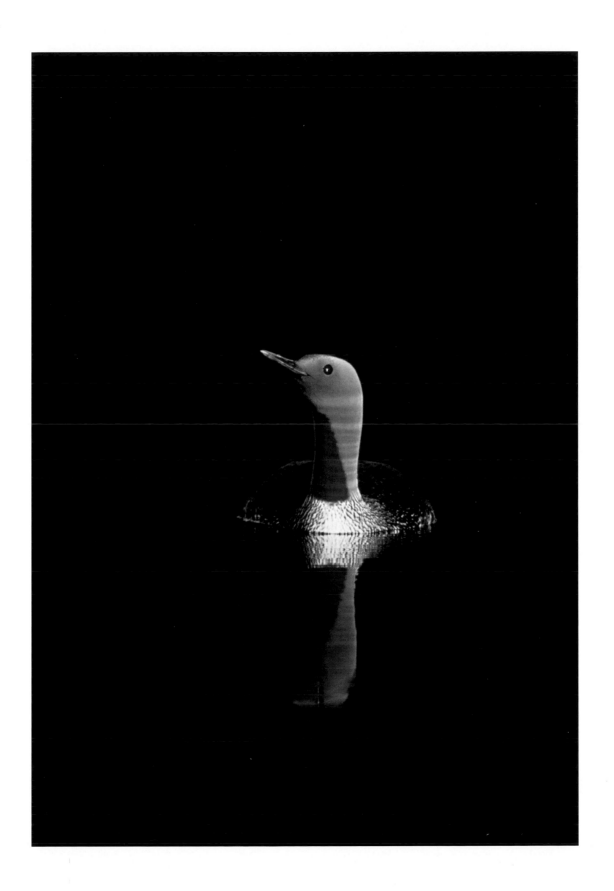

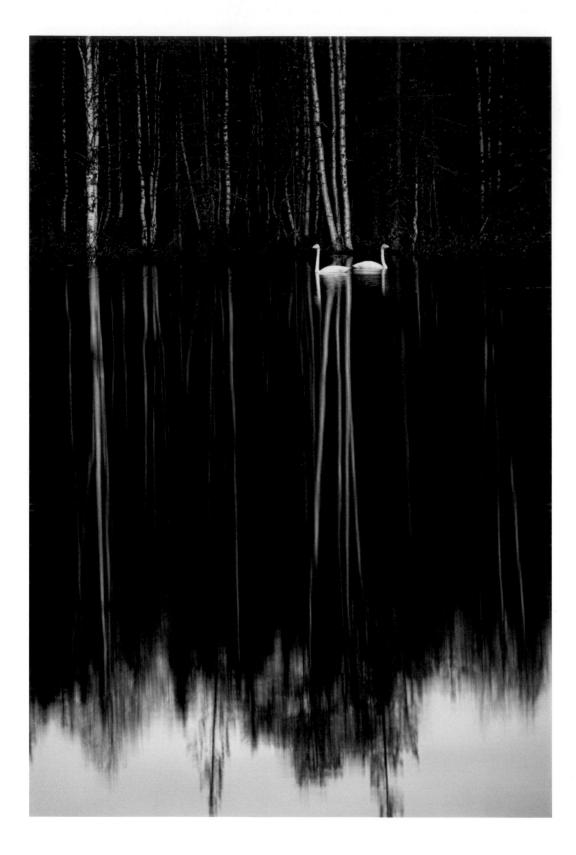

Swan lake

This is a meditative image – a recreation of a wilderness experience. The photographer wanted to show the whooper swans as part of their remote wetland environment in northern Finland, choosing the reflection of the forest to symbolize the link. The low light of an overcast sky in early spring created the perfect conditions for the whites of the silver birch bark and the whooper swan plumage to glow out of the dark forest. Philippe had to wait two days, though, before the wind died down enough for the lake surface to become a reflective glass, allowing the elegance of swan necks and tree trunks to mirror each other. It's a picture influenced by the quiet style of Finnish photographers but also by the muted light found in the far north.

Philippe Henry Canada 1989

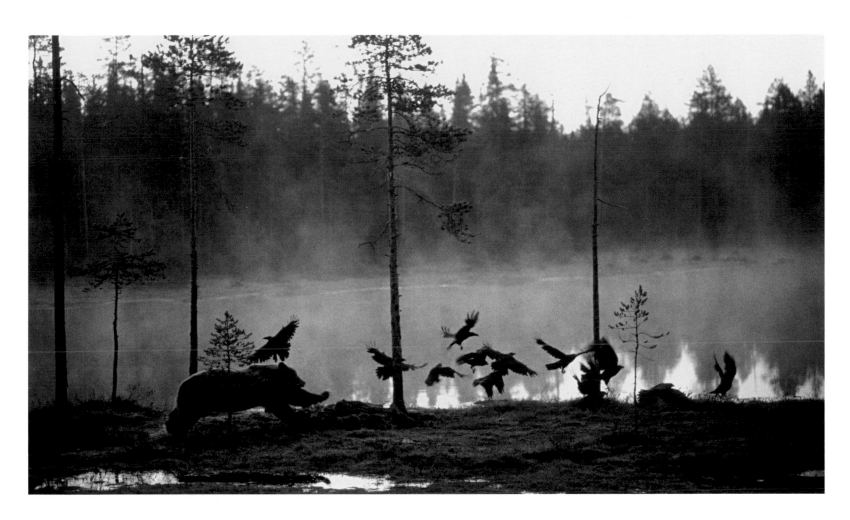

Chasing the ravens

This is one of the winning Scandinavian pictures that influenced a generation
of photographers, through its use of subtle, subdued light and soft impressions
of movement. The scene shows a brown bear trying to scare ravens away from its
carrion in a remote woodland in Kuhmo, Finland. It was taken from a hide, used by
the photographer for bear-watching, and shot at 4am on a spring morning, when
there was still a silvering of frost but enough warm air for mist to rise off the pond
behind. Its beauty is in the delicacy of the light as much as the composition.

Antti Leinonen Finland 1989

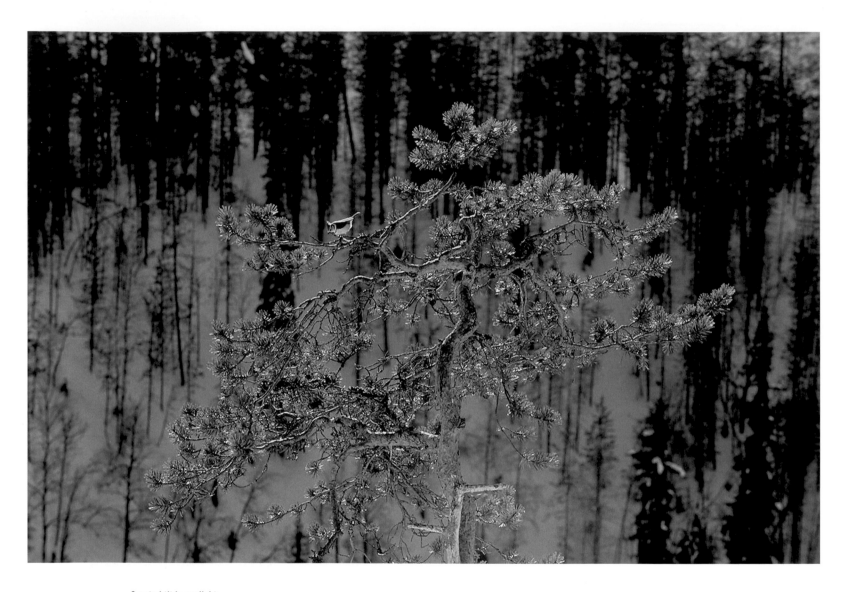

Crested tit in sunlight

To conceive a picture dependent on natural light takes thought, and to capture
the perfect light requires knowledge of a place. Every time Hannu Hautala visited
Korouoma, a river gorge in northern Finland, he became fascinated by the way the
late-afternoon light illuminated a particular pine tree. He began to watch and wait,
in case a bird might alight on the top. It was in early spring that the magic happened.
A crested tit landed just as the low evening sun lit up the tree. Crucial to the picture
was the added light reflected from the snow on the opposite side of the gorge. It was
a typically Scandinavian nature picture, with delicacy, minimalism and surprise,
and representative of a style that influenced photographers from around the world.

Hannu Hautala Finland 1993

Scots pine illuminated

The focus here is on the tree itself, as a beautiful living creature. This individual Scots pine is probably two or three hundred years old. It's bent and crooked and richly textured by time. At its feet is a carpet of heather and bilberry. The picture is representative of the richness of the remnant Caledonian forest of Abernethy, Scotland. It was taken just after sunset, on an overcast summer day, in the few minutes that the sun broke through the clouds and lit up one side of the tree. The light in the far north of Britain is, like Scandinavian light, low, gentle and, like the weather, ever-changing, as reflected in this particular photographer's work – all taken in the natural environment of his beloved Scotland.

Laurie Campbell UK 1990

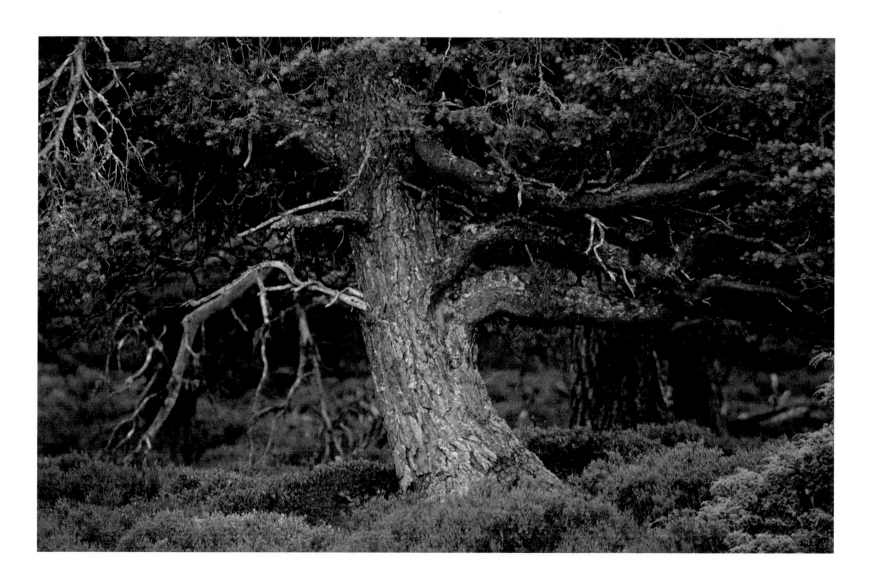

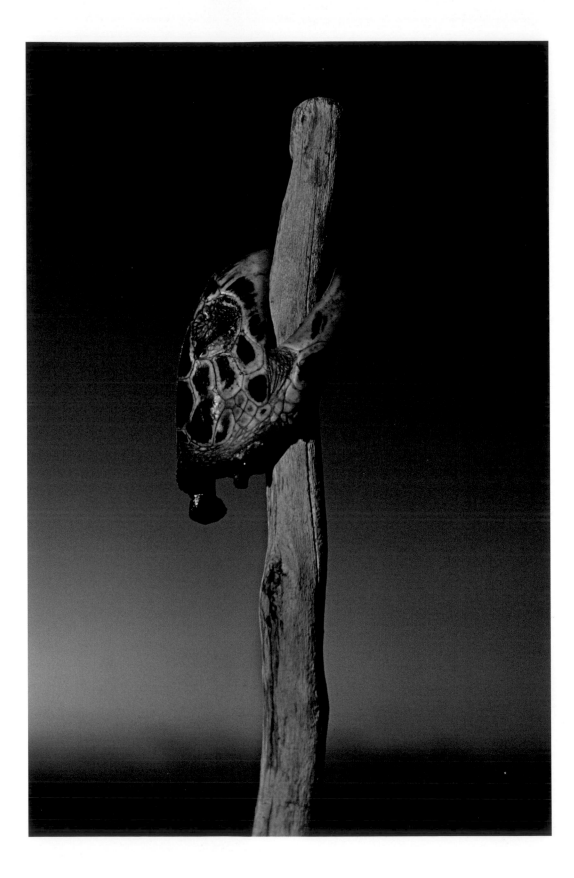

Dying ritual

The impact of this picture is as much in
the lighting as it is in the subject – a graphic
creation as much as a representation. The timing
of the shot was crucial, using an angled flash to
cast an eerie light on the head of the hawksbill
turtle, set against an evening sky at the moment
of sunset. It's also a record of a dying ritual,
symbolized by the dying sun. The turtle head
was staked as part of a ritual of the Vezo people
of Madagascar, who until recently felt a strong
connection with the animals they hunted.
All sea turtles were treated with ritual respect.
The hunter who caught a turtle shared out the
meat at a designated turtle cemetery. The shell
would be kept there and the head placed on
a ceremonial stake until it dropped to the ground
and the turtle's spirit was considered to be free.
The head would then be given back to the sea
the next time a turtle was brought ashore.

Frans Lanting USA 1988

Night walker

It was an hour after sunset in April when this shot was taken, and the old male had just emerged from his winter den. The picture was a risky one, not just because of any danger from the bear or the deep snow – the photographer was used to being out at night in winter, and the bear was an old friend he'd known for eight years – but because of the low light availability. But Antti was not after sharpness and welcomed the graininess that a fast slide film forced on him – rather he wanted to recreate the atmosphere of night in the forest and a bear's nocturnal wanderings, something that few people ever see.

Antti Leinonen Finland 1994

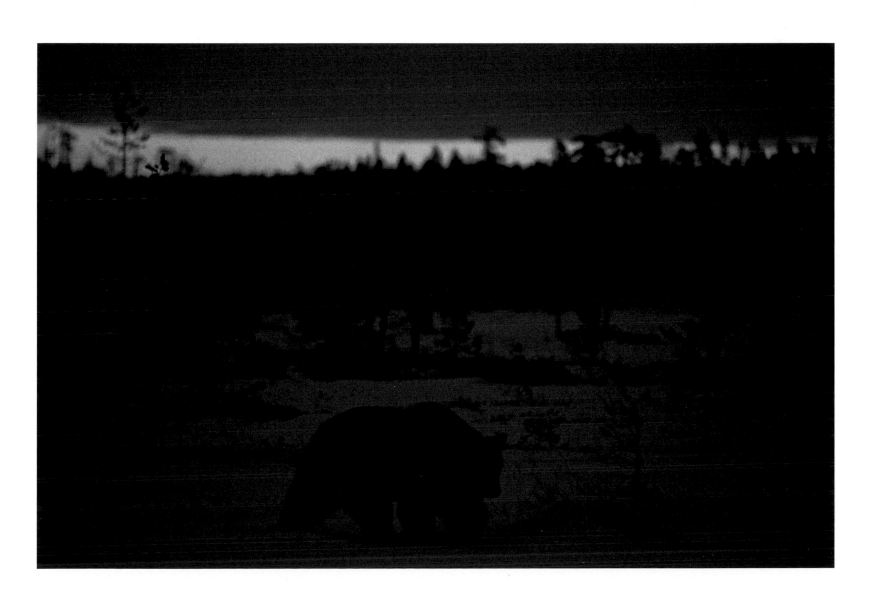

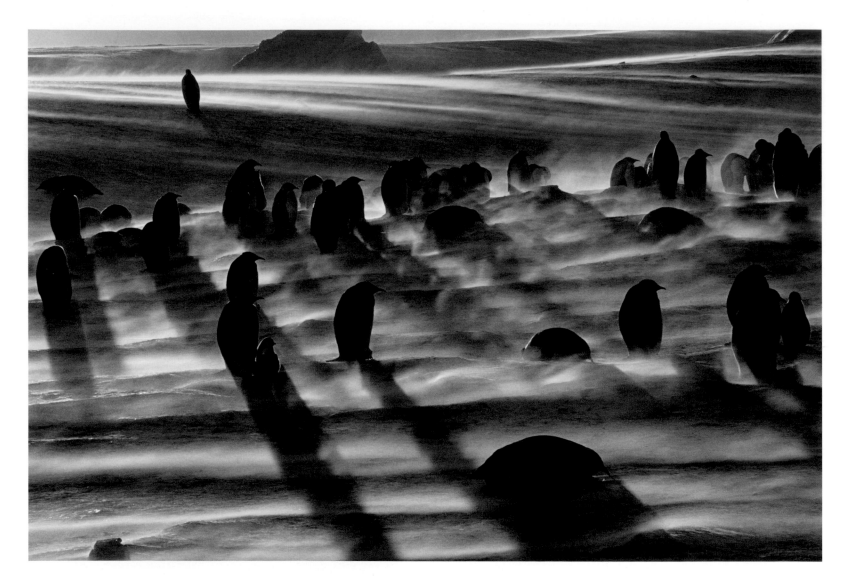

Emperors at sunset

The light gives this strange scene a glow, as if a sandy beach on a warm summer evening. But it's late winter on ice in the Weddell Sea, Antarctica, and the sun is barely on the horizon. The figures are emperors and sand is snow, and a fine blizzard is blowing, causing the penguins to huddle, backs bent against the wind. The angle of cross-cutting shadows gives strength to the composition, pointing to a lone individual who appears to be walking into the sunset. It was a picture taken during a month living with the penguins — a vision of life on the ice that, 20 years on, remains freshly surreal.

Frans Lanting USA 1996

Shadow running

It's an unexpected perspective, but a dramatically effective one portraying the stampeding zebras with light and shadow as much as the movement of the legs themselves. It was a composition created at dawn, when shafts of sunlight filtering through the open woodland were low to the ground, and one that the photographer had planned and waited for while watching the behaviour of zebras and wildebeests coming to drink at a rainy-season woodland pool in Botswana. Such a low-level perspective is a convention now used regularly by film-makers to signify movement.

Adrian Bailey South Africa 1998

Golden lake

What a joy to witness such a scene. It was a composition the photographer had
thought about many times. The lake – near his home in Finland – was his favourite.
In any other light, the water lily leaves crisscrossed with the reeds would have created
just an attractive pattern, but at dawn as the first rays of the sun reflected off the
overlying water, they were transformed. For Johannes Lahti, the extra magic was
that it was midsummer morning when he took the picture.

Johannes Lahti Finland 2002

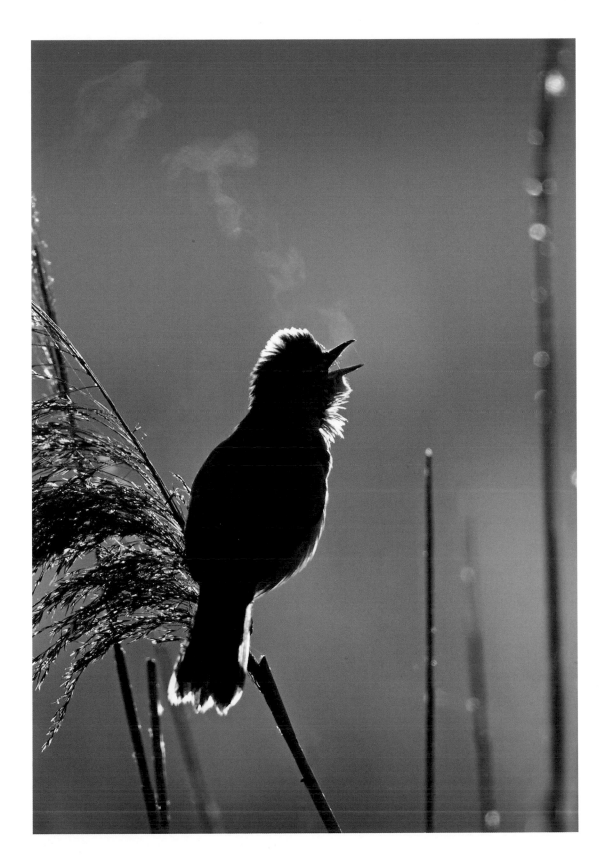

Song breath

It would be hard to find a more beautiful
evocation of birdsong. The notes of the great
reed warbler's strident song have been caught
in the cold morning air and transcribed in
mist. The photographer's luck was finding the
male on a song perch that wasn't hidden in
the forest of reeds – here in the marshes of
Kiskunsági National Park, Hungary. His skill
was in the composition and planning – knowing
where to be and exactly when to use the sunrise
backlighting. It's a style that's been used by
photographers many times since to create
a portrait of song.

Jan Vermeer The Netherlands 2004

First feed, setting sun

Low evening light gently illuminates the delicate act of a parent black-necked grebe feeding a tiny insect to its newly hatched chick as it nestles among the feathers of its other parent. To take such an intimate picture, the photographer was eye-level with the nest, standing chest-deep in the lake in a floating hide, wearing a drysuit and using a long lens to make sure he didn't disturb the birds. The danger of egg thieves meant that the lake's location had to be kept secret and that he had to keep guard duty every day until the chicks hatched. Positioning himself to use the setting sun as backlighting, and with the pink flowers of amphibious bistort providing the enveloping colour, he took his winning shot just at the moment the sun touched the horizon.

Rob Jordan UK 2002

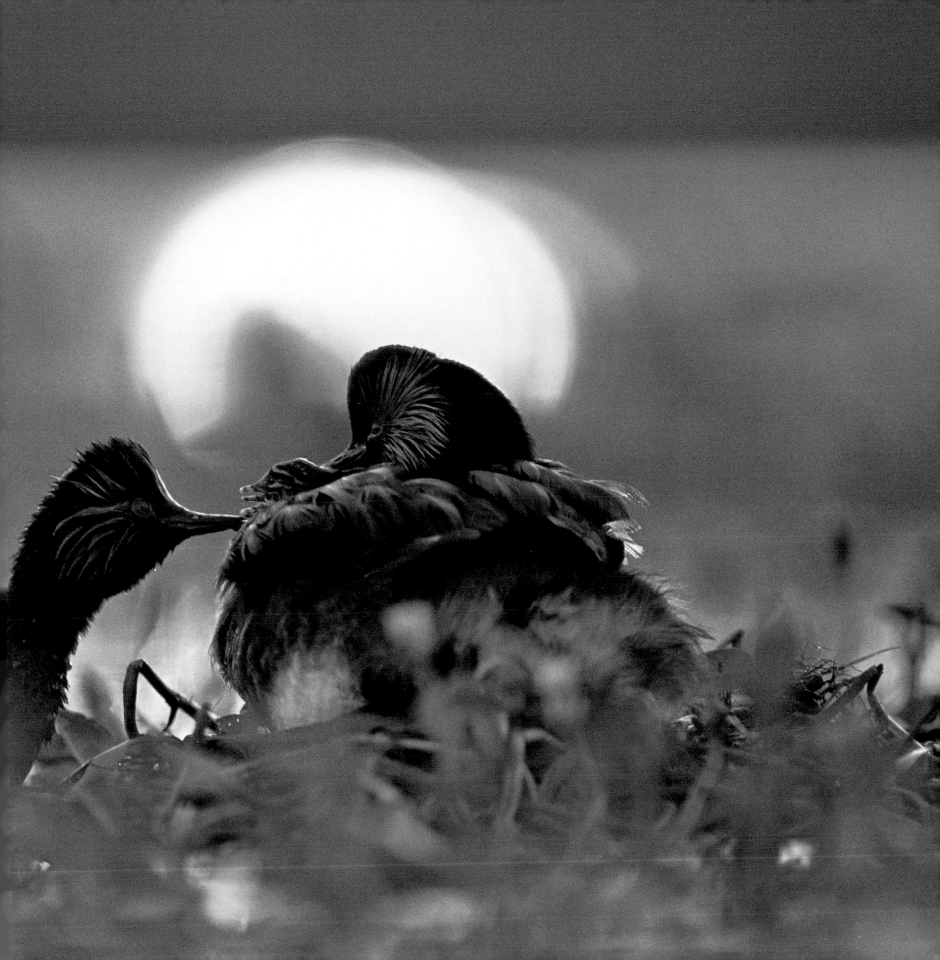

The moment

Serendipity – the gift of a moment – is a rare one for a photographer. An image can be preconceived, but the magic can never be guaranteed. Yet catching that decisive moment still requires experience – both camera skill and fieldcraft.

The photographer must be in the right place at the right time with the right settings and equipment and with the acquired instinct to react. And that's why those winning wildlife shots that capture the unforgettable moment are rare. It's also why many of the oldest examples remain moments that are truly unique.

When it comes to animal behaviour, the chances of catching the moment are greatest for those who spend considerable time with their subjects, merging with their surroundings, following them as they move, without causing distraction or disturbance.

Great patience is required but also extreme readiness, to catch the composition as well as the action. It becomes an instinctive skill and can mean the ability to change angle and camera settings instantly and to frame a long-held vision without thinking. And like all classic photography, capturing the moment also requires the artistic ability to select exactly the right shot.

White wolf leaping

The flat, still water helps freeze the instant of the leap in the strange Arctic scene, lit by the almost moonlight colours of the midnight sun on the horizon. The wolf is using the ice as stepping stones as he looks in the shallow water for anything edible. For the photographer, the image sums up memories of the most special experience of his life – the three summers that he spent following a pack of Arctic wolves on Ellesmere Island in the far north of Canada. That he was able to take this shot without a long lens, just walking alongside the male wolf at the edge of the water, reveals the trust between them.

Jim Brandenburg USA 1987

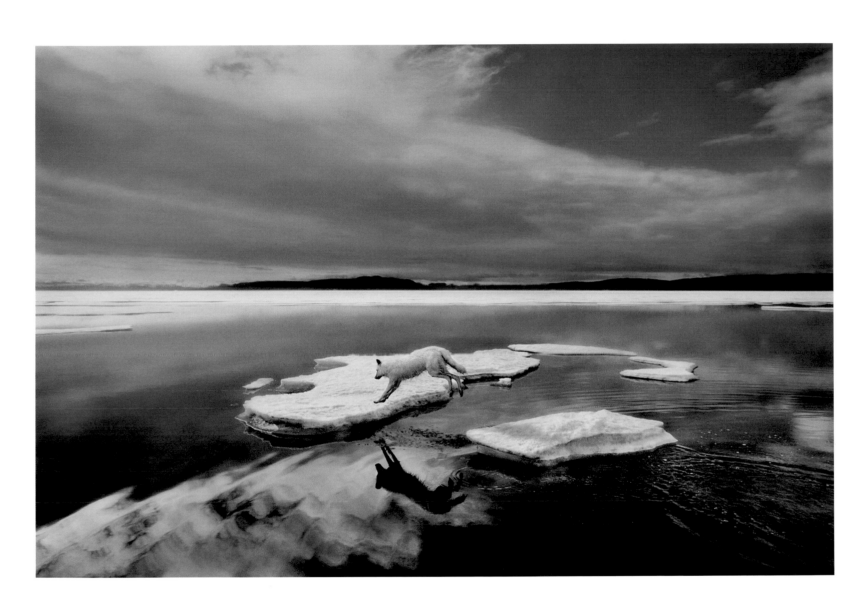

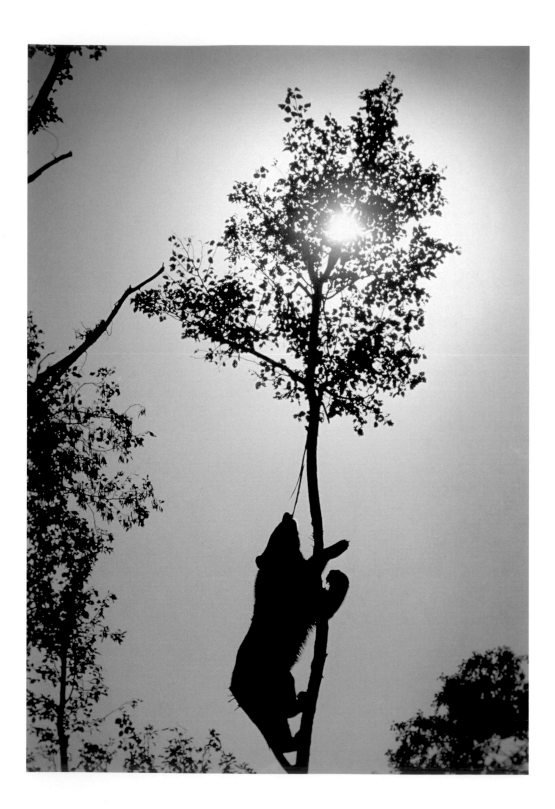

Balancing act

It was early morning in the foothills of the Himalayas, the sun just starting to burn off the mist. The Asiatic black bear, more normally nocturnal, was still up, engrossed in stripping bark from a young tree, possibly to get at grubs underneath or to lap up the sap, but being a youngster, possibly just messing around. Though the photographer had time only to take a couple of hand-held shots, he chose to backlight the balancing act and position the sun as a light-burst in the treetop, angled exactly in the sightline of the bear – an award-winning picture that required both luck and composition skill.

Rajesh Bedi India 1986

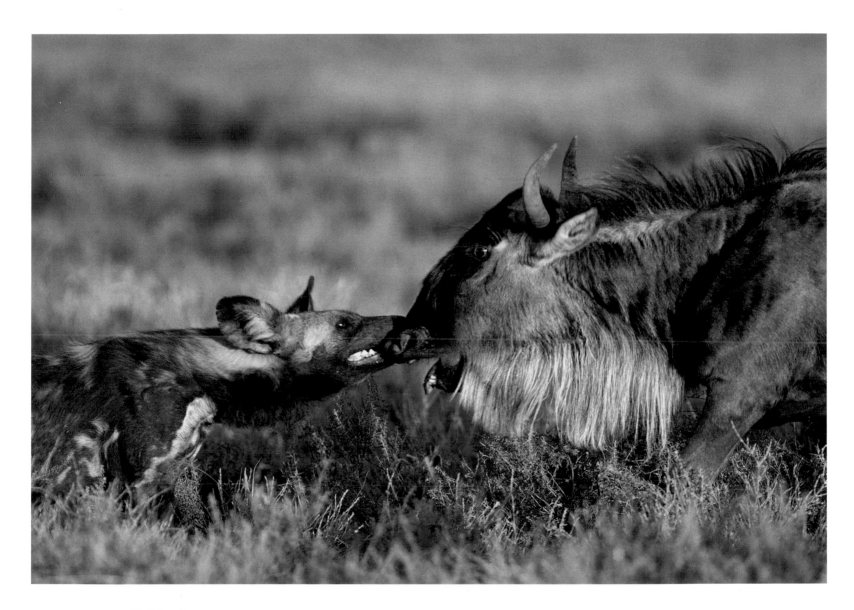

Final struggle

To condense the agony of the drama, a struggle for life – the African wild dog held
fast to the nose of its prey, and the wildebeest braced against its attacker – the
photographer focused on their heads. Shooting slow film in fast-fading light on a
500mm lens, his only chance was to catch a moment when they paused. What made
the difference was that the lead dog's nose grip immobilized the wildebeest enough
for the rest of the pack to attack its rear. And what made the difference for the
photographer was catching the last rays of sun on the animals' heads, highlighting
the whites of their eyes. It was an unforgettable shot that won him the top award.

Jonathan Scott UK 1987

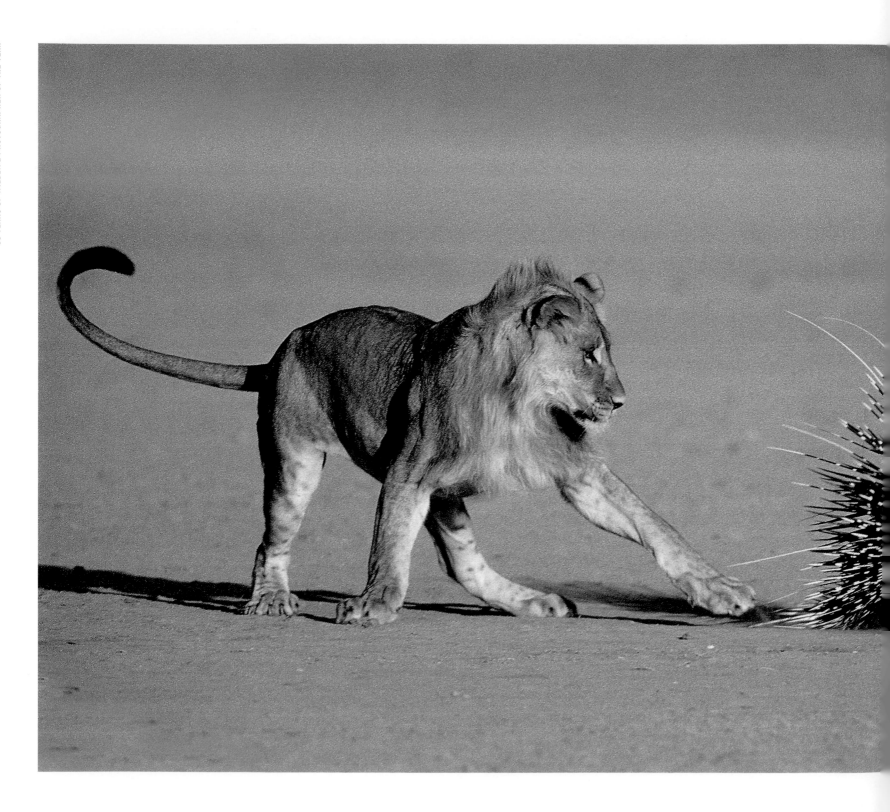

Deadly touch

A perfectly framed, tantalizing moment of daring and danger. The picture was a product of luck, but as with all great behaviour shots, came from the photographer being in the right place at the right time – in this case the South African side of the Kgalagadi Transfrontier Park. The eye-level perspective was crucial to the composition, allowing the detail to show against a clean backdrop of sand. The young male and his brother had already spent several hours in a risky and vain attempt to flip over one of the porcupines. But somehow they recognized the danger of being too daring (a porcupine spine in the paw or face could mean a life-threatening infection), and after another hour the pair finally gave up the game.

Barrie Wilkins South Africa 1993

Woodpecker action

The action is expressed in the explosion of wood chips and the tautness of the
woodpecker's neck rather than in the actual spitting out of excavation matter.
The moment was almost the last act in a two-week marathon of hammering and
chiselling by the black woodpecker, taking place in a forest in southern Finland,
and a two-week watch in a hide seven metres (23 feet) up a ladder in a spruce tree
opposite the action. Only the male worked the hole with his chisel-like bill, though
the female came by regularly to approve the work. On that final day, almost on the
final stroke of work, the sky released a flurry of snow as a backdrop for the picture.

Benjam Pöntinen Finland 1991

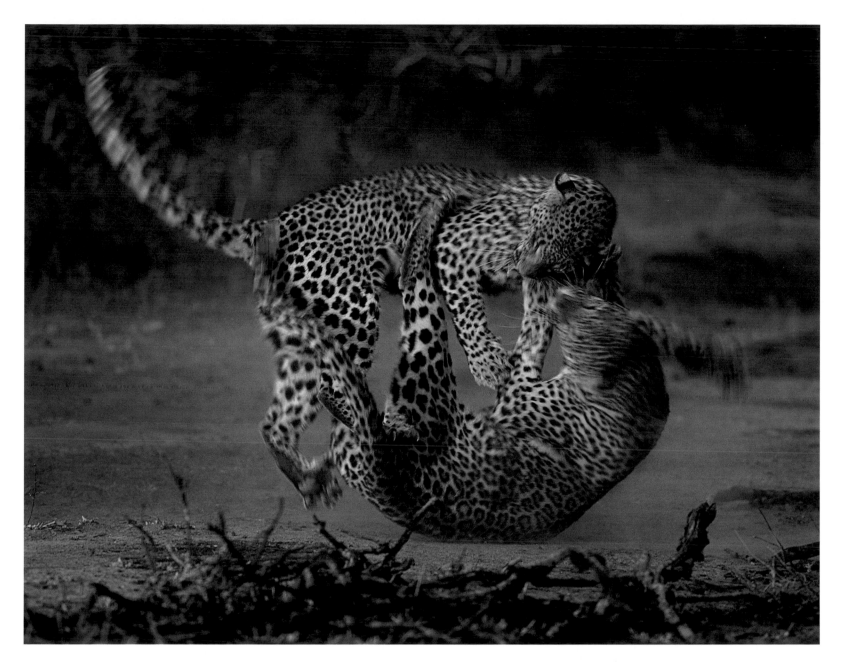

Flash fight

A whirling ball of legs and claws is the result of a sudden attack by the leopard
on top, tearing chunks out of the other female, already in a submissive pose. The
likelihood is that they were mother and grown cub, and that the mother was making
it clear that she wanted the territory to herself. The fight lasted just a few seconds,
and the reason the photographer was able to both catch the moment and frame it was
because he had been following the older female, in South Africa's Mala Mala Game
Reserve, had anticipated an interaction and was ready when it happened. The luck
was that the fight happened at sunset, casting a golden glow over the contestants.

Richard du Toit South Africa 1995

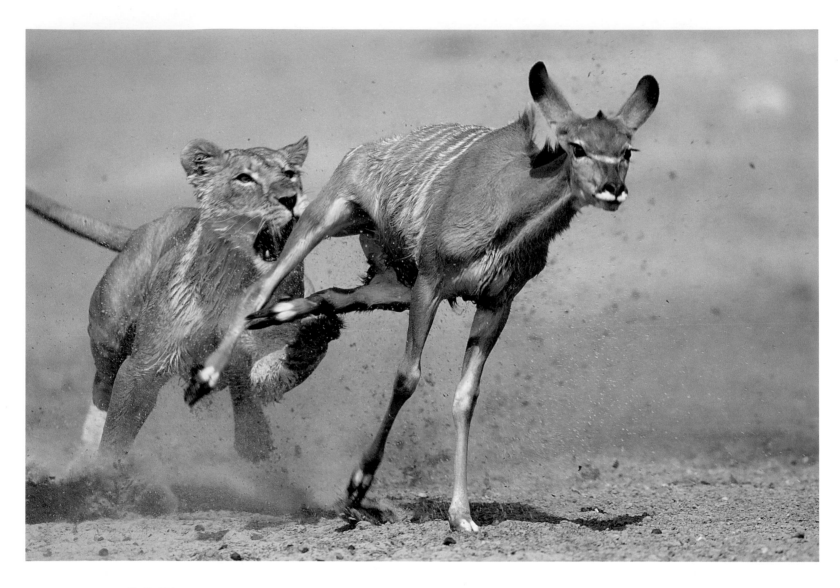

The final trip

Truly, this is the decisive moment, when the paw of the sprinting lioness clips and trips the kudu. The scene took place at a waterhole in Namibia's Etosha National Park in summer, when animals are desperate to get to the water. The young greater kudu made the greatest mistake of her life by stopping to drink near rocks that hid the crouching predator. The open mouth of the lioness, the precision of her paw, the angle of the toppling kudu and the dust and water spray all spell the end of the story.

Martin Harvey South Africa 2001

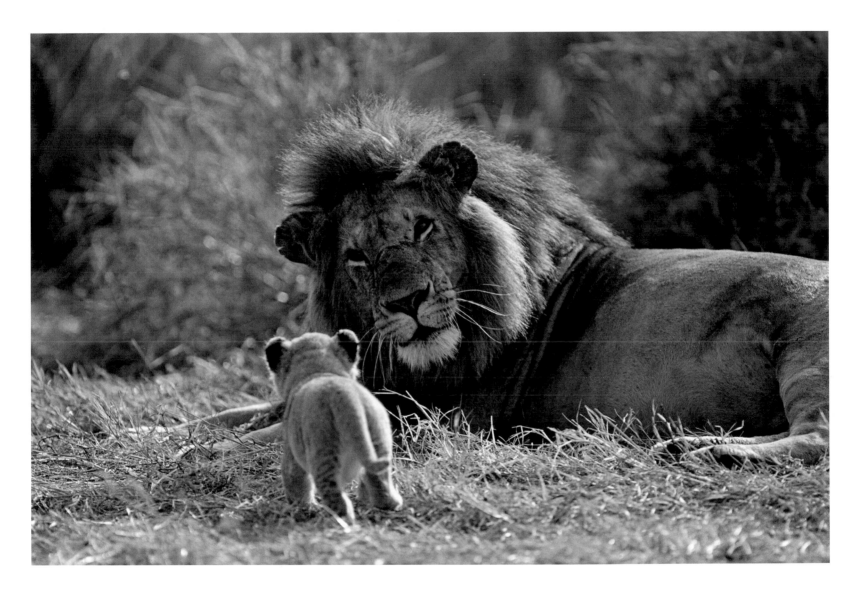

First encounter

The intensity of the look is what makes the picture unforgettable, and the eye-level view is what gives it intimacy. The cub's mother has just returned from the birth den, bringing her new litter with her for the first time, to integrate with the pride and, most important, bond with the pride male. This is the moment that the male has just woken to find the bold little cub at his side – a tense first meeting, not just for the mother but also for the photographer, following the fate of the pride in Kenya's Masai Mara.

Anup Shah UK 1999

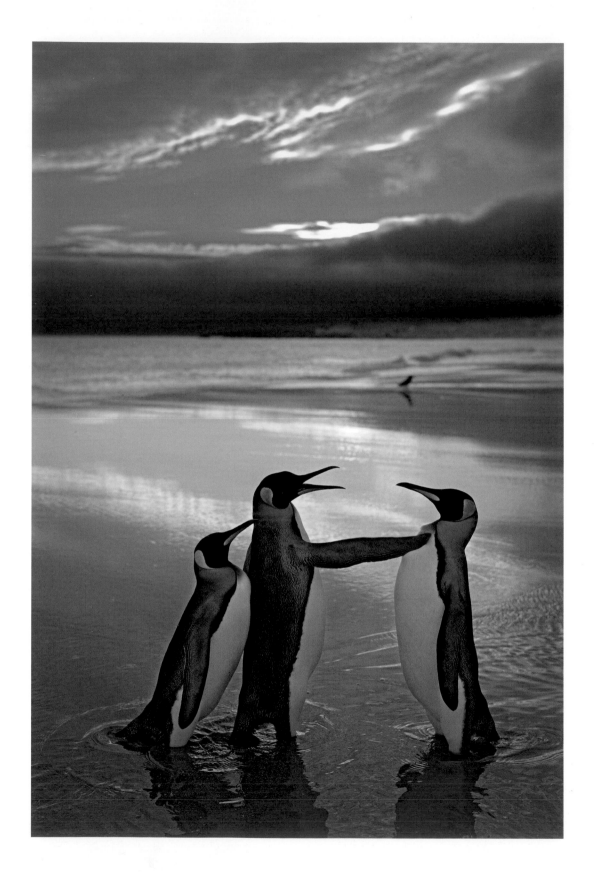

Rival kings

The photographer really thought his Christmas had come when he saw this going on. That the moment is amusing because of the human connotation doesn't make it any less of a picture. The fact is that these are indeed two males squabbling and slapping each other about, the female egging on her mate. It was also, in fact, Christmas morning – midsummer in the Falklands. The reflected colours of the early morning sky were the perfect setting for the tri-colour king penguins, which spent the morning arguing, giving the photographer another few hours of entertainment.

Andy Rouse UK 2006

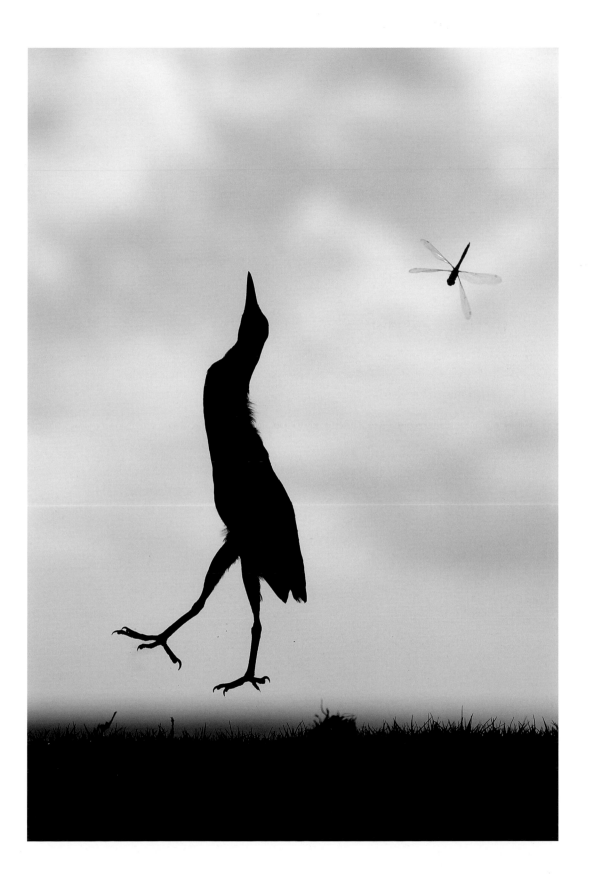

Leaping heron

A perfect balance of a picture and a perfect miss
by the heron – another moment of behaviour that
was a gift from nature. The photographer spent
a month on Aldabra in the Seychelles, but he
only ever saw such insect-catching antics from
a heron once. Normally green-backed herons
eat fish, but this one was set on snapping at
insects, despite the fact that fewer than a third
of its acrobatic leaps resulted in a catch. It was
still leaping around when the sun started to set,
which gave the photographer the chance of an
imaginative angle – a silhouette stage, with soft
background lighting – for his near-final shot.

Thomas P Peschak Germany/South Africa 2009

The assassin

Both a deathbed pose and a heraldic one, this is almost certainly among the most strangely beautiful pictures of a bird of prey kill ever taken, made perfect by the snow background. It was the snow that led to the death of the snipe. Driven out of cover by a severe freeze, it was frantically feeding on a patch of snow-free grass when the merlin swept down, pinioned it and killed it with a few blows to the head. The photographer, who knew that birds would eventually find the snow-free patch on a road verge near his home in Yorkshire, was staked out close by, using his car as a hide. He didn't expect to see a snipe and certainly didn't forecast the few minutes of drama. But his response was second nature, and he captured the moment with the right focus and exposure almost without realizing he'd done it, even managing to expose the last shot to compensate for and make the most of the white backdrop.

Steve Mills UK 2011

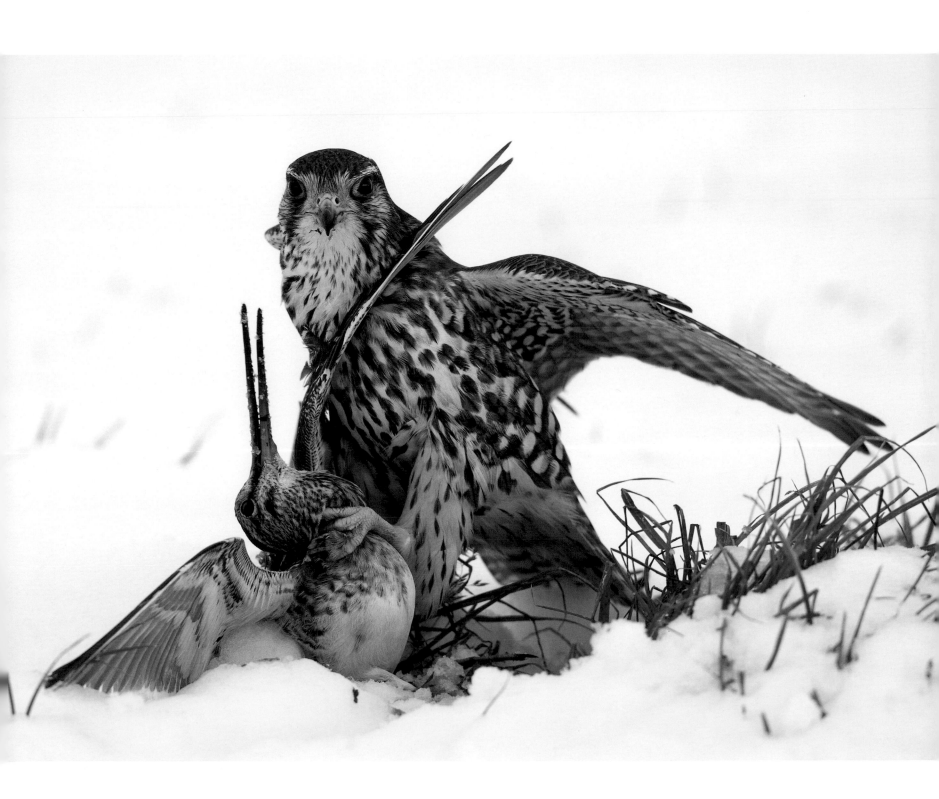

Wild spaces

To create a picture of a wild place that has depth and mood and captures the spirit of wildness or the atmosphere or the emotion of being there requires both the skill of seeing and a considerable amount of planning. First there is the matter of getting there. Then the challenge is to recognize the potential of the scene and find the precise spot and the angle needed to frame the composition. The element of serendipity now becomes not the appearance of a wild animal but the movement of the light and its quality, intensity and angle.

The most successful pictures are produced by a photographer who has meditated on the environment, looked and looked again, over a period of time and become familiar with the subtleties of changing light. It's the lighting that adds mystery or drama, adds brushstrokes of colour or emphasizes form through shadows, bringing out the contours or the textural richness. So the time of day is crucial – invariably early morning or early evening. Side-lighting spotlights or swathes elements of the landscape, or adds subtleties of colour that create mood. Shadows can be played with and rim-lighting used as the sun rises or sets.

The balance of proportions and a feel for visual relationships is vital. A wide-angle lens will incorporate details of the foreground as part of the story, contrasting with the grandeur of the background. Or the choice may be to link a distant, panoramic landscape to the foreground through the flow of elements. Selecting the right format is part of that decision-making, whether to make the shot panoramic to give grandeur or frame it vertically to give depth.

Photographers of wildlife are not necessarily the most experienced at practising the art of landscape photography, but they have the passion for wildness and the desire to express what they feel about a place, whether awe or intimacy. They discover places that others don't, and they are there when the heavenly magic happens. Recording such moments is part of telling the story of wildness and wildlife.

The last refuge

This is a surreal vision that few people have seen of a place where few have been: Campbell Island, a remote subantarctic island belonging to New Zealand and home to unique birds and plants. The photographer set out to show the richness of the strange plant life – megaherbs such as the pink Campbell Island daisy and the yellow Macquarie Island cabbage, here among leaves of Ross lilies. But his vision changed with the light. Normally the island is swathed in cloud and buffeted with gale-force winds, and it rains on average 325 days a year. So sunlight for an hour – a golden light filtered through cloud – was a gift from the heavens. To capture the magic, Kim Westerskov positioned himself just below where the mist was hanging, and used a wide-angle lens to show both the glowing floral carpet in the foreground and the sweep of the illuminated rain-soaked landscape beyond.

Kim Westerskov New Zealand 1986

Glacial sweep

This is an evocation of winter in the Cairngorms, Scotland – the highest mountain
range in Britain and one of the few areas to retain elements of wilderness.
Mist and snow clouds rest on top of the mountains, but the sweeping patterns of
the boulder scree on the steep sides of this glacial valley, known as the Lairig Ghru,
have been revealed by a temporary thaw. Here the light changes constantly,
leaving part of the landscape in shadow, part in cold end-of-day light.
The picture is presented as a simple, graphic statement of the space and grandeur
of the place, taken by a photographer in love with its wildness.

Laurie Campbell UK 1991

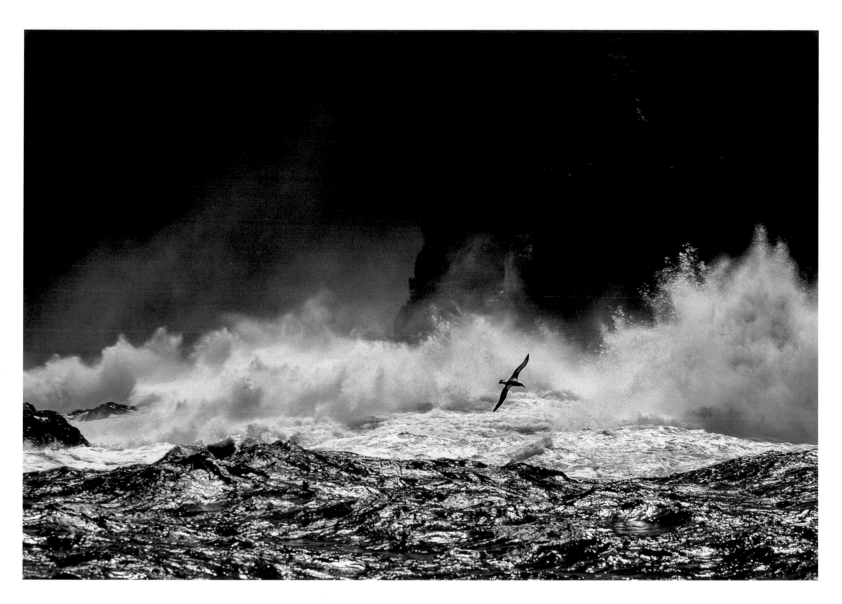

Storm rider

Here is true wilderness – an inhospitable place for humans but home for albatrosses.
A white-capped albatross soars effortlessly over the boiling sea as great waves crash
against the cliffs of the South West Cape of Auckland Island, in the subantarctic
archipelago. The photographer was wedged into the flying bridge of a dive boat,
holding his camera as steady as he could, shooting into the maelstrom, while the
skipper brought the boat as close to the dangerous cliffs as he dared. Tracking
the bird as it rode the waves was exhilarating, but the real excitement came when
the sun lit up the waves and spray behind it and he knew he'd caught the moment.

Kim Westerskov New Zealand 1991

Mountain light

Unless you have visited Patagonia and seen the Torres del Paine, it's hard to imagine that this is a real landscape and not a photographer's digital creation. And in a certain way, it is a creation, since without the special quality of the early-morning light hitting the peaks of the great granite horns, the vista would be as ordinary as the many pictures taken in Chile of these famous mountains. Creating the unreality is also the contrast between the fiery glow and the cool, improbable aquamarine colour of the lake and the yellow-studded green cushions of azorella. Using natural light was the photographer's great skill, and today his name is synonymous with mountain light.

Galen Rowell USA 1996

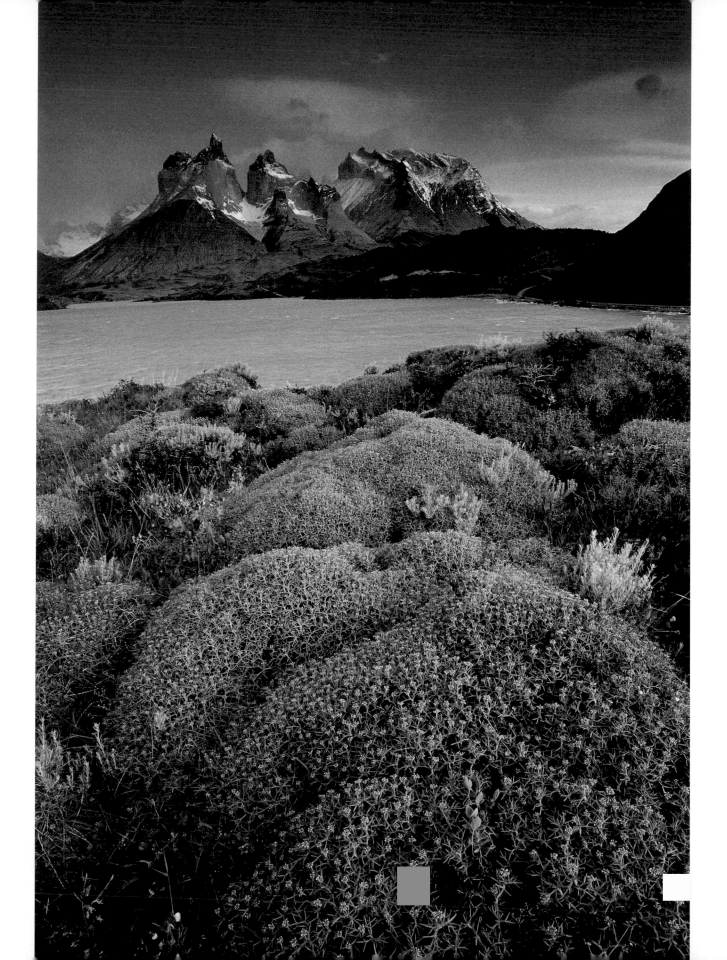

Glorious mud

The magic hour for photographers is the
sundown one. The light can transform any
landscape – in this case mud – into pure
gold. In fact, the mudbanks and sandbanks
of Lancashire's Morecambe Bay are already
full of riches – a multitude of tiny animals
that sustain huge numbers of wading
birds and make the bay a vitally important
European feeding spot for migrants.
The detail in this picture, though, is the
texture of wind on water and the swirls of
the freshwater channels meandering into
the huge bay. It's one of just two exposures
that the photographer took, having timed his
arrival to coincide with the exceptional light –
low sun diffused through a thin layer of
cloud – and low tide, confident that he had
caught the golden moment.

David Woodfall UK 1989

The depths of Danakil

You couldn't find a more awe-inspiring, extreme environment than the pulsating heart
of a volcano. Here the crust of the magma lake is cracking open, and fountains of
molten rock bursting out, lighting the enormous cavern. The photographer had gone
to one of the world's lowest and hottest places, the Danakil Depression in northern
Ethiopia – part of the huge crack in the Earth's crust, the Great Rift Valley – specifically
to photograph inside Erta Ale. He chose dawn to capture the glow within the pit,
but what he hadn't expected was the sudden intensification of activity. He shot the
scene from a ledge a little way down the wall of the pit, using a long exposure and
a wide-angle lens to convey the immensity of the scene – and then made a fast exit
before being overcome by the fumes of this hellish place.

Olivier Grunewald France 2002

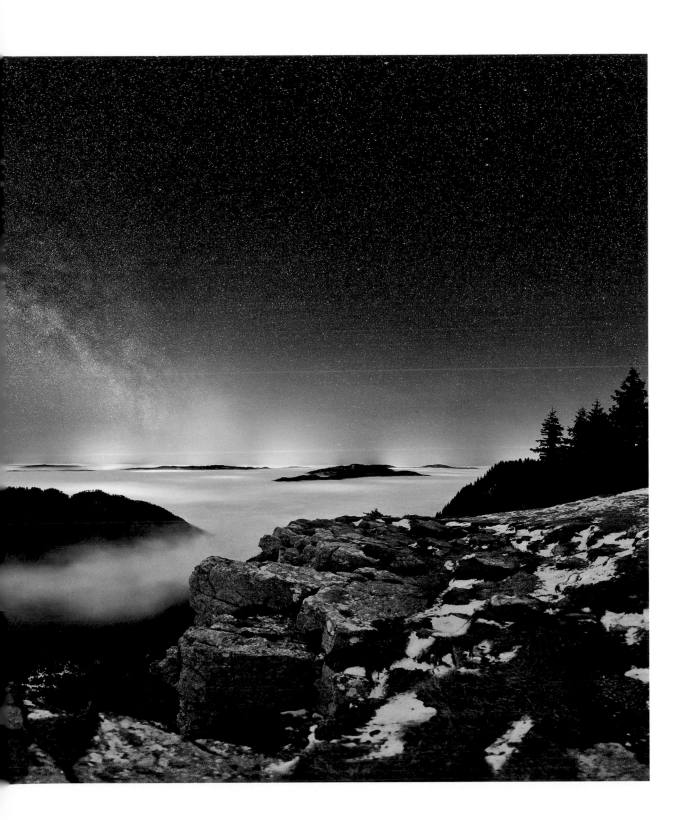

Celestial arch

This image is the photographer's 'synthesis' of his work – 24 images stitched together in-camera to create a grand panorama. It was carefully planned and brilliantly executed. The choice of a freezing cold night meant a clear sky – ideal conditions for photographing the stars. And no wind meant it was relatively safe to set up the tripod on the edge of the ravine. Getting to the Creux du Van in western Switzerland required a two-hour night-hike laden with equipment. The reward was a show-stopping scene of the Milky Way. But catching the celestial curve over the arch of the rocky amphitheatre required precise timing, and starlight and moonlight to illuminate the scene meant a 20-second exposure and a high ISO. The element of luck was the low-lying mist, which muted the light from the towns and villages to just a gentle glow.

Stephane Vetter France 2011

Land of fire and ice

It was April 2010 when the Eyjafjallajökull volcano began to erupt from under its huge ice cap. Though the explosion was relatively small, the ash plume was huge and almost blocked out the sun. The photographer was in Iceland when it happened, but on the first clear evening after the eruption began, the volcano itself was still obscured by a huge ash plume. So he decided to take pictures of the Thórsmörk mountain ridge instead. His reward was a sunset scene far more beautiful than that of the eruption. As the snow-covered slopes turned steel-grey in shadow, the rocks below began glowing red-gold, reflecting onto the low-lying clouds sweeping in over the ridge – a 10-minute light show he will never forget.

Erlend Haarberg Norway 2011

The cauldron

Extreme heat, extreme cold, high winds and the use of an old Russian helicopter combined to make this both a very dangerous and a very special shot. Plosky Tolbachik in central Kamchatka, Russia, erupted in November 2012 – 36 years after the previous eruption. The shoot became possible only when the heat from the volcano was tempered by the extreme cold, and the helicopter could take off. And the window of opportunity came only when the wind blew the thick clouds of ash, smoke and steam to one side to reveal the great rivers of lava below. The photographer had to lean out of the door and grab shots between gusts of hot air, knowing he had just this one chance to create an image that would do justice to the magnificence of the massive eruption.

Sergey Gorshkov Russia 2013

Natural design

Sometimes the most beautiful and memorable of images are the simplest – those that have framed a detail or emphasized a unifying element, or chosen a focus, aperture or speed to simplify light and shade or colour and form. These pictures tend to have a quiet, meditative appeal. They are created using the technology of the camera but are still truthful, if abstracted, reflections of nature.

Today the possibilities offered by digital technology mean that not only can compositions be enhanced, in the computer, but also that new images can be created out of them. Whether such manipulated pictures can ever outshine the original beauty and design extracted from nature or express more to the viewer beyond technical mastery is hotly debated.

The Wildlife Photographer of the Year competition has for the past 20 years offered a category for more imaginative imagery from nature, whether abstract or figurative. Today it allows in-camera adjustments of exposure, framing, white balance and even double exposure (the opportunities made ever more possible with the advance of digital cameras) and the use of special lenses but *not* the misrepresentation of nature. The aim has been to champion the beauty and variety of nature as the fountain of artistic creativity, and the competition has deliberately not allowed post-production digital manipulation beyond 'darkroom' techniques, such as cropping and adjusting of colours and tone.

Photography is, of course, a reflection of our different ways of seeing. And reflections of the natural world are influenced not just by different climates and environments but also by cultural views and even artistic traditions. Indeed, many photographers have mastered techniques that paint with light and focus on abstract pattern and design, much as a painter or illustrator would. Perhaps one way to judge the effectiveness of such imaginative imagery should simply be whether it continues to give pleasure however many times it is viewed.

Reeds on blue

What could be a more perfect canvas than the still surface of water reflecting a clear blue sky, here sprinkled with nature's calligraphy. The photographer spent a week camped beside the Swedish lake, canoeing every day looking for pictures that the water might offer. It takes an artist to recognize and frame the perfect moment, and though many have copied the concept, none have achieved a more beautiful, simple reflection.

Jan-Peter Lahall Sweden 1999

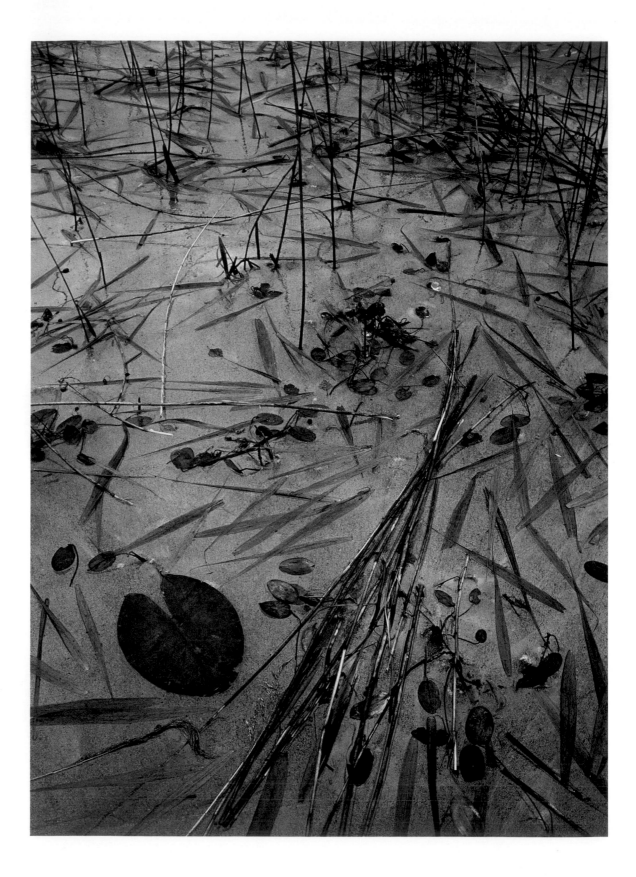

Ice montage

This is frozen chaos – a montage of dead leaves and stems, lit by the cold, blue light of winter using a four-second exposure – and yet there is also a hint of resurrection. That the leaves are near the surface is because they are being released as the ice melts. This ever-changing, rhythmic chaos of nature is what fascinates the photographer, whose compositions always contain an unexpected element or thought.

Pål Hermansen Norway 1998

Miniature

A baby butterfish shelters in the soft arms of a jellyfish – a fascinating detail of life presented as a beautiful miniature, observed with an artist's eye. The purple-striped jellyfish, with a giant bell nearly a metre wide, was floating in the ocean off the California coast, its trailing tentacles (the translucent pink ribbons), covered with stinging cells, providing the tiny fish with protection from predators. Gently lighting the jellyfish from above has revealed the delicate colours of the two animals.

Richard Herrmann USA 1991

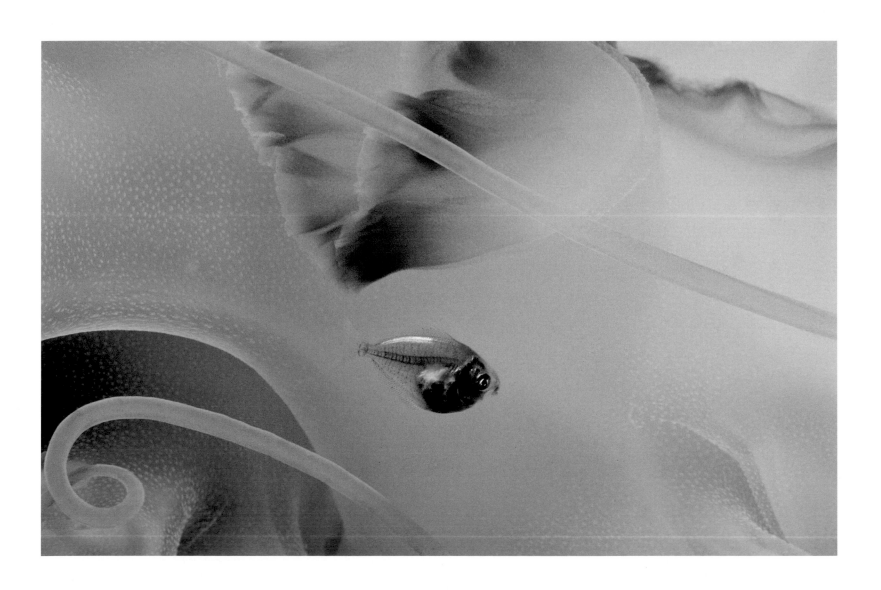

Ashes to snow

Simple but strangely detailed, it's also a picture with a story. The design is in the weave of vertical burnt tree trunks and their long horizontal shadows on the snow, but with a three-dimensional element of undulating shadows. In the corner, the half-fallen tree, still with its branches, recalls the lodgepole pine forest that was there before the wildfires of 1989 incinerated a third of Wyoming's vast Yellowstone National Park. Today, the valleyside is green again, covered by a young, regenerated forest.

Steven Fuller USA 1991

Zebra among the wildebeest

A lone Grant's zebra stands among a milling herd of wildebeest. The animals are on migration and have bunched up in advance of a river crossing in the Masai Mara Game Reserve, Kenya. It was the pattern and tonal qualities of the bodies that fascinated the photographer. The zebra was the gift – the unexpected contrast, standing out from the mass – framed off centre to look into the picture, focusing our attention, too.

Art Wolfe USA 1994

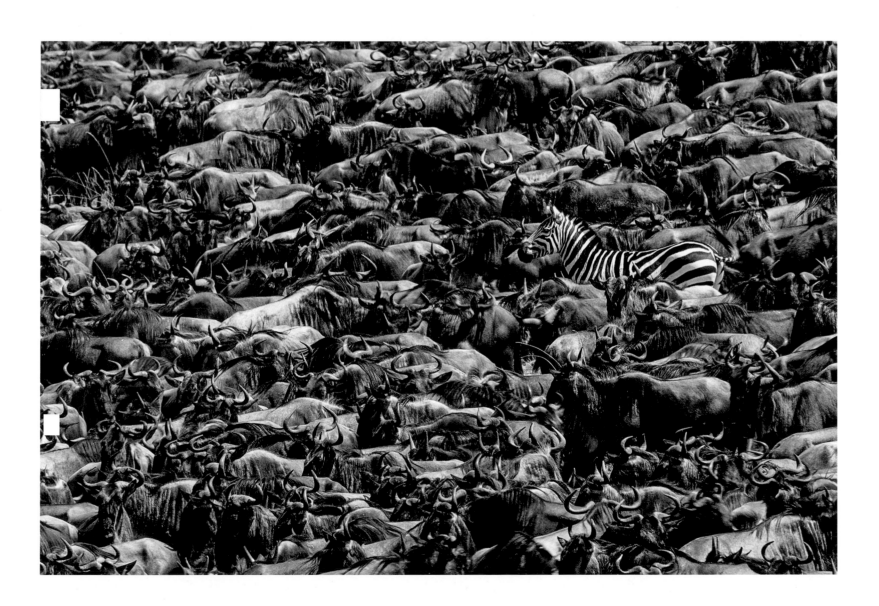

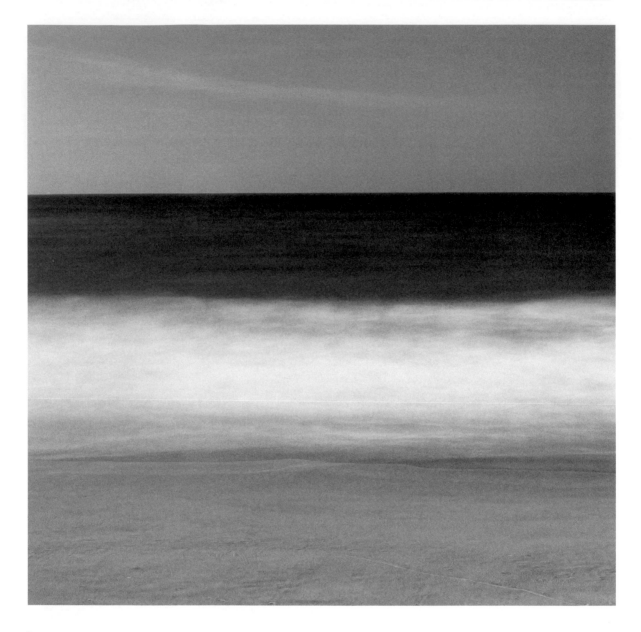

Seascape

This is the simplest of shots in one way but the most thoughtful in another. It is composed from a skilful use of contrasting horizons of land, sea and sky. Taken on a clear night, as a full moon rose over the Pacific, it merges bands of sky, surf, sea and beach, using just moonlight and a long exposure to create the painterly feel. It was taken not in the wild but from the beach at Coogee, a suburb close to Sydney.

Gary Steer Australia 2007

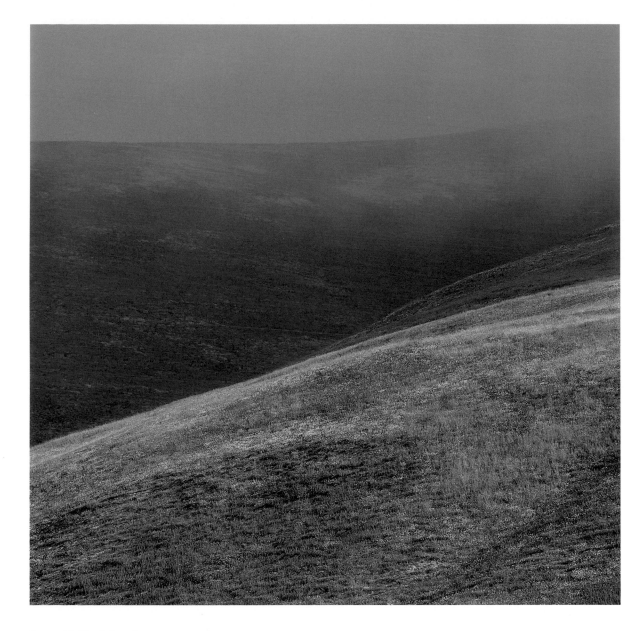

The great California flowering

This great carpet of colour is a floral phenomenon and a visual feast that few have
seen. It's a floral explosion at a botanical hotspot at the Tejon Ranch Preserve
in California, the richness of which depends on the arrival and timing of the rains.
In fact, the photographer had waited more than 40 years to see such a perfect event.
The tapestry of flowers covering the hills includes splashes of California poppies,
lupins and yellow coreopsis, their colours illuminated by a shaft of sunlight that
has broken through the rainclouds and highlighted the foreground exactly as
the photographer had hoped it might, setting it against the muted colours of
the opposite hillside swathed in mist – a momentary gift, framed by an artist.

Rob Badger USA 2009

Paradise performance

The delicacy of this picture is in the tautness of the wires, each tipped by a feather curl. It's all about design, for both the bird and the photographer. To contrast ultramarine legs with crimson plumage, topped with iridescent green makes this little bird rightfully named king bird of paradise. That he is shown upside down is because this is one way he shows off his plumage to potential mates. He also displays the other half of his body the right way up, jiggling his tail wires above his head so the discs flash, and shaking and fanning his other colours. But he does this high up under the rainforest canopy, which is why few have managed to photograph the dance. The photographer, who has taken more beautiful pictures of birds of paradise than anyone else, managed to do so by building a platform in a tree opposite a king bird of paradise's display tree, in the foothills of the Arfak Mountains of West Papua, Indonesia, waiting there until the day when a female arrived to initiate the show.

Tim Laman USA 2010

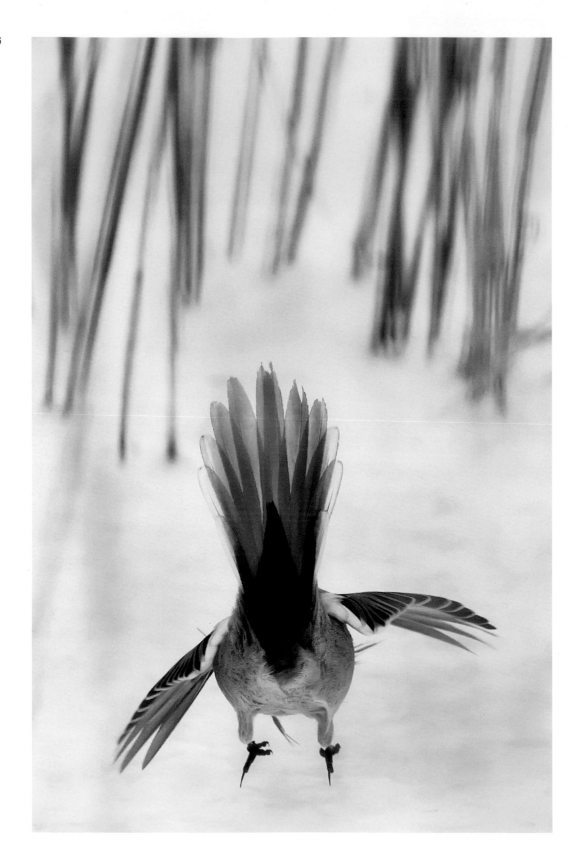

Reed bird

Of the thousands of pictures taken from within a Finnish reedbed over one winter, this was the photographer's choice shot – an encapsulation of the essence of a bird he's fascinated by. Tail fanned out as it prepares to land, the splayed feathers of the bearded tit are echoed by the brushstrokes of reeds. Much of the bird comprises its long tail, which is never still, flicking up and down to reveal, in the case of a male, a splash of dark feathers – the longer the tail, the more attractive a male is to a female. But this is the photographer's view, characterful but also artful, blending the bird with its reedbed environment.

Esa Mälkönen Finland 2009

Midnight tern

This was one of those moments when everything came together. The photographer was on Svalbard in the Norwegian Arctic, working through the night to make the most of the midnight sun. Suddenly the light broke through the thin clouds and illuminated the valley ahead with such overwhelmingly beautiful colours that he felt compelled to walk towards the sunset. It was then that the Arctic tern appeared. Focusing on the bird but panning his camera alongside it to blur the colours, the photographer caught the moment of pure Arctic magic.

Ole Jørgen Liodden Norway 2011

Light show

Mist, snow and low winter sun are an irresistible combination for a photographer fascinated by the effects of changing light on the way we see plants and landscapes. When a forest by the photographer's home was filled with mist from melting snow, the glow of the evening sun reflecting off the wet trunks of the pines was breathtaking. After experimenting with a few lenses to try to capture the light show, she settled on a mirrorless camera and a tilt lens. Changing the layers of sharpness from parallel to horizontal, so the unsharp areas were behind and below the main focus, she kept the light scatter at the top of the frame out of focus and the trunks below relatively sharp, creating a magical vision of the illuminated forest.

Sandra Bartocha Germany 2012

The white canvas

Simplicity of composition can also be a technique, using snow, ice or a pale sky as a canvas for carefully executed compositions. But the colour white is more than a blank canvas – it's a palette of shades that can give texture, shadow and delicate colour to the picture.

The ideal subjects are those that can be presented as if etched on the background with a few strokes, perhaps with tiny accents of colour. Their arrangement is all-important if the composition is to work – a matter of luck, but luck gleaned from planning and waiting, sometimes in extreme cold, and an ability to recognize the perfect moment.

Of course, there are many ways to paint a plain backdrop, usually when a portrait is required, using the sky or sea, or limiting the depth of field to create a solid background colour from vegetation, but out-to-white remains the classic canvas.

Gull on ice

Snow-dusted ice was the canvas for this sketch of a black-headed gull in its winter plumage. The photographer took just one, carefully composed shot of the frozen scene, slightly overexposed to simplify the detail and leave just dabs of colour and a brushstroke of shadow.

Chris Packham UK 1986

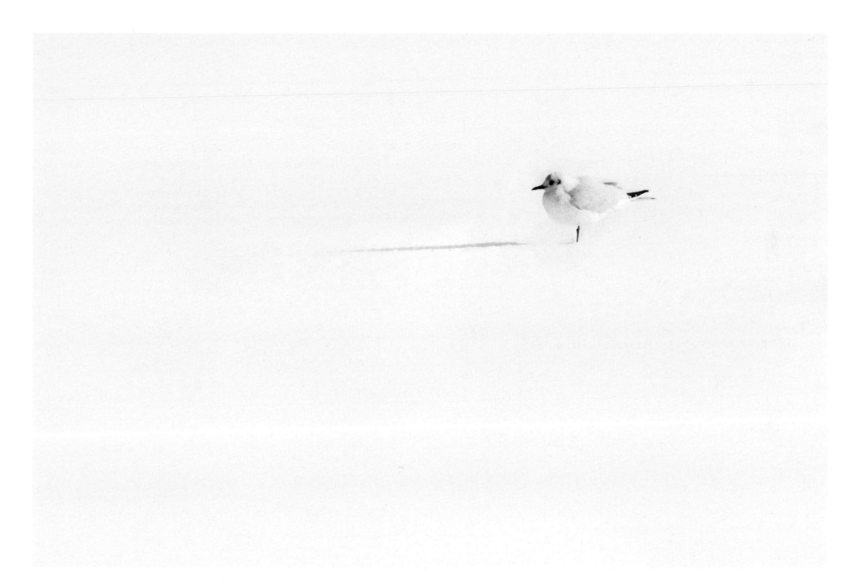

White-out

For this photographer, snow and ice provide the simplicity that he looks for in
his compositions. Snow singles out an animal and focuses on the subtlety of an
expression or movement. A frozen backdrop is also a reminder of the otherness of
the animals that survive in such harsh environments. Here a male snowy owl, almost
pure white, flies silently over the wind-sculpted snow, the curve of his wings echoed
in the curves of the drift. Just before he flies out of frame, he turns to look at the
photographer. The picture remains one of Vincent Munier's favourites, partly because
of the memory of the encounter – he spent many freezing hours with the little bird –
and partly because he thinks snowy owls are poetry in motion.

Vincent Munier France 2006

Apollo at rest

Here mist becomes the neutral background that allows the white of the Apollo butterfly
to shine, its translucent wing edges helping it to merge with its environment.
It's one of a colony of rare Apollo butterflies in the pre-Alps in the Veneto region
of Italy that the photographer has been visiting for more than 20 years, to the
extent that he knows where their night roosts are. He finds the species exquisitely
beautiful – a queen among butterflies. Knowing where this individual would be at
dawn, and that it would have moved higher up in the grass, to warm up when the
sun came out, he took advantage of a windless morning to take its portrait against the
blanket of mist, to reveal its delicacy and vulnerability as it balanced on a grass stem.

Vallei Dinullo Italy 2011

Illusion

Here again ice provides a canvas – in this case on frozen Lake Kussharo, on Hokkaido, Japan. A population of whooper swans gathers around the lake in winter, migrating there to take advantage of areas of open water kept ice-free by hot springs. It's also a photographers' hotspot, and so to create an original swan composition required imagination as well as artistry. The breakthrough came when the photographer began to see the group of whoopers as one – flowing over the ice, seen at different points in time and space. He set out to create the illusion, using a morning when a sprinkling of snow had made the ice ultra-white, allowing the individuals to be portrayed as separate. A swan enters lower right, wanders around a bit, sits down a few times and exits top right – a single shot of continuous time and motion.

Stefano Unterthiner Italy 2011

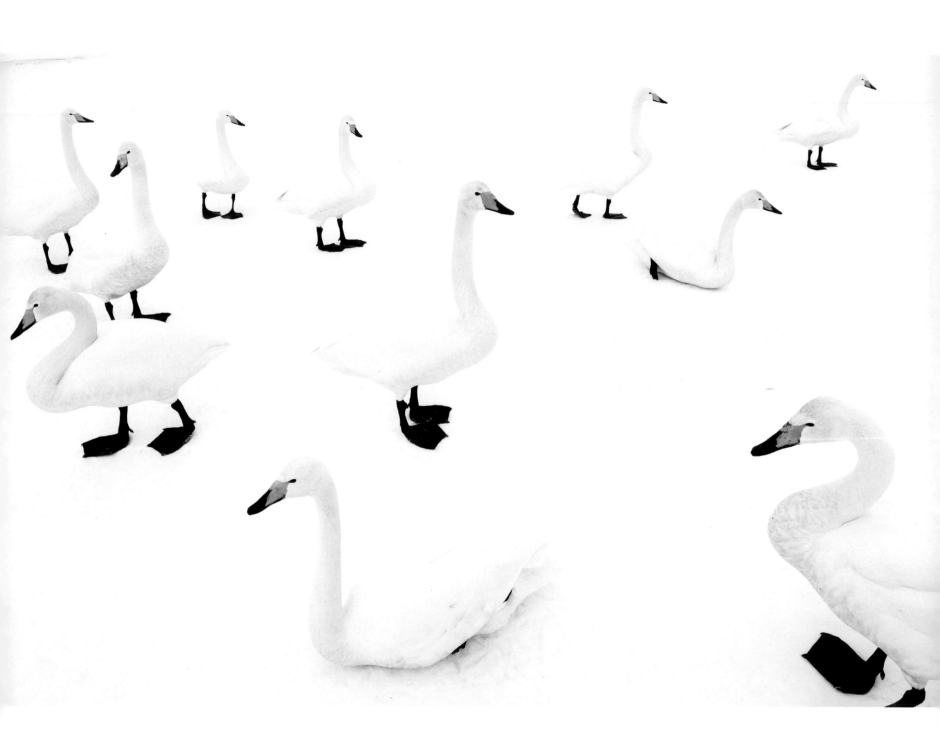

Faster and faster

Long before the advent of fast film, the pioneers of wildlife photography were taking pictures of moving animals. A quality lens was key, but so was the shutter speed, and the use of a flash-powder burst of light to freeze the moment. By the 1920s, still using glass plates and heavy tripods but with cameras capable of shutter speeds of 1/500th of a second, surprisingly detailed pictures of flying birds and even insects were being taken.

The advent of film with ever-increasing speeds in the 1970s and 80s, together with electronic flashguns, allowed more and more detailed action to be revealed. But pictures still remained comparatively grainy, and loading your camera with fast film restricted what else you could shoot – if it was faster than 400 ASA (indicating the sensitivity of the film to exposure to light), it wasn't much use for most other wildlife photography without artificial lighting because of the coarser grain and therefore the reduction in detail.

One way around the speed-versus-grain issue was to embrace the grain and use it as a positive feature, to enhance the mood. Another technique was to extend the length of the exposure while panning the camera along with a moving animal, deliberately to blur the movement and create the illusion of speed.

Things became truly fast, though, with the arrival of digital cameras. Today it is possible to shoot with a sensitivity (measured as ISO – the sensitivity of the digital imaging system) thousands of times faster than Kodachrome. And with motordrives, autofocus and through-the-lens metering, it's now possible to shoot sharp high-speed action sequences. The result is stills of moments of behaviour which even five years ago would not have been possible to freeze, indeed, would not have been seen with the human eye.

But speed isn't everything. A pin-sharp image of a mediocre composition doesn't make a winning picture, however interesting the revelation. The key remains the eye of the photographer.

Swan in swift pursuit

Running on water, at speed, this mute swan is aiming straight for a rival who's just landed on the lake. He's pumped full of the hormones of spring and bent on defending his mate and their nest. To create an impression of the swan's velocity and trajectory, the photographer used both a long exposure and panning – moving the lens with the bird – also catching the sparks of kick-spray in its wake. That he was on eye-level with the swan was because he was standing chest-deep in the lake, resting his lens on the opening of the floating hide that camouflaged his top half. The soft evening light added perfection to the picture.

Rob Jordan UK 2003

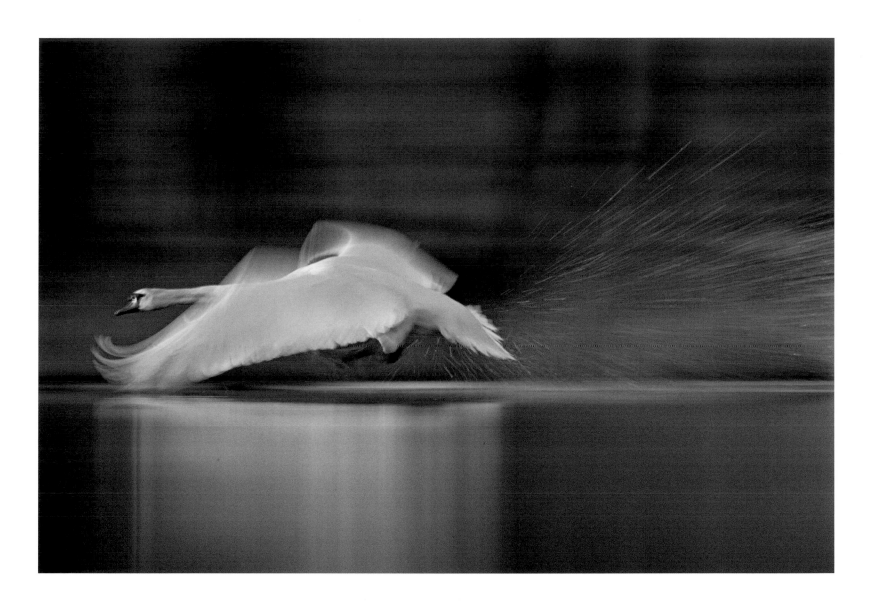

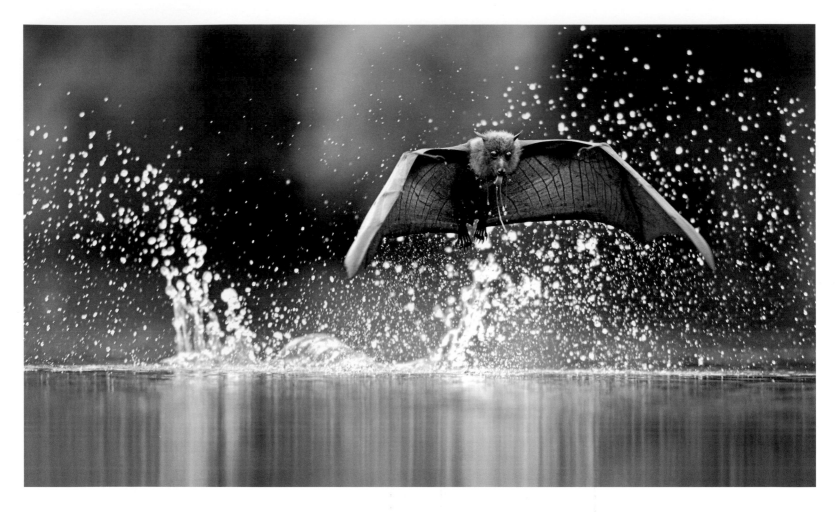

Fly-by drinking

Ten years ago, this picture would have been impossible to take – rather, it would have been impossible to show such detail with an animal travelling at speed in low light. This grey-headed flying fox, Australia's largest bat, is swooping down at dusk to skim the water with its chest, drinking water off its fur as it flies back to its roost. It's the first time this behaviour has been photographed, done so with a perfect composition – the movement of the swoop shown in the splash and with the bat in the act of licking up the water. To get the shot required perseverance and luck – it was so hot that summer that the bat was forced to drink while there was still light, risking being caught by a diurnal bird of prey. In temperatures of more than 40°C (104°F), the photographer had to stand chest-deep in the water for several hours a day for a week until he got a bat flying towards him and the framing exactly right.

Ofer Levy Israel/Australia 2012

Light path

To show so much in one vivid scene required insight, passion and a lot of planning. The kingfishers were local, in southwest England, but though the photographer was intimate with their behaviour, he had to wait two seasons and many days to get the lighting right. The picture shows not only the kingfisher taking food to its young but also the family's riverine territory and the other parent. The flight path was lit in such a way to show the nest hole but also to create a shadow on the bank to highlight the colourful trajectory, and two strobes were fired at the end of the exposure so the detail of the head and wings would be sharp while keeping the action blur.

Charlie Hamilton James UK 2013

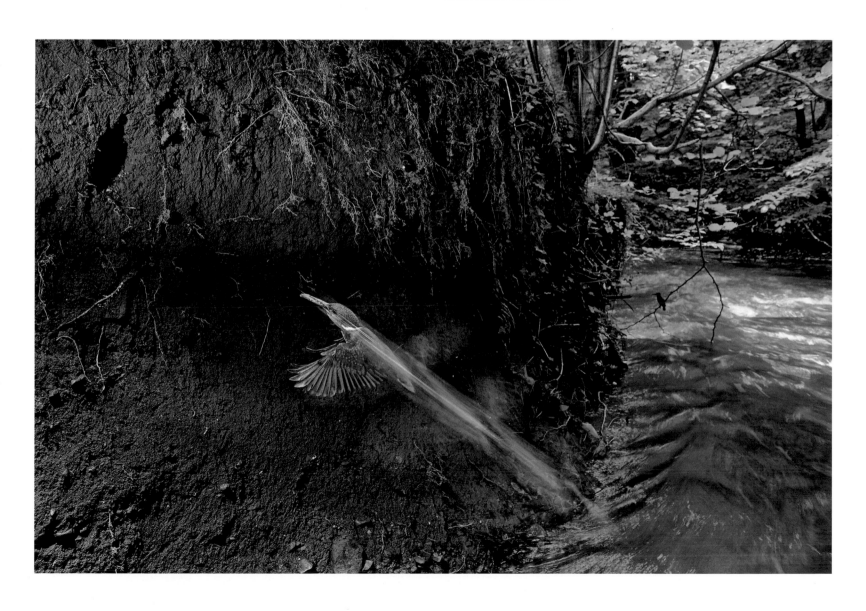

Frozen moment

Every bit of the flying emperor penguin is sharp, its jet-propelled exit from the sea frozen with a 1/2000th-of-a-second exposure, captured with a large, highly sensitive sensor. Advanced technology made the image possible, but so did the expertise, endurance, polar experience and visual skill of the photographer. The luck was the blue sky, but the composition is all in the positioning. Lying flat on the ice, with part of the great ice shelf as a backdrop, Paul Nicklen waited for the emperor penguins at the edge of the Ross Sea, Antarctica. The penguins are returning with full bellies to feed their chicks at the colony, 10km (six miles) back on the sea ice, and they exit at speed to bypass any leopard seals that may be lurking by the ice edge to catch them. At up to 1.2 metres high (about four feet) and weighing the same as a heavy child, flying penguins were something the photographer had to learn to dodge as well as photograph, along with the occasional flying leopard seal.

Paul Nicklen Canada 2012

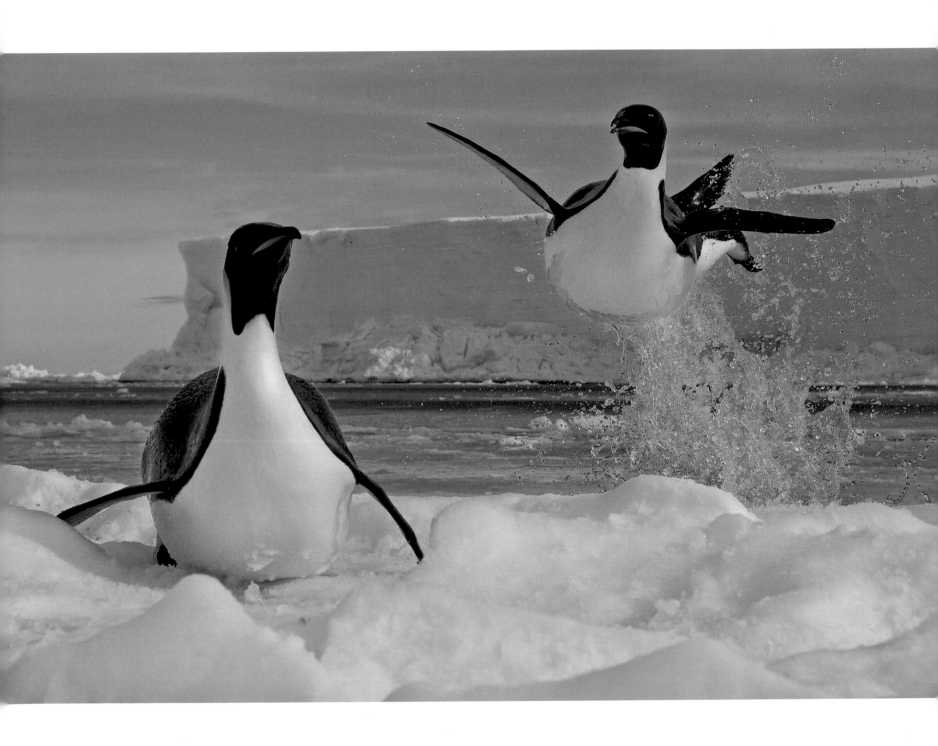

The portrait and the pose

In classic portraits, eye-contact is often an essential ingredient, but in the case of a wild animal, it might not be possible or desirable. Then a natural, unguarded pose may be the more vital element, conveying the subject's personality as much as its face. As with portraits of humans, the most expressive ones result from the photographer's understanding of the subject and empathy with it.

Skilful use of lighting is also as important in setting the mood as in illuminating the subject. The format or framing can also be important to simplify the pose. And as with a traditional portrait painting, uncluttered backgrounds, with a studio-like dark or light backdrop, help concentrate attention on the expression – unless, of course, the photographer is trying to say something more about the subject and its relationship to its environment. A compelling portrait makes you think about the animal, its character and its life. It makes you pause and ponder, and any style that achieves that is valid.

Fox in sunlight

Sometimes the simplest portraits can be the best. Here the subject of this award-winning picture is a young red fox, in a garden in a city. Carefully framed with a green surround of soft-focus grass, spotlit in a shaft of late-afternoon sun, it stares straight at the camera. It's a shot made possible through the photographer's intimacy with her subject.

Wendy Shattil USA 1990

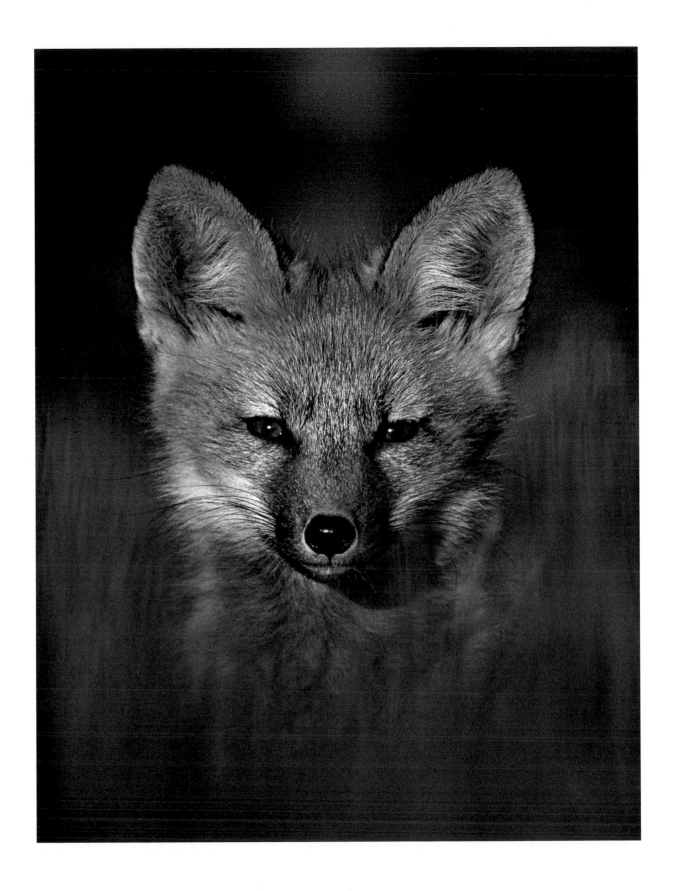

Brother wolf

The half-hidden pose sums up the elusive nature of the wolf: inquisitive but wary, watching but hidden. The photographer didn't even know if he had got the single shot as the glimpse was so fleeting. Though he has since got many shots of the wild wolves in the woods around his Minnesota home, this image started Jim Brandenburg's photographic homage to wolves and remains seminal for him. The half-and-half portrait is also one that many photographers have since adopted, used to symbolize the wildness of their subjects.

Jim Brandenburg USA 1988

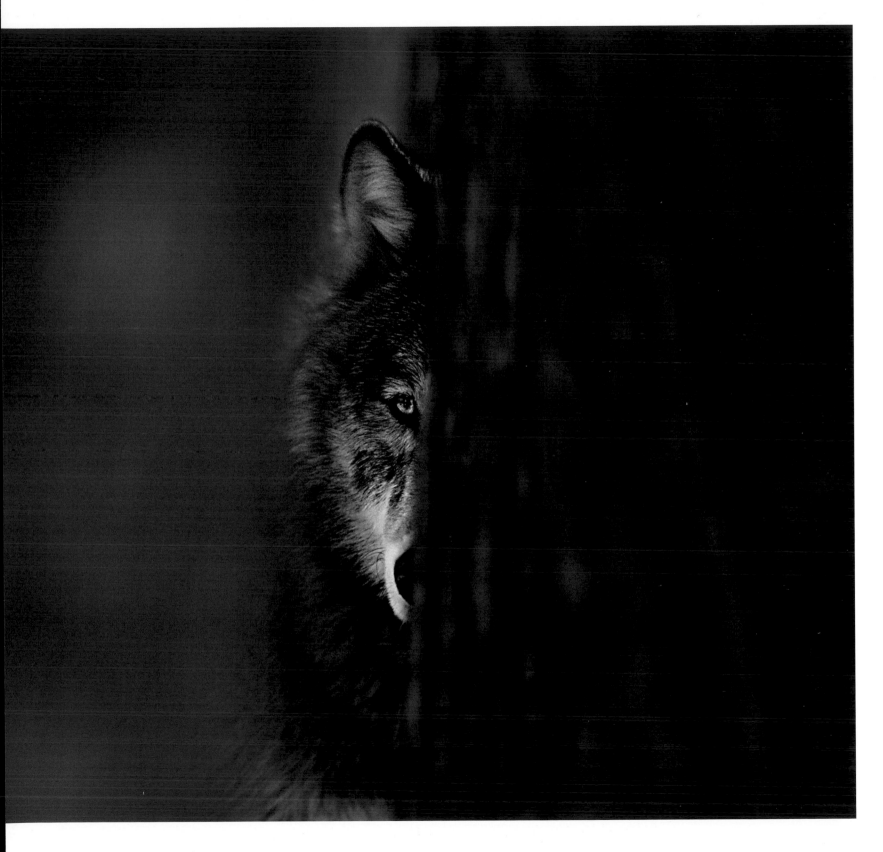

Porcupine pose

The amazing blond hairdo is a necessary accoutrement for a North American porcupine, living where winter temperatures drop way below freezing. In this case the photographer encountered the porcupine at dusk, in Glacier National Park on the border of the US and Canada, when the temperature was already below -10°C (14°F). In the low light, a long exposure was necessary, made possible because the porcupine sat motionless, not wanting to abandon the elk antler it was gnawing – a valuable source of salts and minerals for a herbivore – and probably because its armoury of quills (hidden under the raised guard hairs) gave it a little confidence. This is a simple portrait against snow, but no less beautiful because of that.

Carl R Sams II USA 1994

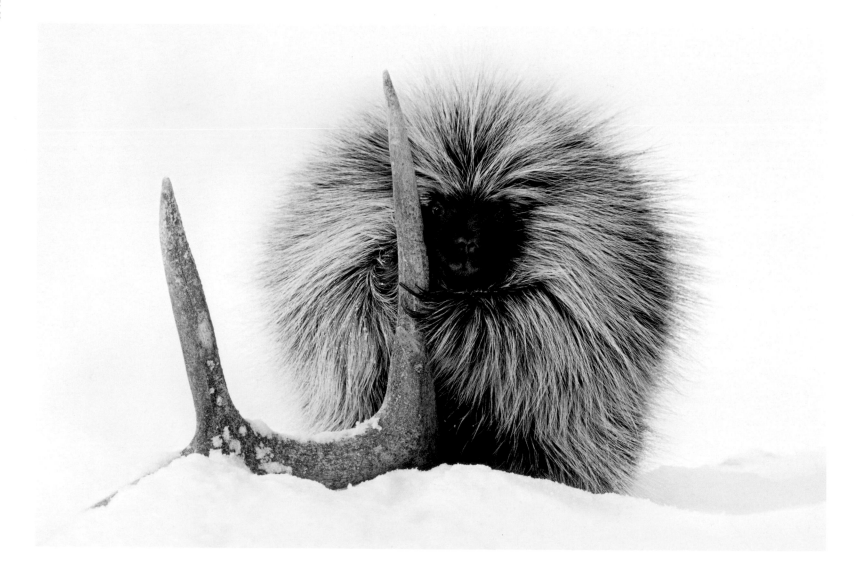

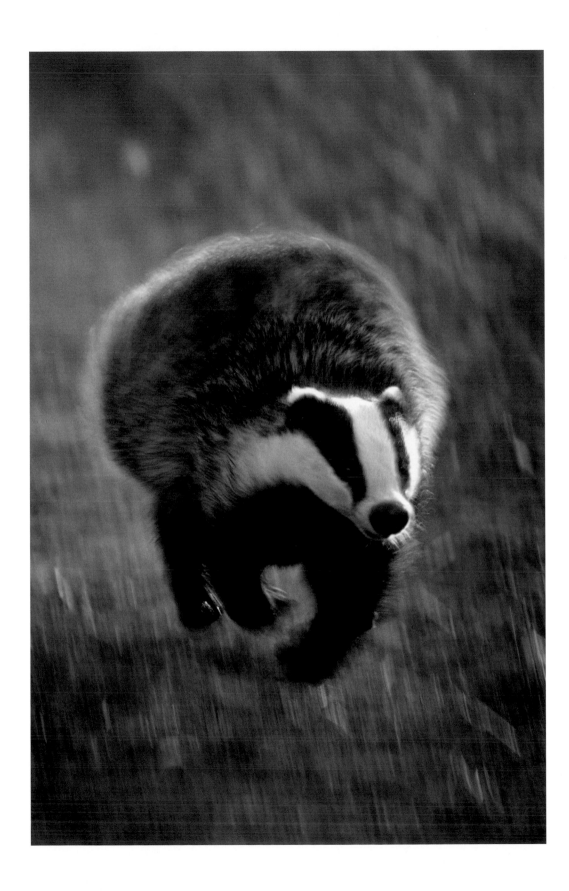

Evening run

The light was perfect, the time was right and the photographer was in position when this badger came bounding down the hill. It's a portrait that conveys the essence of badger-ness, capturing the movement of the rolling gait by panning the camera, and using the low sun as backlighting to create the golden setting. It was a summer evening in Somerset, England, and the photographer, intimate with the badgers' habits, knew they would be above ground by 6.30pm. He had stationed himself downwind, overlooking the path that he knew they always ran down (to avoid being out in the open too long) on their way to a favourite worming field. This youngster was also racing to catch up with its family.

Jason Venus UK 1996

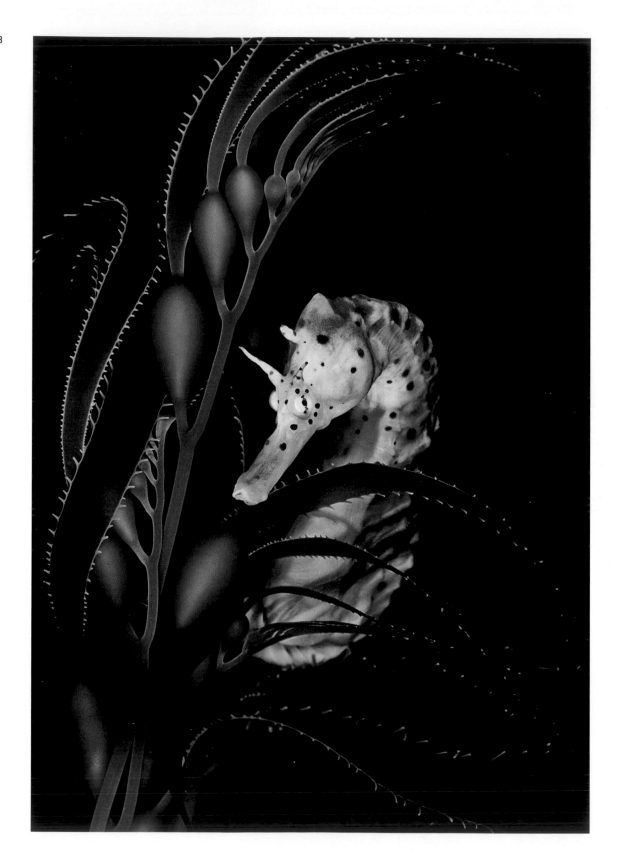

Seahorse in kelp

The pose of the seahorse is a perfect one — upright, head slightly turned, eyes on the photographer, prehensile tail attached and holding her steady in the current. The sitter is a female pot-bellied seahorse — at 30.5cm (12 inches) tall, one of the largest species — taut yellow skin covering her bony body, clasping a frond of giant kelp. In the spotlight she is a study in yellow and green. Out of it, in the low natural light of the Tasmanian kelp forest, she would present a classic example of camouflage.

David Hall USA 2000

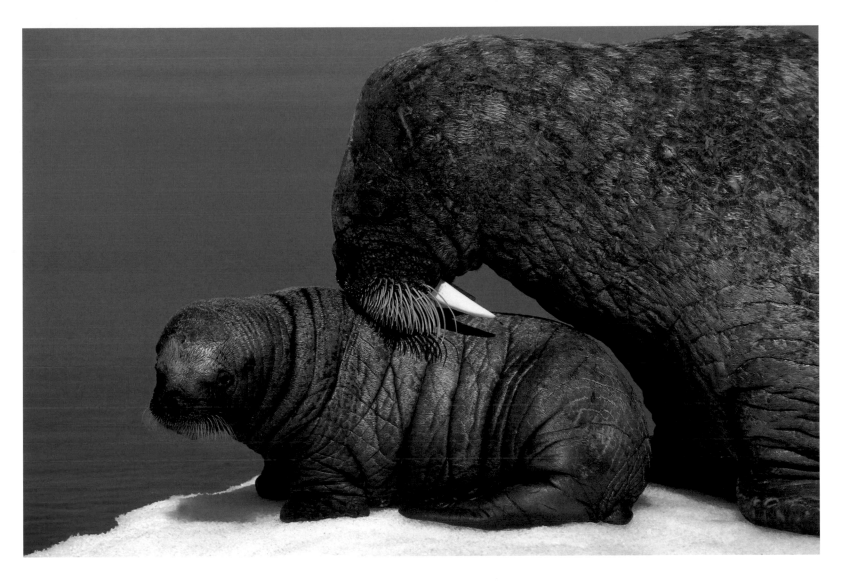

Walrus caress

Given that this portrait was taken using film, from a boat, of a mother with her
newborn on drifting pack ice, the definition and eye-level intimacy are extraordinary.
But the photographer had been photographing walruses for several years, both in
and out of the water, and was both knowledgeable about their behaviour and how
far to approach without disturbing them. Despite her bloodshot eye and cracked
skin, the tenderness with which the mother caresses her baby is obvious. In fact
she will care for her pup for more than two years, even carrying it on her back.
But what makes the picture shine is the tropical-blue background — a lucky
sunshine break after days of bad light in the Canadian High Arctic.

Paul Nicklen Canada 2000

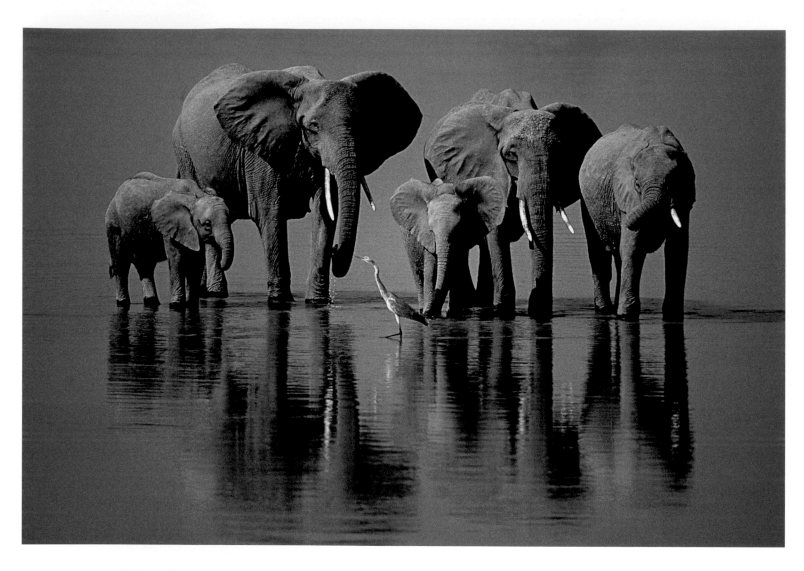

Elephant reflections

There is something so serene about this picture – and so unusual. It's partly that
the elephants are obviously relaxed, but also that they are perfectly composed
and almost perfectly still – hardly a ripple in the water. They all appear to be
meditatively watching the heron walking slowly in front of them, looking for fish they
might disturb when drinking. The solid blue of the sky mirrored in the water helps
unite the family portrait, their reflections hanging straight down from the surface
midline. The photographer chose the spot on the Luangwa River, Zambia, where she
knew the elephants would come to drink, and a position on the bank where she had the
height to compose her picture with just water as a backdrop and with the elephants
lit from the side. She got the shot – and with it the competition's top award.

Angie Scott Kenya 2002

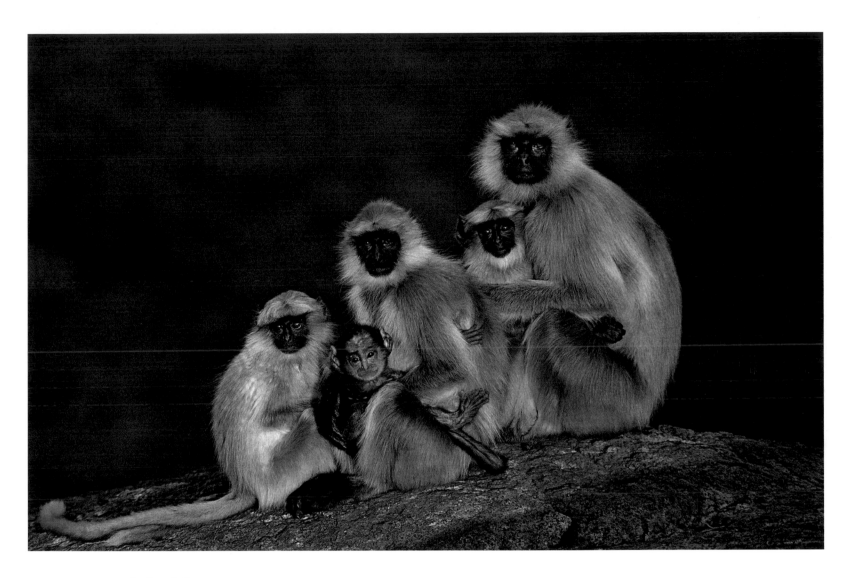

Family portrait

This is the perfect group portrait, two families appearing as if posed and groomed for the camera. The langurs are, of course, just basking in the early morning sun, aware of the photographer, whom they know, but unconcerned. The strange changeling is a young monkey, its brown baby fur a signal to adults in the large troop that it is an infant and should be treated with care. The picture was not, however, just a lucky shot but was the result of an eight-week stay in India's Thar Desert, living alongside the Hanuman langurs and getting to know individuals and their behaviour, including when they would rise and favourite spots for warming up in the morning. It also required that the monkeys be familiar with the photographer and his tripod and therefore relaxed in his presence.

Ingo Arndt Germany 2000

Curious bison

These bison are so close that you can almost feel their warm breath and sense the lightly falling snow. They are staring intently, and though they can't see any humans, they can sense the presence of one. The photographer was in fact quite close in a hide, where he had been since before first light. He was at a feeding site in a clearing in Poland's ancient Bialowieza Forest, where he knew the bison would arrive after a night of heavy snow. The low, dull light was ideal, creating the atmosphere of the cold forest environment and enhancing the subtle browns of the bison. The framing was deliberate, focusing on the eyes and muzzle of the lead individual and including the horns of its companions. The Bialowieza herd originates from a handful of bison that survived in captivity after the last wild European bison was shot in the early twentieth century. Reintroductions in other countries mean that more than 2,700 now range wild and free.

Klaus Nigge Germany 2004

Heart of an agave

This is a plant portrait that remains unforgettable, photographed with great thought
and care by someone obviously passionate about the sculptural forms, colours
and textures of plants. The mountain agave, a drought-resistant succulent, found
only in the mountains of the Sierra Madre Oriental, Mexico, grows slowly but to
huge proportions – up to 1.5 metres (five feet) tall and 1.8 metres (six feet) wide.
The photographer fell in love with the subtle colours and shapes of the plant, and
using the low light of sunset to give a glow to its heart and a long exposure to soften
its colours, he created a picture that conveys some of the essence of its beauty.

Jack Dykinga USA 2007

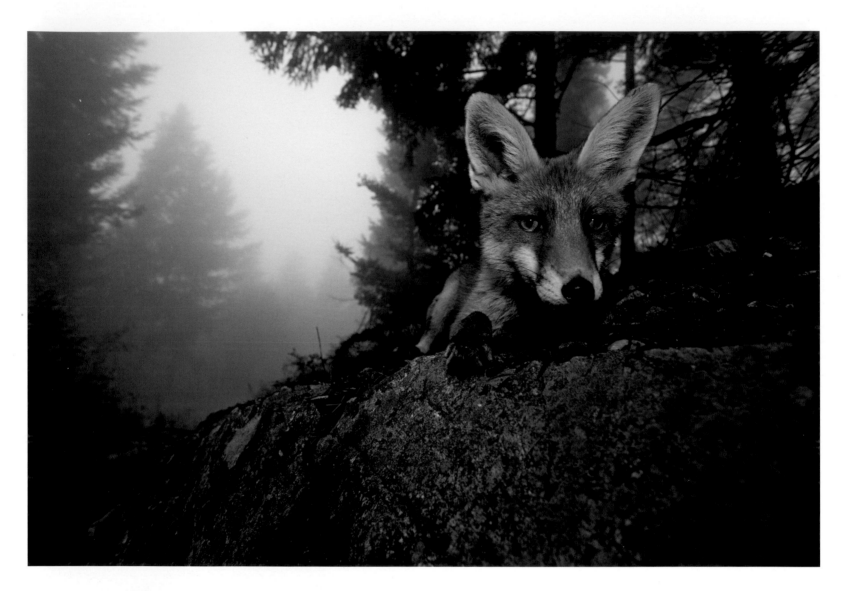

Trust

To take a portrait of a wild animal as close as this without a hide requires considerable trust from the subject. And just as the best human portraits are often those where the subject is at ease, the fact that the vixen is so relaxed is what makes this image beautiful. The photographer, a forester, had got to know her over several months, making a point of regularly walking in the part of the Black Forest where she hunted, particularly when it was wet and there were few people around. She became so trusting that on this special day, she lay down close to him and let him take a series of pictures, and even change lens to a wide-angle and shoot with a low-light flash. Shortly after that day, at the start of the mating season, she disappeared, and he never saw her again.

Klaus Echle Germany 2011

Territorial strut

Simplicity and framing is the key to this portrait of one of the most frequently photographed birds in Britain. It's a robin with attitude, taken in the photographer's garden, simply by lying on the snow, observing and seizing the moment when the bird reacted to another male, flicking up snow and striking a tail-up warning pose. A careful exposure compensated for the bright snow but caught the subtle colours.

Ross Hoddinott UK 2011

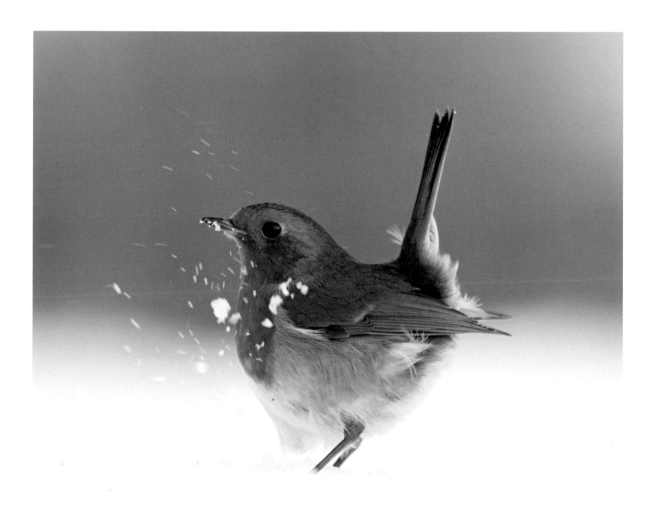

Remote design

From the earliest days of wildlife photography, photographers have experimented with taking pictures remotely. One of the first images of a wild animal, a lapwing, was taken in 1895 by Reginald B Lodge (see page 13) using a trip-wire attached to his camera. At about the same time, in the US, George Shiras was using trip-wires to photograph deer and even devised a system linked to flashlight so that animals would take their own photographs at night (see page 15). But the equipment was heavy and cumbersome, flashlights involved flash-powder and the synchronization of flash and shutter, and the camera could only be triggered once before the glass plate had to be changed.

Though the development of lightweight cameras, film and flashbulbs opened up huge possibilities from the 1950s onwards, it was only in the 1990s, with the arrival of wireless-operated remote-controls, that wildlife photographers started to experiment again seriously with taking pictures remotely. Wireless control allowed the camera to be placed on the ground, to take pictures from an animal's perspective. And a link to an infrared trip-beam meant that a camera could be triggered over and over again, increasing the chances of capturing pictures of rare animals in difficult terrains.

But for a picture to be more than a visual record – to be composed as if the photographer was there – requires much thought, experience and engineering. It means not only predicting where the animal will walk but also working out how to achieve the exact pose required and therefore the exact angle of the lighting. In such preconceived compositions, the setting is as important as the subject, and the result is a picture of a moment that no one will ever experience first-hand.

Elephant mud-shower

This is what happens when you leave your camera at the edge of an elephant mud wallow. The decision was, of course, deliberate, to get a dramatic eye-level view, and the camera and wide-angle lens was attached to a shutter-release cable running to the vehicle being used as a hide. The first elephant to arrive fell asleep by the tree, in a perfect pose. But the second one went straight for the camera and showered its irritation by aiming a great trunkful of mud at the clicking object. For the photographer, the swirl of mud was a gift – and well worth the camera's repair bill.

Andy Rouse UK 1998

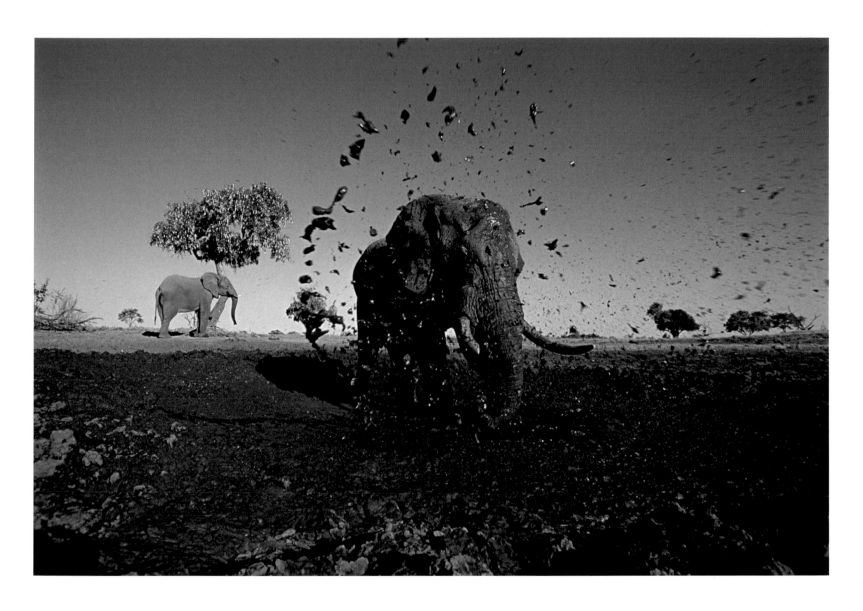

Cool tigress

The tiger's expression says it all. She's been snapped. In fact, she only heard the click of the shutter and carried on angling herself into the rock cleft for a long, cool, period of relaxation – ignoring the camera. The shot was taken in Bandhavgarh, India, and required both knowledge of the routine of the tiger – a female called Bachhi – and an extraordinary amount of setting-up, both to avoid a direct meeting with her, but also to position the infrared beam and the camera so she would take her portrait as she lowered herself into the water. This was in the days before digital imaging, and so the use of a monitor was not possible, but the photographer still managed to get the exact shot he'd planned, head-on.

Michael 'Nick' Nichols USA 1998

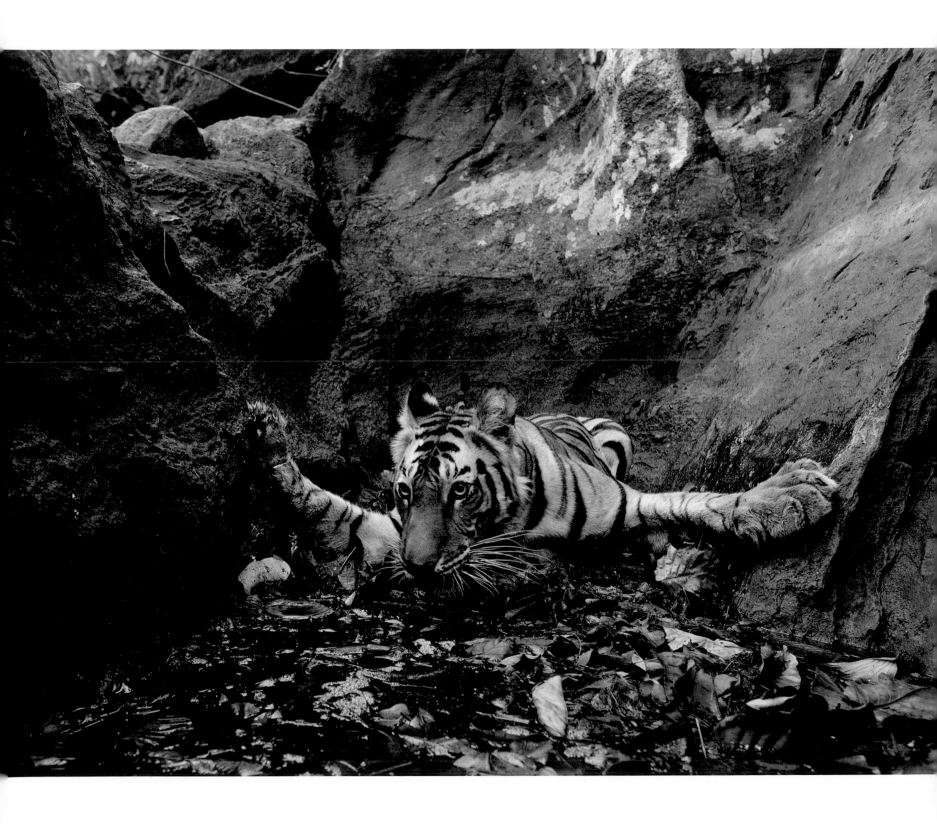

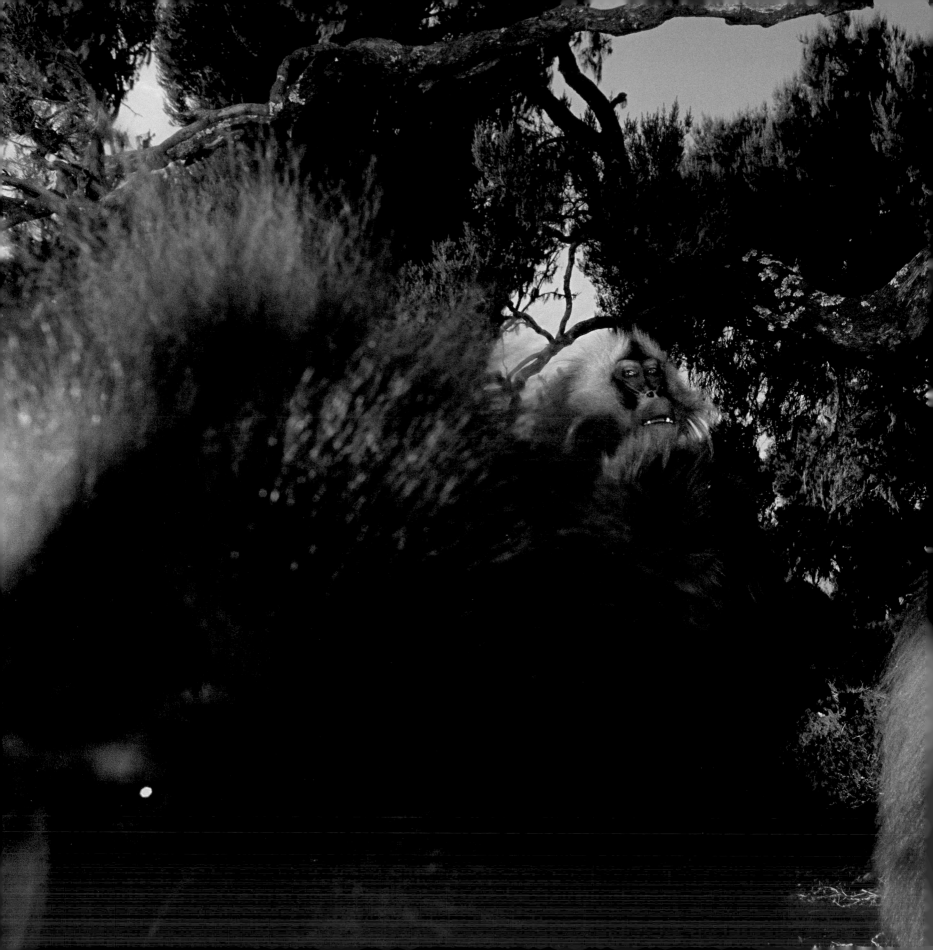

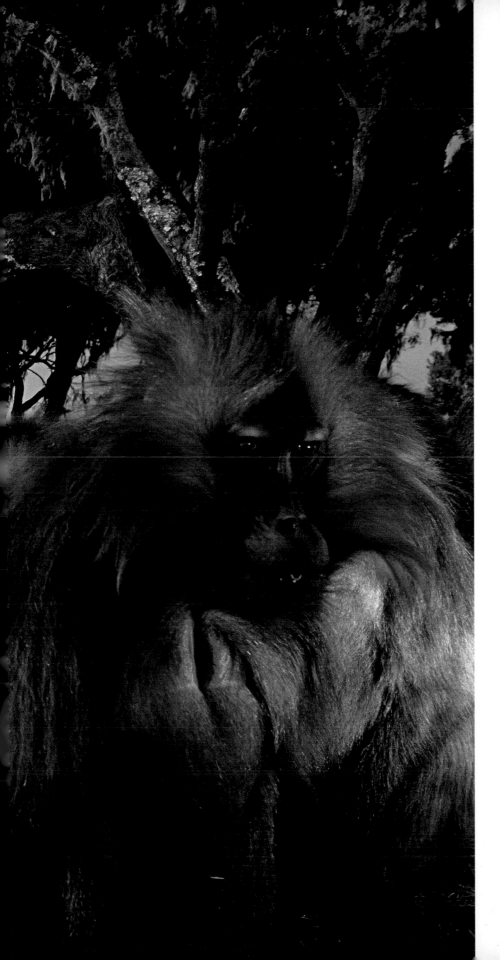

Gelada get-together

This is a picture with character, a glimpse of the social life of Ethiopian geladas. It is made so by the intimacy of the upward angle, the use of a wide-angle lens and the lighting, under the radio remote control of the photographer a short distance away. Three strobes have been positioned among the old heather trees on a hillock where the gang of bachelor males likes to hang out and watch the rest of the troop feeding on the alpine grass below. The artificial lighting adds stage drama and allows the expressions of the male at the back to be seen, flashing his eyelids and baring his teeth at a rival, while another gang member lunges forward. It's an adventurous, original choice of shot — with a style that others would subsequently emulate.

Michael 'Nick' Nichols USA 2003

Zebra crossing

To position the camera in the right spot beside the waterhole took planning
and experimentation. The photographer worked out exactly where the animals
preferred to come to drink and their exit route. He also knew that the zebras
were skittish, constantly on the lookout for predators, and sooner or later would
provide him with an action shot. A wireless remote control allowed him to trigger
the shutter, though making sure at least one animal was full frame was still going
to be down to guesswork. But as if according to script, the group of zebras arrived
to drink in the early morning, one animal panicked and then the whole herd took
off. It took just a single shot, and Anup Shah had the ant's-eye view he wanted,
of powerful animals and the feel of thundering hooves – a shower of muddy water
adding to the sense of movement.

Anup Shah UK 2007

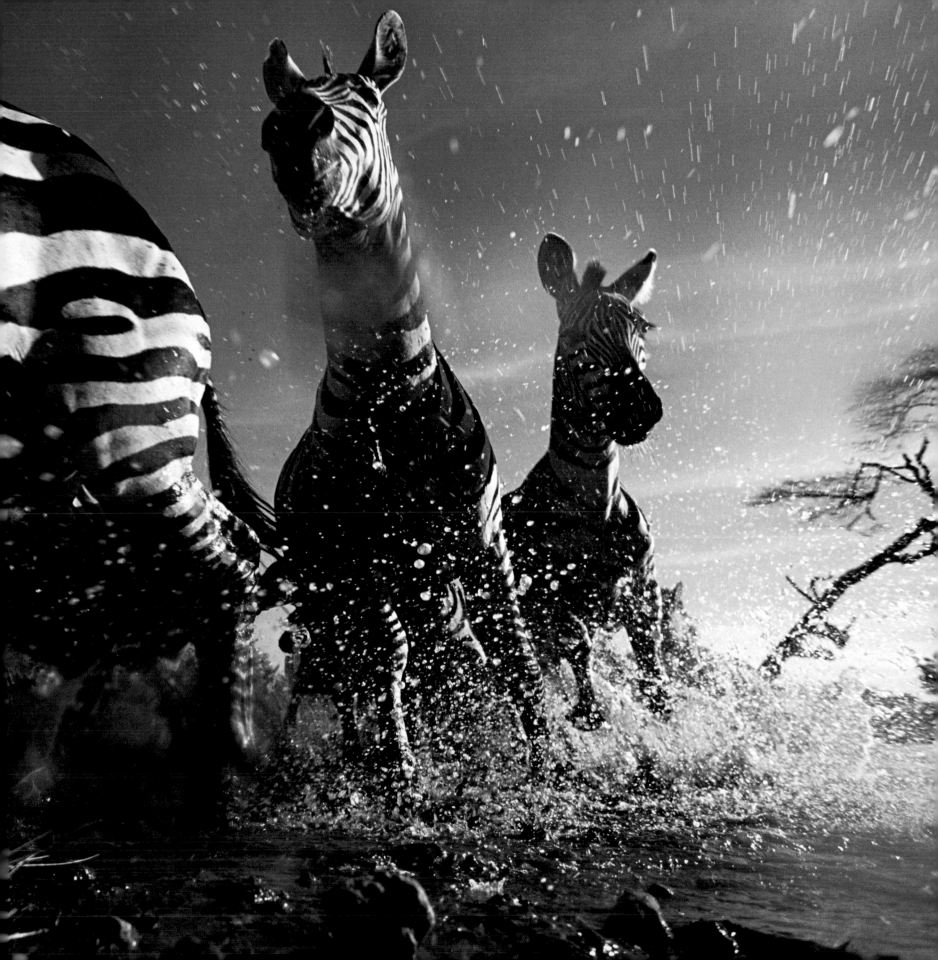

Snowstorm leopard

A symbol of wilderness and wildness, the elusive snow leopard has long been a holy grail for writers and photographers. Found only at high altitudes, it is nocturnal and superbly camouflaged, and until this picture, only a handful of photographs of snow leopards taken in the wild existed, and none were so evocative. The sheer technical challenge of developing and positioning a remote set-up in such extreme conditions – the only way to get such a portrait – meant that it took the photographer months before he achieved the composition he was after: a snow leopard at night in a snowfall. The location was the Hemis High Altitude National Park in Ladak, India. After many unsuccessful attempts in the first winter, he set up the camera, the Trailmaster and the lights at a high-altitude point where three trails converged. After three months (with the camera checked every three weeks), it all came together and he saw the shot he had dreamed of – a wild snow leopard in its element.

Steve Winter USA 2008

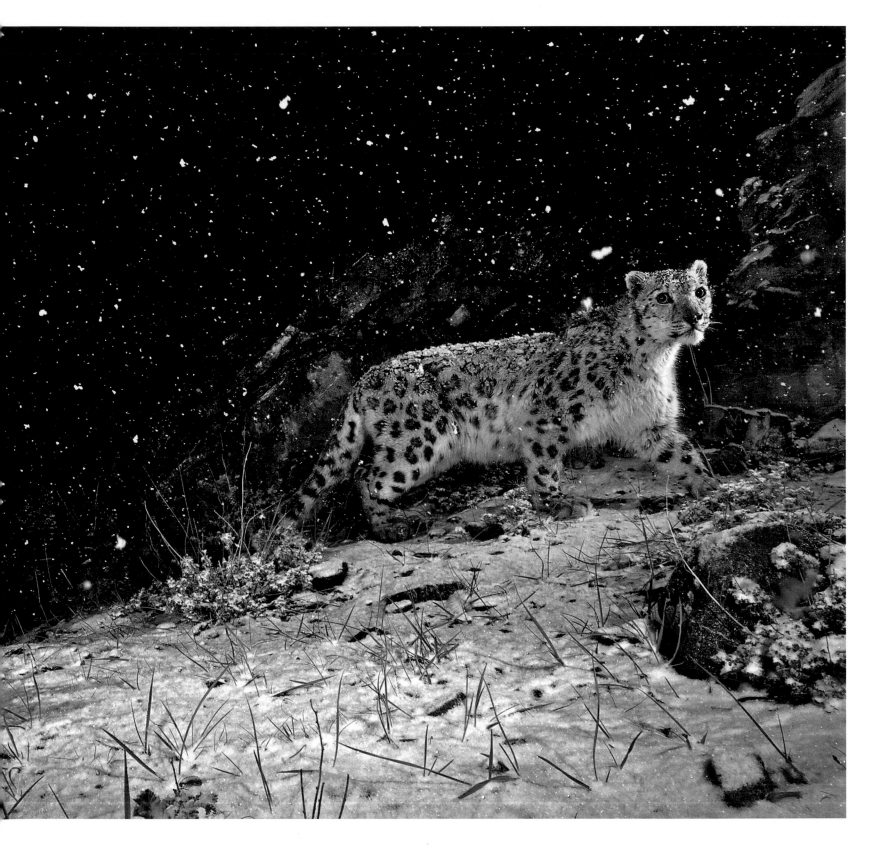

The tiny things in life

Close-up images of little creatures have always featured strongly in the competition. Insect subjects were especially popular in the early days. One reason was because so many photographers were naturalists, who saw the camera as a tool for identification and discovery – a magnification lens able to reveal what the eye couldn't see unaided. But the technical problems they faced were many.

For close-focus work, the trade-off was – and still is – between sharpness and depth of field (higher magnification gives shallower depth of field), lighting (the greater the magnification, the more light is needed), shutter speed and resolution. If the animal isn't shy or likely to move, the lens can be positioned close to it and some of the problems are reduced, but in most cases, a tripod is still necessary to prevent the risk of vibration blurring the high-magnification picture, and if the animal is moving, the problems of magnification and lighting become truly challenging.

In earlier days, a lot more macro photography was done under controlled conditions – often the only way to get close to a tiny subject and to avoid lugging around heavy, bulky equipment. The challenges of lenses and lighting also meant that many such photographers needed to be technical wizards and often inventors, designing and building their own equipment and using special lenses, extension tubes or bellows to allow small apertures and fast shutter speeds.

Now, with the arrival of digital cameras, the available range of specialized lenses has expanded. The increased light-sensitivity of digital cameras means telephoto-macro lenses can be used at a distance, and specialized super-macro lenses can create larger-than-lifesize pictures. The possibility of all-over sharpness has also been opened up by focus-stacking software (fusing a series of pictures taken in a sequence of focal planes to produce one sharp composite image).

Wide-angle and ultra-wide-angle (fisheye) lenses are used a lot more now for larger insects, allowing both foreground and the surroundings to be part of the picture, putting the creature into context. LEDs and modern strobes – lighting that doesn't fry an insect – have also made it possible to light scenes to create more detailed storytelling. But the skill of macro is still very much linked to the knowledge of how little creatures behave. And to record and reveal things with artistry as well as accuracy still requires that extra ingredient of imagination.

Little jumper

Jumping spiders are notoriously quick movers with exceptional vision, and when warmed up, they can be particularly jumpy. So to photograph this 6mm (quarter-inch) male head-on, close-up, on a hot day, in a natural setting – a woodland clearing – and with a clean background, required patience, fieldcraft and planning. The secret was the creation of a mini-outdoor 'studio' by half-encircling a small part of the clearing with a home-made windbreak. To bring out the detail while keeping a soft, even natural light, two flashguns were mounted at a distance, one of them illuminating the background with the use of a silvered reflector. Film was expensive then, and so photographers were considered in what they shot. This picture, taken as the jumping spider paused on a frond of false brome grass, was one of just a dozen shots, and turned out to be an award-winner.

John A Horsfall UK 1982

Bug eye view

Going eye to eye with this tiny Brazilian treehopper was difficult. It's a skittish jumper, and bellows, great patience and skill were needed to get close enough and level enough to frame a portrait with a clean background and both the eyes and the false eyes in the same plane of focus. Many have wondered about the function of the sap-sucker's protuberances. Formed out of a redundant third set of wings, their most likely function is as a disguise to scare off a predator. And they would certainly make the bug hard to swallow. But why so many hairs, and why is the structure hollow? Could it be an amplification device? But like so many things in nature, no one knows.

Mitsuhiko Imamori Japan 1994

Ants tending their aphid herd

The detail and definition of this shot belies the fact that it was taken on film. It was also taken in the garden and features common carpenter ants tending common oleander aphids on the pod of a relatively common butterfly milkweed. But it remains an uncommonly superb picture of the behaviour, shot with dual strobes, softened by diffusers, to bring out the colour and texture. The ant at the top has just carried a straying aphid back to the herd, the middle ant is sucking up the honeydew that an aphid is excreting and the bottom ant is standing guard. Though the aphids' yellow warning colour indicates they contain a toxic chemical (absorbed from the milkweed), they still have some parasites and predators. The ants guard them from these in exchange for the honeydew, which the ants take back to their nest to be fed to the colony's grubs – an ancient partnership that this picture celebrates.

Gerry Bishop USA 1998

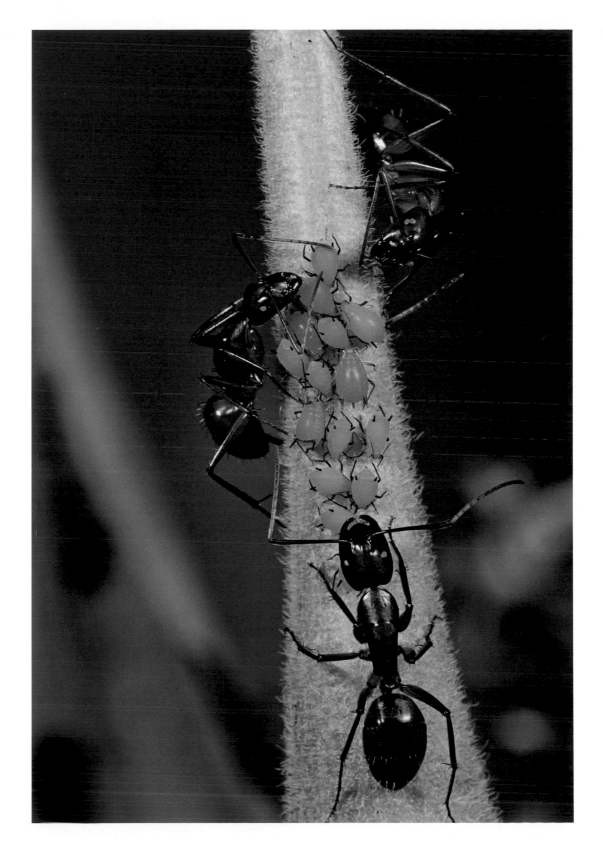

Angry queen

It's a face to take notice of – an armoured ant queen, with mandibles that could crush a lesser insect and an exceptionally hard exoskeleton. She is angry at being under a plastic diffusion box placed by the photographer so he could use flash to offset the glint of her armour in the tropical sun. Discovered in Cambodia on the forest floor, having just completed her nuptial flight and looking for a place to found a new ant colony, she is understandably unhappy at her temporary captivity and has her abdomen twisted forward to spray formic acid. It's a straight portrait, yet there are few such eye-to-eye views of invertebrates and certainly none as well framed and lit and that make a 10mm (half-inch) insect look so magnificent and malevolent.

Piotr Naskrecki USA 2008

The filter-feeding forest

This enchanting living landscape is what you would see were you to look down into the 'mouth' of a sea squirt, but few people have and no one has taken quite such a picture. The tiny, cylindrical green-barrel sea squirt, common in tropical waters, feeds by pumping water through its tree-like filters, which catch the organic particles. Its colour comes from microbes (prochlorons) containing green chlorophyll, which live within it and photosynthesize like plants, providing nutrients in return for a home. This individual had a relatively wide opening that the photographer could just see into, and its external white tunic provided the perfect diffuser for the light from the strobes.

Lawrence Alex Wu Canada 2009

Raindrop refresher

A red ant drinking from a raindrop on a carpet of pink petal — a glimpse of everyday life at macro level that few would notice and fewer would portray with such artistry and style. The ant was on aphid duty on the stem of a common mallow plant. It was guarding the sap-suckers from predatory insects as they fed on the mallow flower buds and would soon be sucking up a stomachful of aphid sugar excretion to take back to the colony nest. To portray the ant in such detail required not only a macro lens, but also two sets of extension tubes and a teleconverter, using flash to bring out the colour and texture.

András Mészáros Hungary 2009

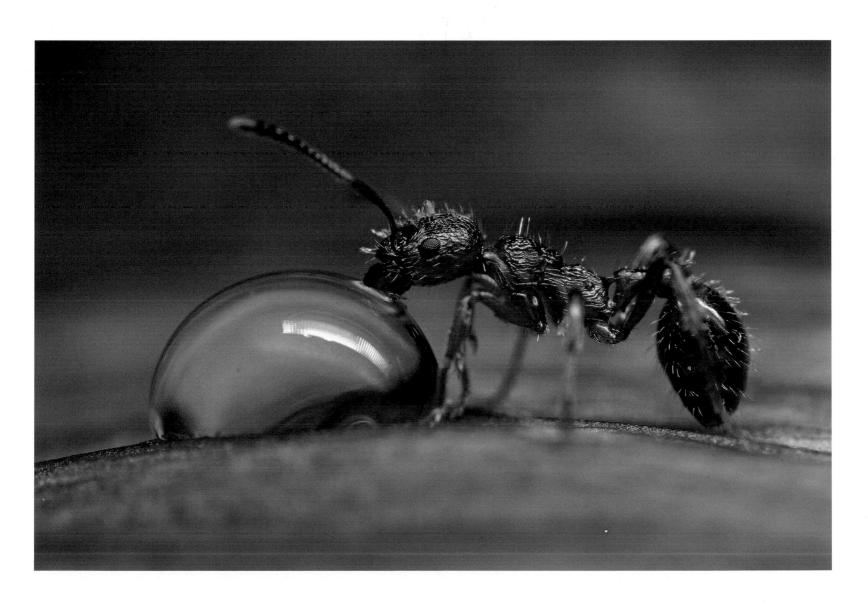

Springtail on a snowflake

This is a scene few have knelt down to examine. Indeed, without magnification, the beauty of the crystal landscape would be impossible to see, and the two-millimetre-long snow flea, or springtail, would look like a tiny seed on the snow. On a relatively mild winter day, the insect has climbed the scaffolding of snowflake crystals to forage on top of the snow, springing around in search of organic morsels. To reveal every little hair on it and show the snow sparkle before the tiny creature sprang away, required times-five magnification, a flash with a home-made soft box and practice. The result was a delightful portrait of a seldom-photographed animal.

Urmas Tartes Estonia 2009

A marvel of ants

The secret of this picture is both its simplicity – silhouettes against a plain leaf background – and its complexity – revealing the social behaviour of a tiny creature. It took many days of observation in a Costa Rican rainforest for the photographer to discover that the leaf-cutter ants were most active at night, high up in the trees, and then to devise a way to photograph them. Having found a branch of a shrub being stripped by the ants, his next breakthrough was seeing a silhouette of ants at work created by his head-torch. Now that he knew backlighting was the key, he just had to wait for the right composition to present itself. But the ants worked so fast that he had to keep moving his lights so they didn't show through the hole. Here four activities can be seen: workers cutting holes, workers carrying bits of leaf on their way back to the nest, tiny lookouts watching for parasitic flies and big soldiers on guard, all in perfect, contrasting detail. It's a picture of a biological marvel illustrated with artistry, and a deserving winner of the competition's top award.

Bence Máté Hungary 2010

And then there was night

Night is when many animals, moths and mammals in particular, are active, but when photographers are not. Before digital photography, the only way to expose nocturnal behaviour was to create artificial daylight with flash, as a street photographer might. This allowed a certain amount of detail and action to be recorded, but it limited artistry mainly to composition. Gradually, as film sensitivity increased, it became more and more possible to use the last light of sunset or the early light of dawn to capture active wild animals.

Nocturnal scenes and happenings have always attracted imaginative photographers, and long exposures of relatively still animals allowed the creation of atmosphere even in the days of primitive flash. Digital photography has now opened up the possibilities. As the sensitivity of sensors has increased, it has become ever more possible to use moonlight and starlight alone.

The night sky itself has become a subject, with the new challenge of knowing when and where to be to capture the most spectacular heavenly landscapes, which can be stitched together to create grand panoramas (see page 92). But most of all, starlight and moonlight offer the possibility of creating pictures of mystery and romance as much as revelation.

The long drink

A convolvulus hawkmoth, its long tongue unwound, drinks from a tobacco flower in a garden on a warm South African night. The photographer knew exactly which flowers were offering nectar for long-tongued moths and waited, at exactly the right angle, with his hand-held large-format camera and homemade flash and power unit. The resulting picture, extraordinary for its time, won the second-ever Wildlife Photographer of the Year Award.

Anthony Bannister South Africa 1966

Social drinking

Few photographers work at night in the African bush, mainly because it's dangerous, and also because many national parks don't allow it. But in this case the photographer was living and working in Etosha National Park in Namibia and so was on site to observe the behaviour of animals at night. Black rhinos are normally solitary, but at night, when they usually choose to drink, they take the opportunity to socialize. Here two are drinking at a waterhole, their reflections adding to the sense of a relaxed encounter. They greeted each other in a familiar way and stayed relatively close. Today, such a scene is a rare one outside Etosha, as the rapid increase in poaching has caused the black rhino to be listed as critically endangered.

Wynand du Plessis Namibia/Germany 1998

Cranes preparing to sleep

It's a strange image – true to life but ghostly– an original, imaginative picture
that inspired other photographers to try taking similar atmospheric night shots.
The photographer entered his hide in the Polish marsh before sunset, before the
common cranes flew back to their roost site. The picture shows them gathering,
about to wade into the marsh, where they will be safe from predators. There they will
stand knee-deep in the water and sleep upright. The shot, taken on film, required
a three-second exposure to capture enough light to record the forms of the birds
standing motionless in the mist, but the resulting grain is also part of its success.

Klaus Nigge Germany 1993

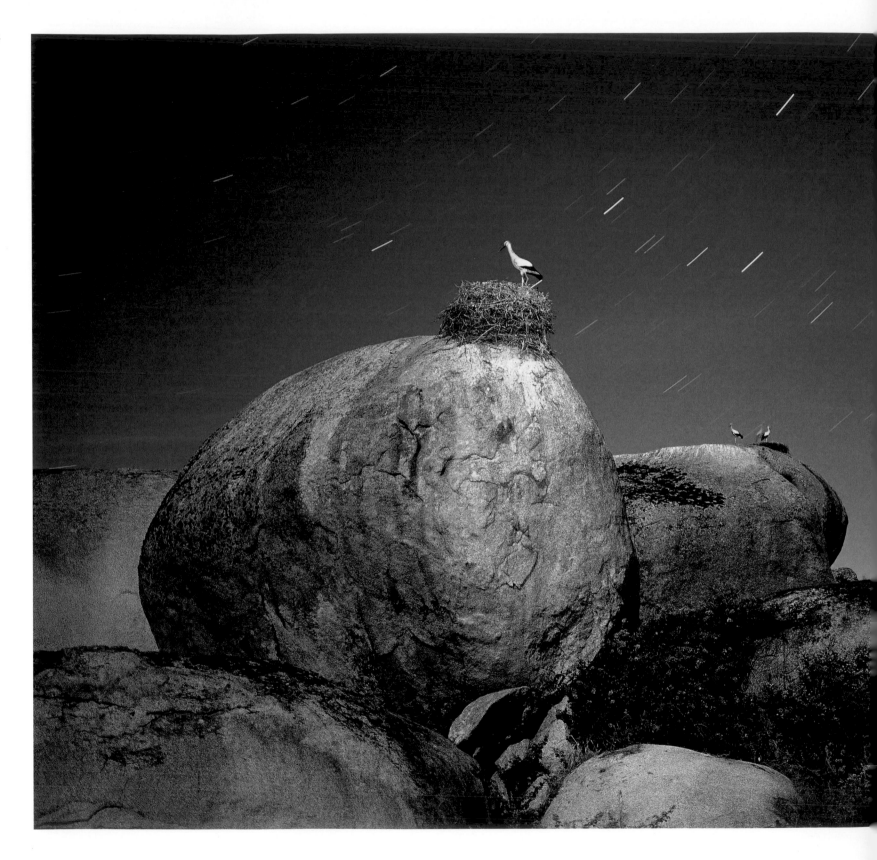

Celestial roost

This is a composition of grand proportions, requiring considerable planning by a master of night photography. The ancient granite boulders, in Barruecos National Park, Extramadura, Spain, are dramatic enough in daylight, but at night they become otherworldly. White storks roost and nest on top of them, standing like white sentinels, emphasizing the rocks' vast proportions. It took several months to work out the exposure options for the picture, taking into account not only distance and flash-reach but also the phases of the moon and the exact angle of the camera. To gather enough moonlight and to paint long star trails, the exposure needed to be six minutes, and the camera had to be pointing southeast — far enough away from the north star for the Earth's rotation to cause star trails but not a light-wheel effect. It was still necessary, though, to light the foreground, which the photographer did using a teleflash system, fired five times during the exposure, accompanied by a prayer for the sleeping storks to remain absolutely still, which they did.

José B Ruiz Spain 2003

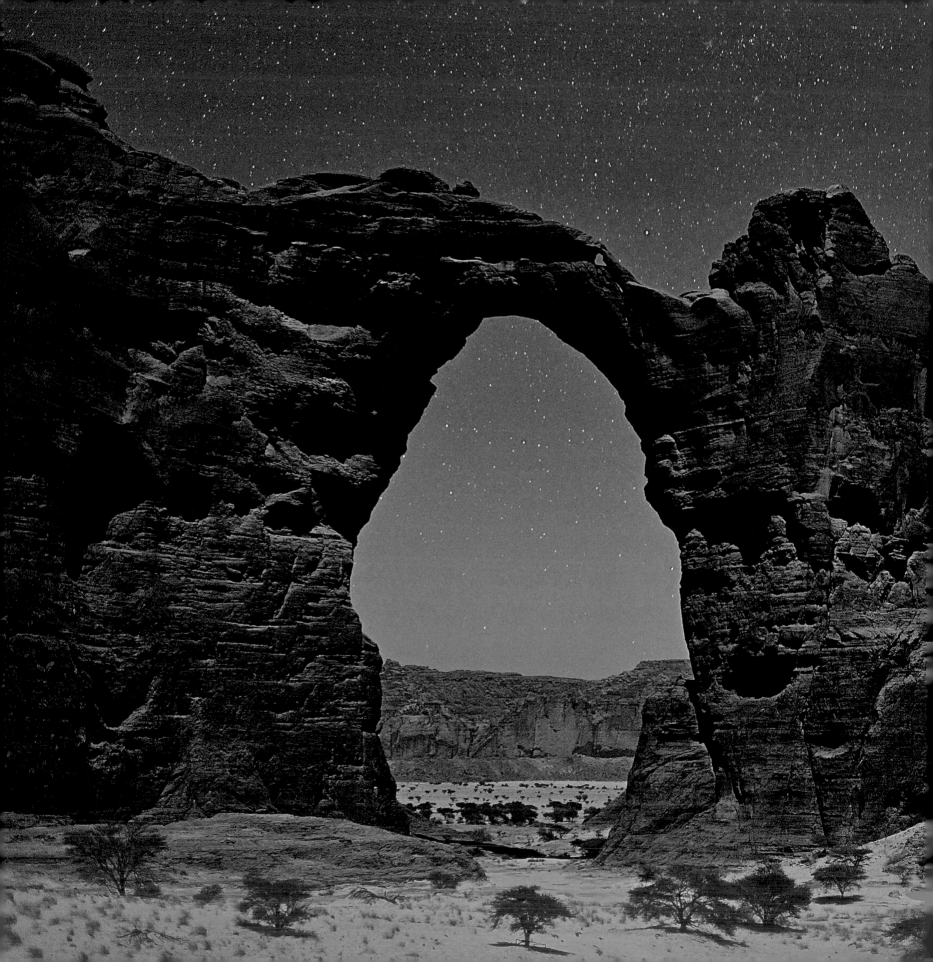

Moonlight over Aloba

The sensitivity of modern digital cameras allows the use of moonlight alone to illuminate a scene if the exposure is long enough. Here the photographer has used the moon to cast an otherworldly light on the extraordinary landscape of the Ennedi Plateau in northeastern Chad — an eroded sandstone plateau in the centre of the Sahara that few ever get to see. The chosen view is through one of the highest and most spectacular rock arches in the world, the Aloba Arch, to a mysterious desert land beyond. The exposure was 15 seconds — long enough to light the whole scene but short enough to keep the billions of stars overhead, adding to the sense of mystery and the sheer magnificence of the landscape.

Marsel van Oosten The Netherlands 2011

Telling a story

A love of being in nature is why most photographers of wildlife first started taking pictures, aiming to capture an element of the experience and joy of just being there. Some even trained as biologists before turning to photography. Some are still practising scientists who use photography to reveal their findings to a wider audience. Others work alongside biologists, using their knowledge and gleaning stories from their discoveries, providing photographs in return.

Curiosity is what drives biologists – understanding why creatures behave the way they do. It's a trait shared by photographers fascinated by animal behaviour. But the challenge is how to present the stories, especially in a single image. If action is involved, it so often happens out of sight – underground, high up or at a microscopic level – rarely or unpredictably and in an instant. And to represent all of the elements of the event can be a technical impossibility.

One way to do this is to compose a shot that invites questions from the viewer. Another is to incorporate an element of symbolism in the picture – in the same way that the cover of a novel might do. In other cases it's the incongruous mix of elements that creates the story. The secret is incorporating some element that fascinates or is intriguing, with the result that we never tire of looking at and thinking about the picture.

Peeping anemonefish

A pink anemonefish peeps out of the curtain of her all-enveloping protector, the tip of one of its tentacles hanging stylishly across her head. The stage is lit with two strobes to bring out the vivid hues of the folds of the magnificent anemone. The story is suggested by the clever viewpoint (looking down from above).
But the real story is the pink anemonefish's extraordinary lifestyle. She lives with her mate and a few small males within the anemone, never moving far from her protective host, immune to its stings and laying her eggs close to it. Should she die, her partner takes over her role – literally – changing sex, and the second-largest male becomes the new female's mate.

Michele Hall USA 1992

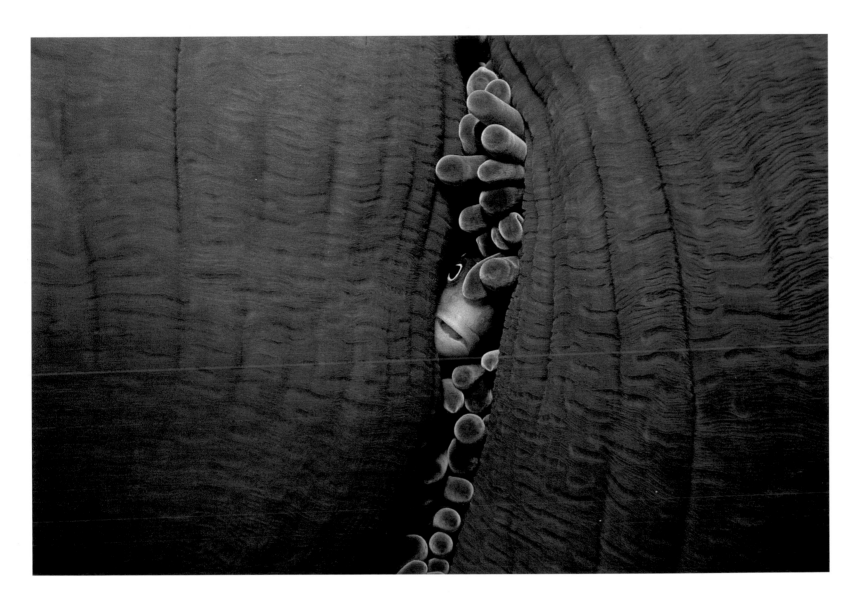

The cowshed bats

It took years to achieve such a shot: to learn about the behaviour and hang-outs of the rare Geoffroy's bat – the photographer's favourite – and to win the trust of the owner of the cowshed, one of only a handful of known nurseries in southwest Germany for this endangered bat. It took a number of visits before Klaus noticed that a few bats would do a lap round the shed in daylight, to stretch their wings and to catch flies generated by the cow dung below. In fact, cowsheds provide vital fly food for nursing mothers. To show all in one shot – the nursery, the cows and a bat in flight – meant finding the exact spot to place an infrared trip-beam so the camera would fire exactly when a bat's wings were outstretched on the turn back up to the roost. It also meant careful work so as not to disturb the bats, though they were used to farm activities and took no notice of the flashes. The result? A storyboard picture illustrating the link between the endangered bat and traditional cattle farming.

Klaus Echle Germany 2006

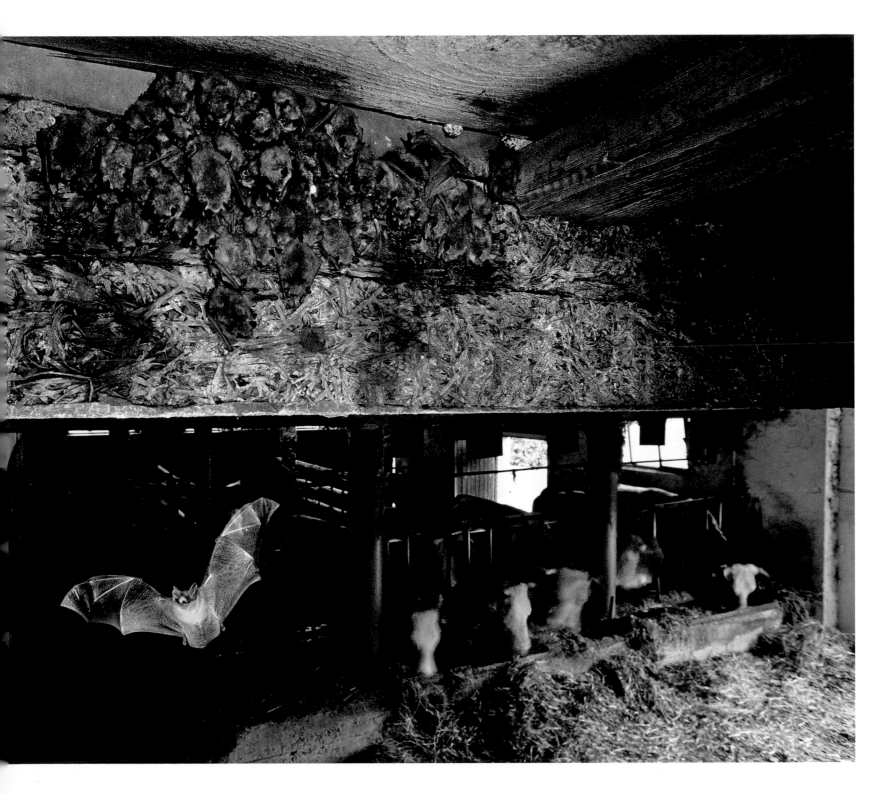

Snake surprise

A cat-eyed snake attempts to swallow a mouthful of red-eyed treefrog eggs, but as it does so, the eggs begin to slide out of its mouth and down the leaf. The leaf overhangs a rainforest pond, and the very action of the predator is causing something amazing to happen. Most of the tadpoles are hatching spontaneously, about to wriggle out of their jelly. Normally they don't hatch until they are six days old, but by four days old they can hatch prematurely if attacked, wriggle their way across the leaf and drop to the water below. It's an amazing strategy. It's also impressive that the moment has been photographed – the result of a combination of fieldwork (the photographer works alongside scientists in the rainforests of Panama), weeks of preparation and the technical knowledge to have had the camera and flashes in exactly the right place at the right time.

Christian Ziegler Germany 2004

Sweet intimacy

This is a story about pollination, how a species of orchid in the cloud forest in Panama has manipulated hummingbirds into carrying its pollen from one flower to another to fertilize its eggs. The picture shows the very act of a magnificent hummingbird depositing tiny bags of purple pollen, seen stuck to its beak as it dips it inside a floret for a drink of nectar. The hummingbird is dependent on energy-rich nectar and so patrols the orchid flowers in its territory, checking for newly open florets. The lighting for the shot was crucial (two flashes for the flower, two for the bird and two for the background), and the photographer then had to wait for two weeks before the hummingbird visited this flower at the right angle and he could trigger the shutter.

Christian Ziegler Germany 2010

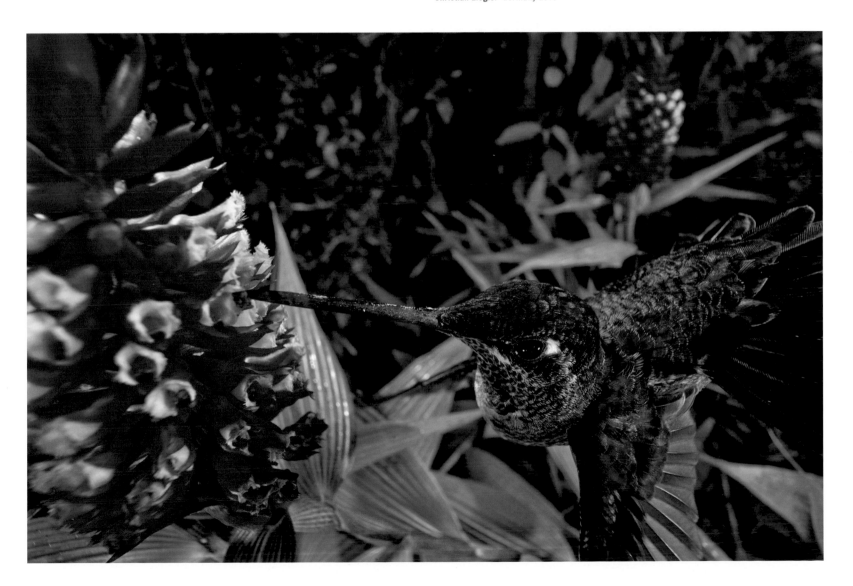

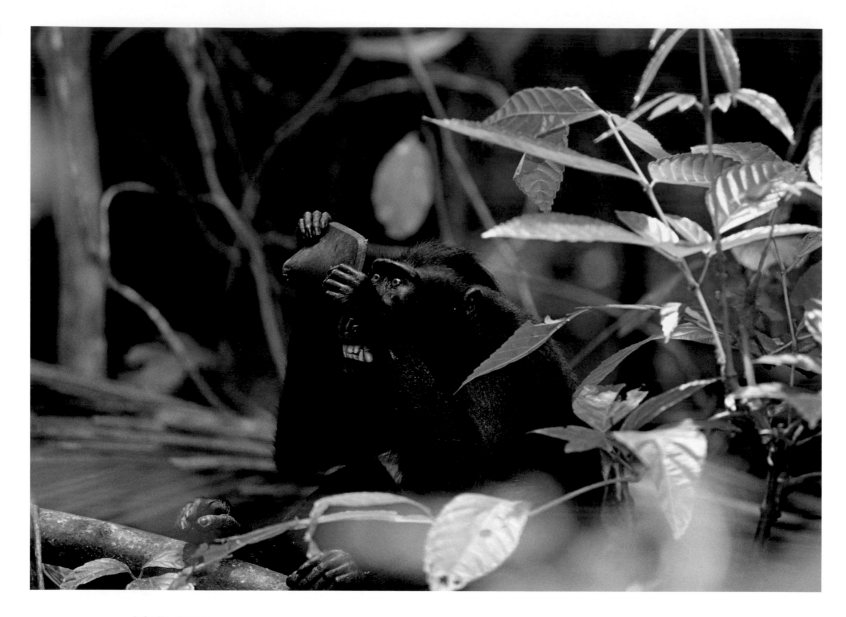

Reflective thoughts

Imagine seeing your reflection for the first time. The macaque's expression says it all.
He is transfixed, the baring of his teeth indicating he's also nervous. The mirror he's
holding indicates a second element to the story. This young male is one of a remnant
population of the critically endangered Celebes crested macaque on the Indonesian
island of Sulawesi. A new road has just been cut through his forest, and a logging
vehicle has lost a wing mirror. A road gives access to hunters as well as loggers, and
since one of the reasons for the decline in macaques is hunting as well as forest loss
and gold mining, the likelihood is that this macaque is no longer alive.

Solvin Zankl Germany 2003

Red squirrel keeps a lookout

This is a carefully constructed, story-telling picture. The message? When people move out, nature moves in – and if you are patient and visit the house at the right time, you might witness the secret activities of the animals that have taken up residence. The location is an abandoned house in a wood in Finland. The red squirrel is living there and has built a drey in the attic, and the photographer has tempted it onto the windowsill with nuts, so he can photograph it against the shredded curtains, looking out into the woods. Of course, the next part of the story of the house in the woods is in the imagination of the viewer, but then that's one of the secrets of good story-telling.

Kai Fagerström Finland 2010

The bat, the boy and the moths

Standing on his bed, the photographer's son watches spellbound as a long-legged myotis bat, mouth open as if communicating with him, flies to the window. The bat is in fact echolocating – using sonar signals to home in on the satin moths attracted to the window by the light. A professor of biology, the photographer uses his images to tell stories about animal behaviour. It took a couple of summers to work out how to shoot this scene at his research cabin in the Montana wilderness. Two remote-controlled flashes were used to illuminate predator and prey without disturbing them and without overpowering the warm glow of the table light. What transformed the scene was the company of his son, who became fascinated by the nightly activities of the bats.

Alex Badyaev USA 2011

Life after rust

This is a picture to read and digest. Dividing it in two is the pillar of a birch tree, thrusting up between the piles of old cars, some dumped as far back as the 1940s. It's symbolic of the plants that are slowly enveloping and cracking apart the rusting hulks in this Swedish car graveyard. To the left, a carcass has become a habitat for wildlife, including a brood of thrushes. To get it all in focus required a wide-angle tilt/shift lens. The lighting was a challenge, needing sunlight to the right and indirect flash to the left, operated remotely so as not to disturb the birds. It took days to get right, and days to catch the final touch – the parent bird landed with a worm in its beak.

Pål Hermansen Norway 2013

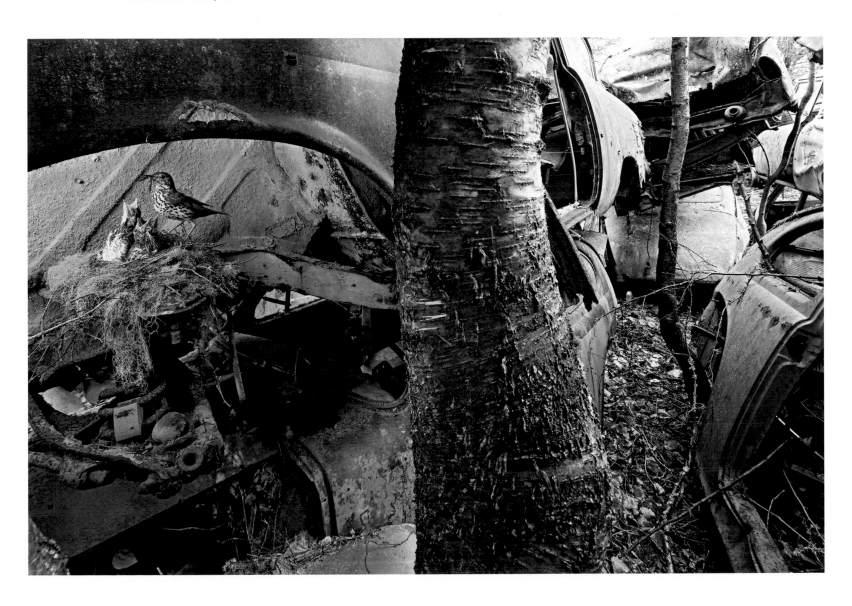

Back to black and white

When the competition launched in 1965, it invited colour transparency entries only. The magazine was being printed partly in colour (as were more and more publications at that time), and it needed more artistic colour images. Colour-slide film was by then available, affordable and seen as the obvious choice for nature photographers. Processing was included in the film cost, and transparencies also offered the chance to do slide shows.

Twelve years went by before a category was created for black and white photographs, with the hope of having entries with the quality of composition that the masters of the art of black and white had achieved in the past. That first year, the winner of the category went on to win the overall award. But there had been comparatively few black and white entries. Most nature photographers, it seemed, had converted to colour, and the skill of processing, including creative dodging and burning to emphasize the tonal qualities, had fallen out of fashion.

There was a revival in interest in the 1990s by a few wildlife and landscape photographers who saw the potential beyond that of photo-reportage – for print sales and exhibition work. But it was only with the advent of digital photography and the development of increasingly creative processing tools that black and white photography of wildlife subjects took off again and finally became a regular feature of the competition.

The perch

This is the first black and white award-winning picture in the competition, featuring one of the most colourful of Eurasian birds. Instead of focusing on the colour of the plumage, the photographer chose the tonal possibilities of black and white and focused on the composition. It's a story-telling pose, the adult offering a minnow or young perch to its fledged young, taken with a fast-speed film to freeze the moment. It's also a pose that the photographer envisaged, requiring an intimate knowledge of his subject to locate the parents' dining perch – an alder branch overhanging a small lake some distance from the nest hole where the young were reared – then setting up a hide, framing the stage, and waiting for the moment.

Fritz Pölking Germany 1977

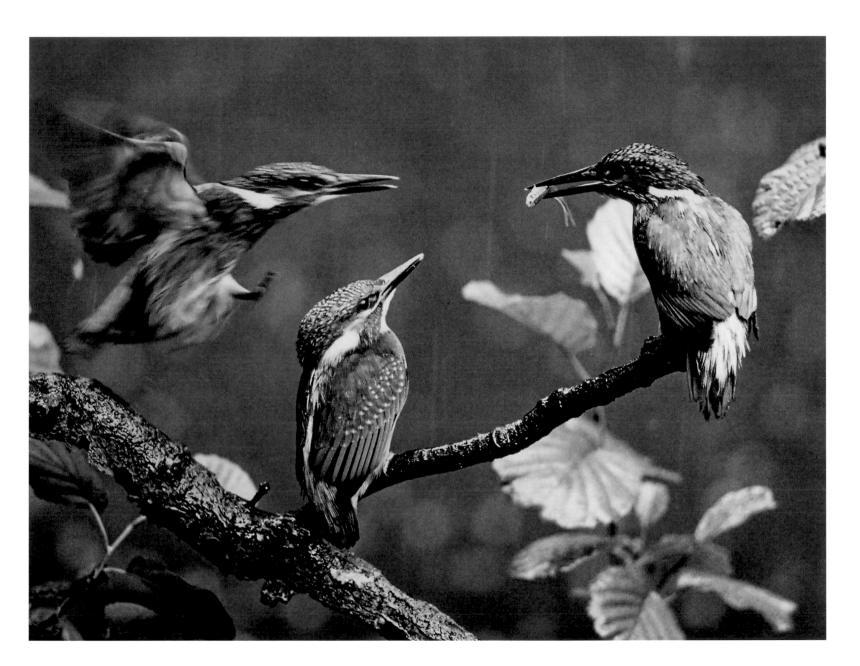

Clash of the bulls

The picture is a toned silver-gelatin handprint – a fitting medium for an archaic scene of the clash between two huge bull elephants, and a scene that could have been witnessed a thousand years ago. It is also a medium that had fallen out of fashion among most nature photographers but which was used to great effect by Martyn Colbeck to create timeless scenes of elephants in Amboseli National Park, Kenya, home to the largest free-ranging population of savannah elephants in Africa. The photographer, who had filmed and photographed these elephants over a number of years, anticipated the dispute and got ready for the charge. Though the light was fading, he used a slow shutter speed to portray a sense of movement and power. The two bulls clashed with a tremendous thud of skulls and clank of ivory. The picture shows the right-hand bull – the loser – bracing himself to avoid being twisted off his feet and speared, just a few seconds before he struggled free, turned and ran.

Martyn Colbeck UK 2005

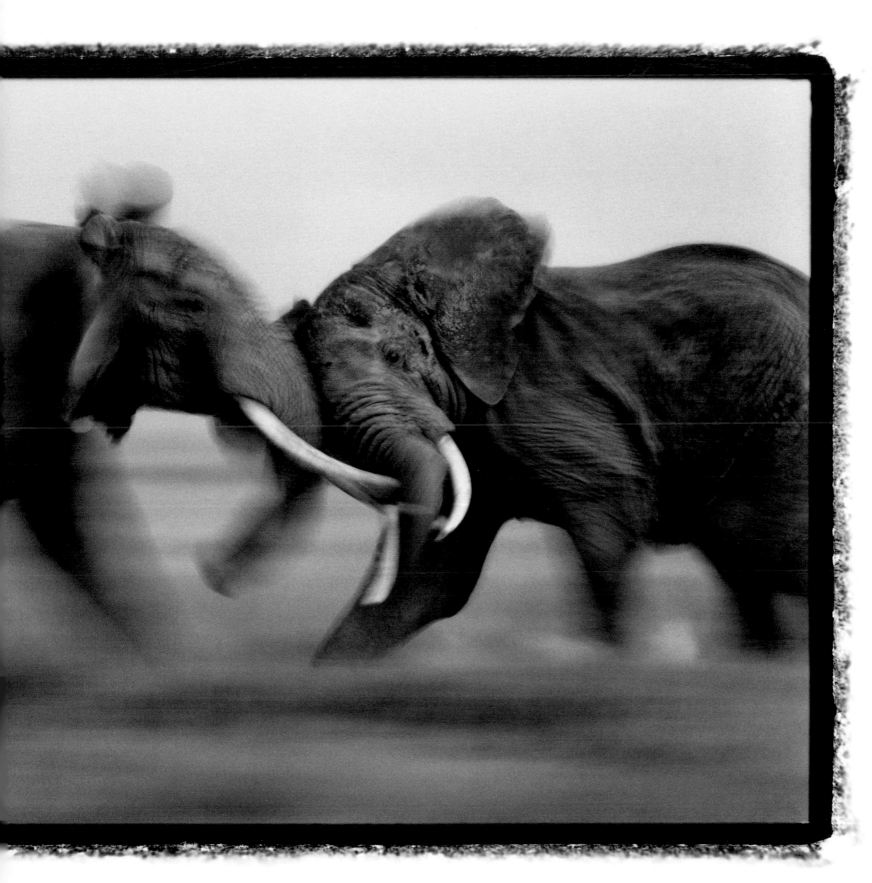

Starling wave

One of the last great wildlife spectacles to be seen in northern Europe is the winter
evening gathering of hundreds of thousands of starlings over their roost sites. Here
the stage is Gretna Green in Scotland, the swooping, swirling flock boosted by huge
numbers of wintering starlings from Scandinavia. It's a dusk event and so, naturally,
a black and white graphic one. The photographer chose the view carefully, with
a large open space of sky to show the extent of the spectacle and a stepped horizon
of trees. Using a slow shutter speed to paint the sweeping movement, he caught the
curve of the flock over the shapes of the trees as a hunting peregrine caused ripples
of panic and a huge wave of movement. Five minutes later the sky was empty, as
the starlings vanished, dropping in unison into the trees with one last whoosh.

Danny Green UK 2009

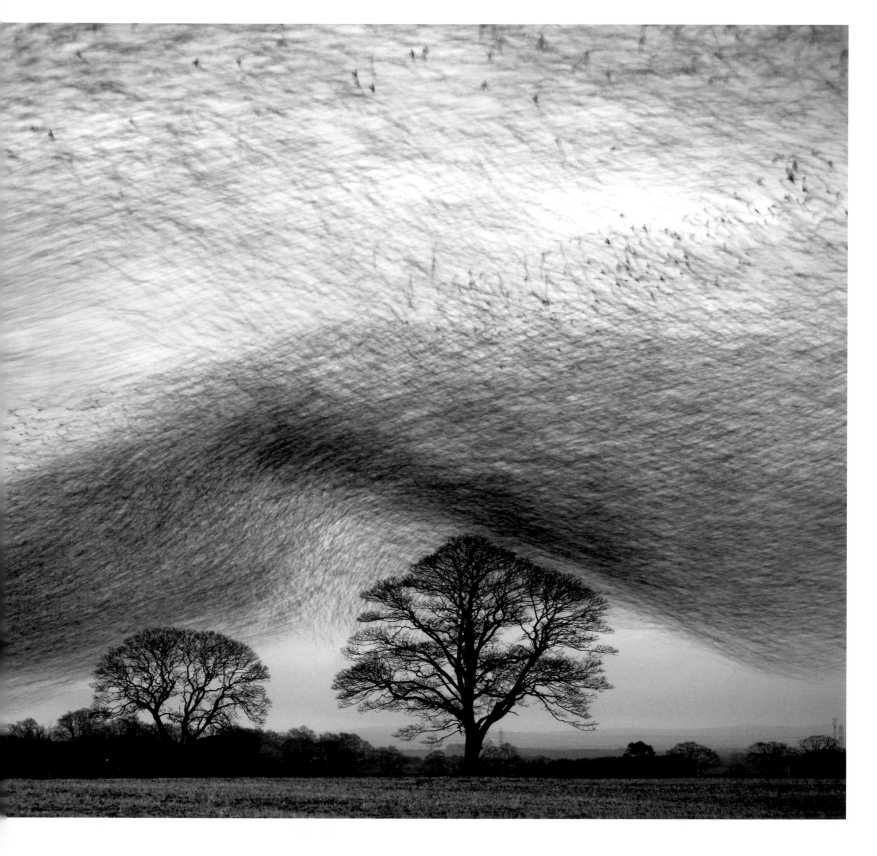

Out of the ashes

A true black and white, printed using traditional black and white film, this is also a truly surreal scene. The stage was the site of a huge bushfire that had just blazed through Ndutu, Tanzania, burning trees to the ground and leaving scorched bodies, smouldering charcoal and ash in its wake. Animals were wandering around disorientated, and smoke was still in the air. As dusk fell, a cheetah appeared, looking unsettled and almost ghostly against the burnt ground. The photographer chose to show it walking out of the picture and used a long exposure to create movement, allowing the grain to show to replicate the alien mood of the scene.

Britta Jaschinski Germany/UK 2010

Ant line

A dry leaf is a surprising choice of subject for a photographer who lives within the rich rainforests of India's Western Ghats. But the shape fascinated him, and the leaf was hanging from a tree on his small farm, which meant he passed it every day. He took several photographs of its abstract form against the sky, but what he wished for was an insect as a counterpoint. He started to watch the leaf in the morning and evening, almost as a meditative act. Four days later, he was watching when an ant ran underneath it, and he got his shot. It seemed meant to be that the insect was an ant, since ants are among his favourite subjects.

Adithya Biloor India 2011

In the flick of a tail

Though the photographer missed the moment of the first flick of the tail, he saw the opportunity – to incorporate in one frame both close-up detail and a representation of the world's tallest animal and to use the giraffe's tail to forge a visual relationship between them. Hand-holding his zoom lens, he waited five minutes for another flick, praying neither animal would move, and got one shot before they walked out of frame – a shot with tonal qualities that made it an obvious conversion to black and white.

David Lloyd New Zealand 2011

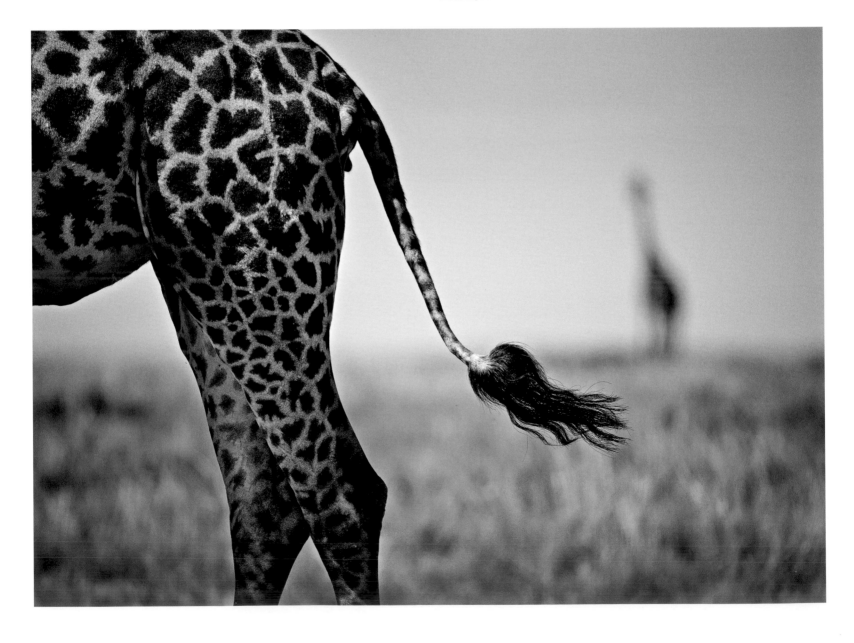

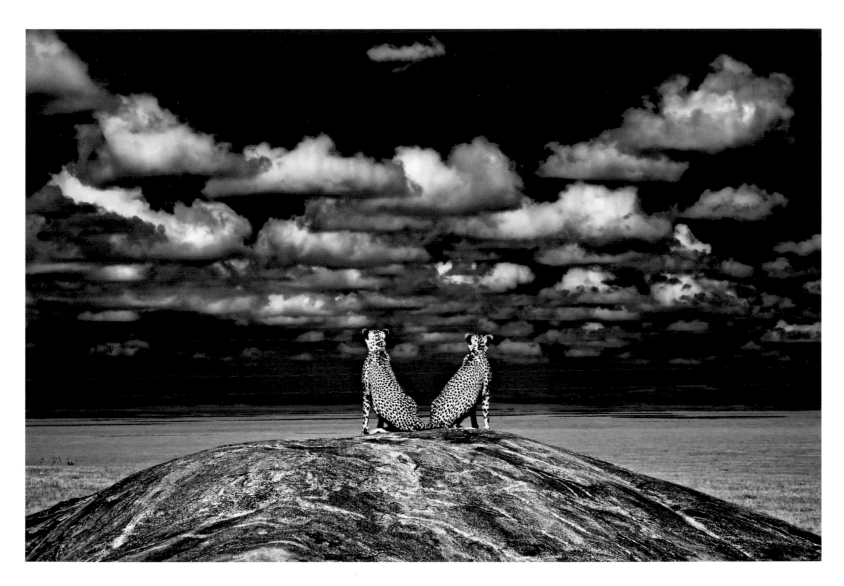

Lookout for lions

The strong contrast in this picture is the result of it having been shot in infrared, which has transformed the azure-blue sky at midday — not normally the best time to take photographs because of the overhead light — into a dark and dramatic background. This highlights the symmetry of clouds, which mirrors the symmetry of the cheetahs, crowned by a small cloud hovering over the central point of the picture. Grass reflects infrared, stone doesn't, which highlights the texture of the kopje on which the cheetahs are sitting. As if under heavenly command, the cheetahs remained posed, watching the lions on the horizon until the shot had been taken and then going straight to sleep.

Charlie Hamilton James UK 2012

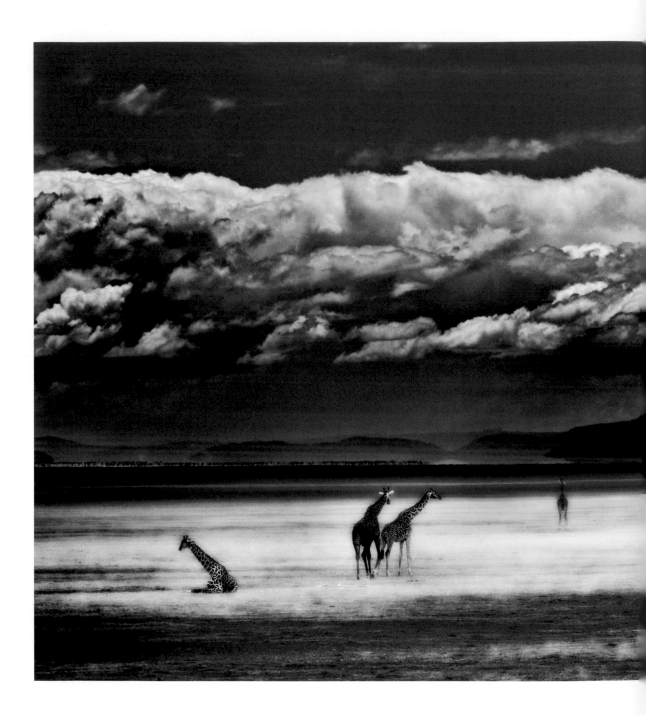

Storm gathering

What the photographer most wanted to achieve with the picture was a sense of the vastness of the African savannah wilderness. Shooting in black and white, to enhance the drama of the sky against the landscape, he tracked the storm rushing up the Great Rift Valley in Tanzania's Lake Manyara National Park. The gift was the conjunction of elements: the line of wildebeest on the horizon, the storm clouds rolling in and the decision of a group of giraffes to stop walking and pose in a flood of sunlight, as if waiting for the storm to break overhead. Panning the camera slightly to take away detail from the foreground, the photographer caught the strange moment of calm before the sky turned black and the heavens opened .

Antonio Busiello Italy 2010

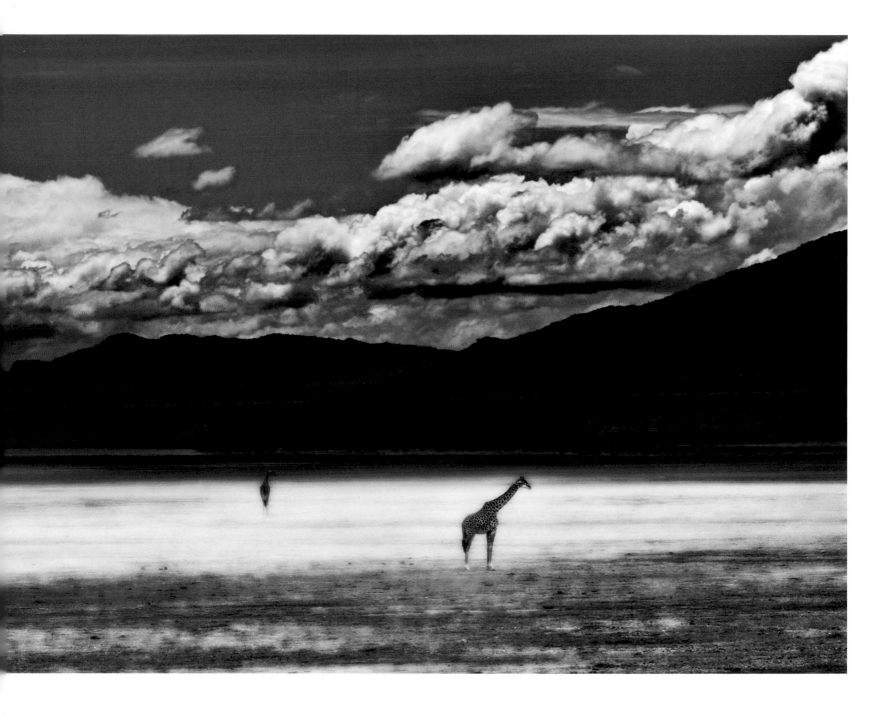

Aerial exposure

It was cinematographers who first demonstrated the power of aerial photography. Aerials highlight patterns in the landscape and patterns of animal movements or aggregations that can't be seen from the ground. They also reveal the scale of damage to an environment. Sometimes the view from the heavens is the only way to show the sheer scale of things.

But aerial photography is dangerous – to shoot from an aircraft requires an open door. It is also both technically and physically challenging because of the movement and vibrations of the aircraft and the buffeting of the wind. It can be prohibitively expensive to hire a plane or helicopter, and many factors, including weather, affect the chances of success – which is why most aerials are taken by photographers on assignment.

One option is to partner with a pilot or to learn to fly and acquire or hire your own plane. But flying solo and trying to shoot at the same time can be even more dangerous and has led to the death of photographers and film-makers. The results of aerial photography do, though, include some of the most memorable pictures and some of the most powerful in their environmental influence.

A river runs red

A simple, stark image of a despoiled landscape. Only by taking an image from the air could the extent of the devastation be made visible. The landscape is that of the central highlands of Madagascar, denuded of vegetation to the extent that the soil is washing into the rivers, turning them red. Shot with a wide-angle lens, the image was taken specifically for its message, and when published in *National Geographic*, it triggered a wave of foreign aid to Madagascar. It remains memorable enough to have impact today.

Frans Lanting USA 1987

Bleakscape

Such a strangely beautiful floorboard design is also as bleak a picture as you
will ever see of the Scottish lowlands. It's what was once the great raised bog
of Letham Moss, now stripped bare. The grooves are drainage channels cut into
the peat, the patterns on the giant boards are the tracks of huge industrial
machines, one of which is loosening and milling the peat, to be sucked up and
bagged for British gardeners to buy. The picture brought home the disturbing
proportions of the destruction, and was part of the campaign to stop further
licenses for peat extraction being granted. But 94 per cent of Britain's raised bogs
have already been destroyed. Though their value – as vital water-filter and
storage units, carbon sinks and refuges for a special wildlife community –
has been realized, and though most are protected by legislation, their drainage
for peat extraction and agriculture continues under existing rights.

Lorne Gill UK 1998

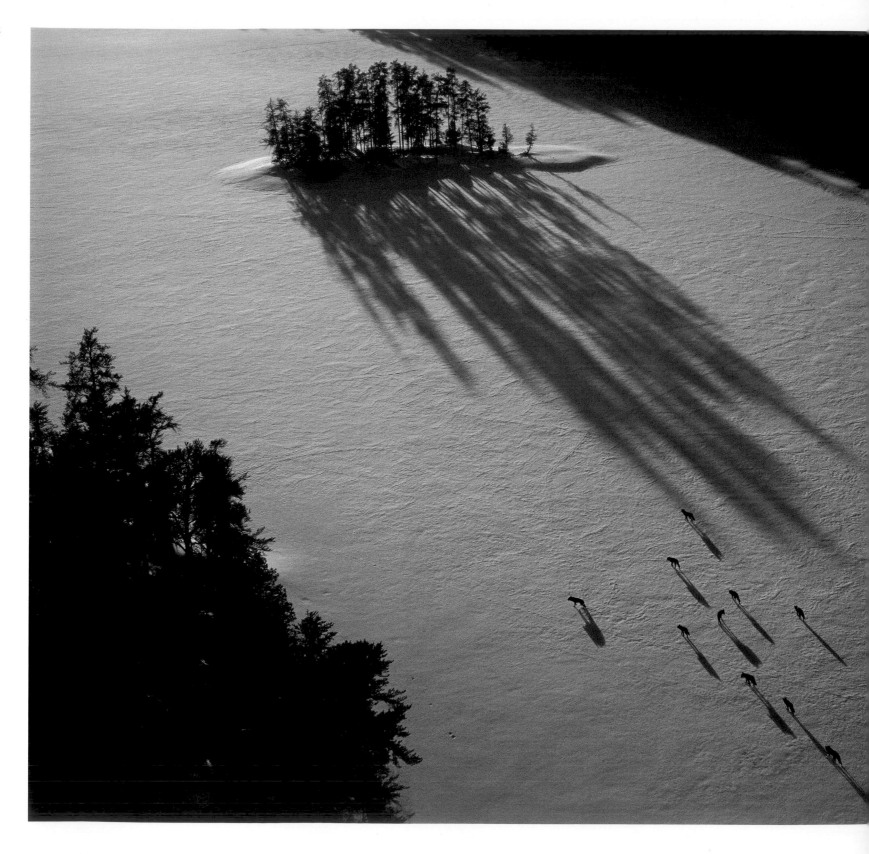

Wolf highway

Long shadows and a pink glow on the snow signify that it's sunset. The wolves, tiny in the vast wild landscape, are setting out for their evening hunt, using the frozen lake as a highway. As they walk they are keeping watch for movement and tracks of potential prey. It's an intimate glimpse, a picture possible only from the sky. That the wolves are totally relaxed, seemingly unaware of the plane above, is because they were used to being tracked from the air as part of a long-term study of wolf numbers in the north woods of Minnesota, USA. Minutes after the shot was taken, the pack leader (left) spotted a beaver and shot off after it into the forest, with the rest in pursuit. In 2001, the year this picture was awarded a prize, a moratorium on wolf hunting and trapping was enacted. In 2013, despite a decreasing wolf population, recreational hunting and trapping of wolves was once more allowed in Minnesota.

Joel Sartore USA 2001

Freezing issues

Flying a plane in the Arctic is both dangerous and risky, partly because the weather can change rapidly and also because the chances of rescue are slim if you do crash. But the rewards are great. On the sixth day of a search over the slowly freezing water of Hudson Bay, this was the scene that the photographer witnessed: a mother polar bear and her twins setting off for their seal-hunting grounds across the great sheets of thin ice, cracked apart by the tide. Flying at height so as not to scare the bears, the wind was intense and focusing was tricky, even with a body pod and a gyro-stabilizer attached to the camera. But having visited Hudson Bay for more than 20 years, the photographer's real concern was how late it was that year for the ice to start freezing. In fact it has frozen later and later almost every autumn, and the ice has melted earlier nearly every spring for the past decade, reducing the length of time the bears have to use the ice for hunting, and pointing to an uncertain future.

Norbert Rosing Germany 2007

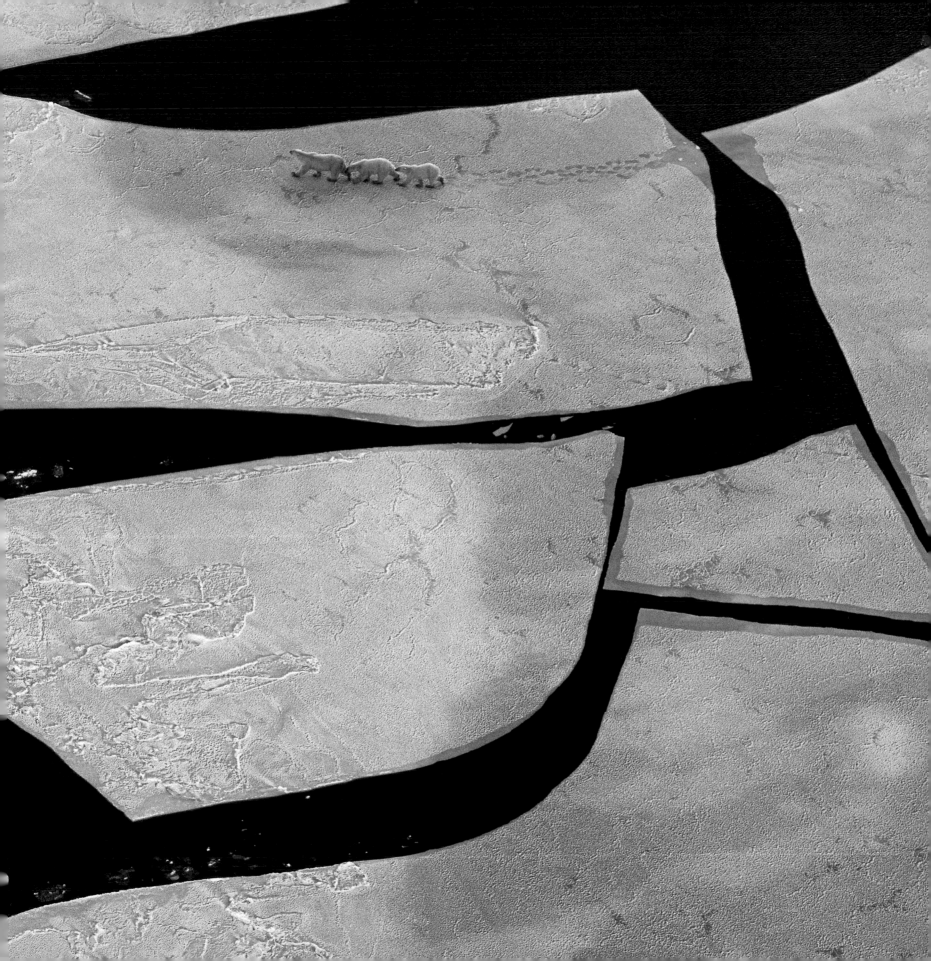

Flight of the rays

No one knows why rays travel together like this – whether to migrate, mate or even herd prey. But it is one reason they are declining, as fishermen can easily net whole populations. From a boat, the ocean can appear to boil, as groups of a shoal fly out of the water, slapping down on the surface. Few people, though, ever witness the spectacle from the air. From his plane, flying over the Sea of Cortez, in Baja California, Mexico, the photographer could see down into the water and grasp the extent of this aggregation of Munk's devil rays – almost as thick as it was wide. The colour of the sea added to the unreality, and the single leaping ray gave both a signature and a sense of movement.

Florian Schultz Germany 2010

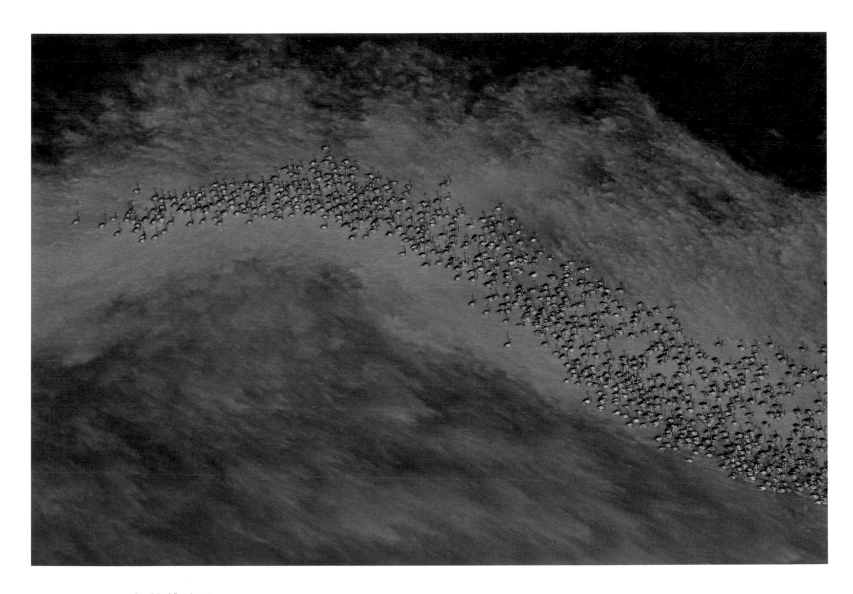

A swirl of flamingos

In winter, thousands of Caribbean flamingos congregate in their full orange-pink breeding plumage to feed on the microscopic life in the shallow, briny water of the Ría Celestún on Mexico's Yucatán peninsula. When shown from above, an aggregation becomes a great swirl, curving with the flow of the water down to the coast. What the photographer wanted to show was the birds as part of their estuary environment, but as the plane made tight circles high over the flock, framing the picture was a challenge, as was holding his lens steady, relying on its image stabilizer to overcome the vibrations. The result, though, was a winner.

Klaus Nigge Germany 2012

Breathtaking

As soon as he took the shot, the photographer knew he had something special.
It was one he had dreamed about taking: a composition of narwhals in sea ice,
but more than that – a picture of fascinating beauty. To achieve it required the
development of an obsession. It also necessitated buying an ultralight plane on
floats, convincing a friend to pilot it and shipping the plane within Canada to Arctic
Bay off Baffin Island. It took six weeks and a series of disasters before the moment
when he saw the composition: a group of males taking a breath within a teardrop
area of water surrounded by a pattern of melting ice. As the plane pulled back up,
he framed the shot, just close enough to show the bullet scars on the backs of
the narwhals, a reminder that these whales are hunted with guns.

Paul Nicklen Canada 2007

The last cut

This single image encapsulates the story of the rape of Asian rainforests, to provide palm oil for the West. At its centre is the skeleton of a huge tree, a relic of the rainforest that once covered this part of Kalimantan, Indonesia, on the island of Borneo. Only by flying over the area was this picture possible, taken on assignment for Greenpeace, as only an aerial shot could sum up the devastation. The green shoots are of newly planted oil palms, which will grow on the thin soil until the nutrients are depleted and the land is abandoned. It's a story that is being repeated throughout the region as the demand grows for palm oil, now used in half of all consumer goods.

Daniel Beltrá Spain/USA 2010

Oil spoils

This is just one small section of one of six huge tar-sand mines in Alberta, an ugly scene with a strange beauty – both reportage and art. Only with an aerial shot was it possible to show the landscape-scale devastation of wildlands caused by these vast mining works and the toxic lakes created in the process of extracting bitumen – a heavy, viscous oil, which is being piped across Canada for export. For the photographer to capture the composition he wanted, the pilot had to make multiple passes of the open-pit mine. The result was a photograph to make us gasp at the scale of this most environmentally costly form of oil production.

Garth Lenz Canada 2013

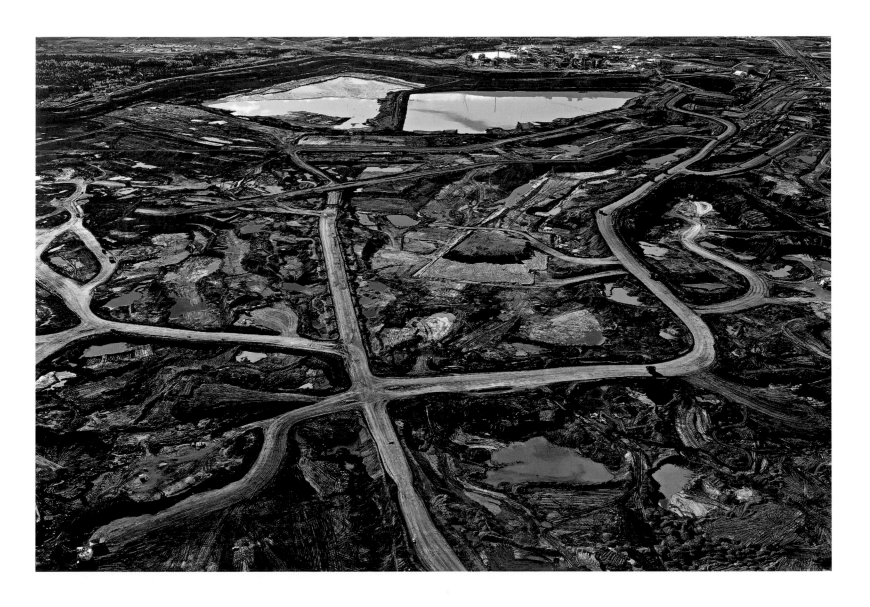

The underwater revolution

Photography under water differs radically from land photography. It requires a different set of skills and equipment and can be both dangerous and expensive. But it can also be hugely rewarding and highly creative, as underwater environments are still largely unrecorded and unexplored and offer the most beautiful of scenes.

In this alien environment, the use of breathing apparatus limits what time there is to take pictures. Also, because light is absorbed by water, it's necessary to get close to a subject to photograph it. On top of that, seawater absorbs red, orange and yellow, leaving everything with a bluish-green tinge and reduced contrast, and so artificial light is needed in all but the shallowest of water. But as seawater is full of tiny particles that scatter the light and create a haze, any external light requires careful positioning. There is also a world of new species and interaction between them to become familiar with. So it's not surprising that photography under water has had a slow start.

Its history is full of inventors – finding new ways to take camera equipment under water, developing housings as much as special cameras, and new ways to light underwater subjects. But until the invention of the modern aqualung, in the 1940s, and the arrival of Kodak fast-colour film, there were very few underwater nature photographers. Even then most images were record shots. One of the first photographers to go beyond record shooting was David Doubilet, who pioneered the split-field technique – creating a sense of place under the water by simultaneously showing the above-water scene – as well as the artistry of painting colour with strobe lighting to create drama and depth.

It was digital photography, though, that brought real change, enabling photographers to capture movement and more detail and, most important, increasing vastly the number of frames that could be shot on any one dive. A photographer no longer had to surface to change a 36-frame film. Now a memory card could store many more images. But the first digital cameras were hugely expensive, and the breakthrough was as much to do with the development of affordable housings as with the digital cameras themselves. As the price of equipment fell (though a housing can still cost more than a camera), the take-up of digital photography increased, and in 2004, Doug Perrine became the first Wildlife Photographer of the Year to win the award with a digital image (see page 212). Today, the potential for new and unforgettable images from the relatively unexplored underwater environment remains even greater than it is on land.

Sky, sea and stingrays

This was an underwater image that created a stir. It was both creatively beautiful and surprising, combining the world of air and the magical world of water with an original split-level view. What made it memorable was not only the gracefulness of the strange-looking stingrays gliding over the sand but also the play of the sunlight, painting ripples from the water's surface onto the wave-raked sand. That such an image was possible was due in part to the fishermen of Grand Cayman in the Cayman Islands, who had started to feed the gentle stingrays, attracting them to the shallows. But it was the photographer who saw the potential and had the ingenuity to use a split-focus diopter filter as part of his underwater kit to create the image.

David Doubilet USA 1989

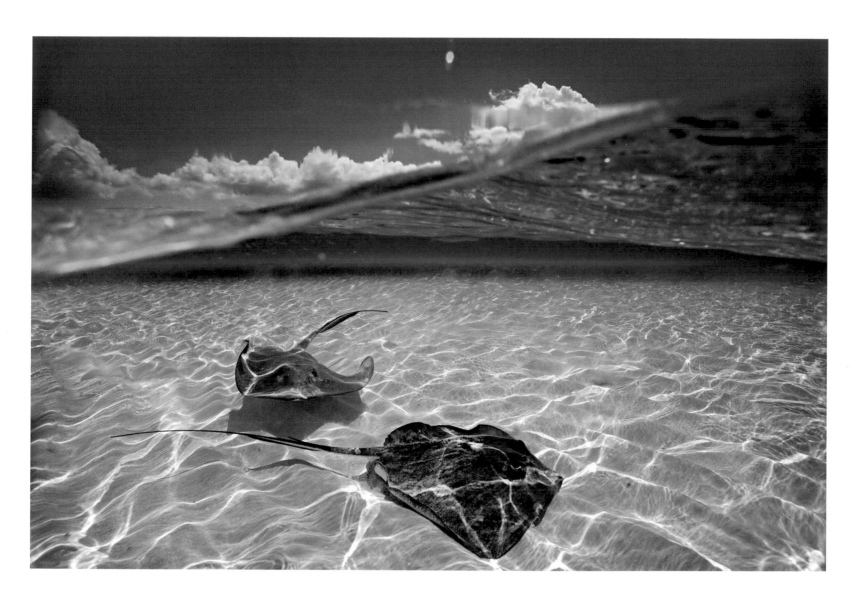

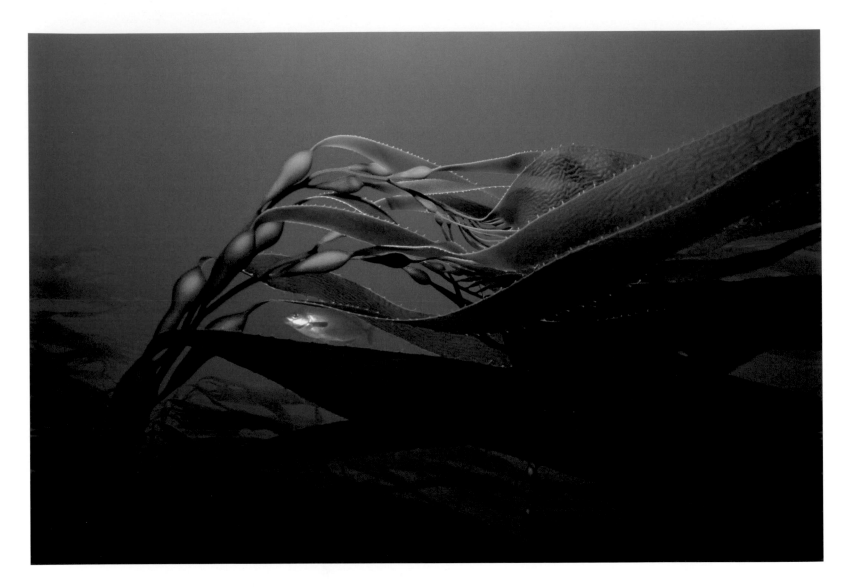

Kelp with blue moki

Throughout his diving career, the photographer has been fascinated by kelp – the way
it moves, how it grows and the life it supports in the deep cold waters off New Zealand.
He wanted his picture to show the beauty and the mystery of an underwater forest,
the fronds dancing in the current, and the beauty of the fish that swim through it.
The current was so strong that staying still enough to compose the ideal picture was
almost impossible, but in the end he managed to frame a shot showing a blue moki
glimpsed through the six-metre-tall (20-foot) bull kelp, using a single strobe to give
colour to the scene and light the fronds to reveal their strange tracery and flexible form.

Kim Westerskov New Zealand 1987

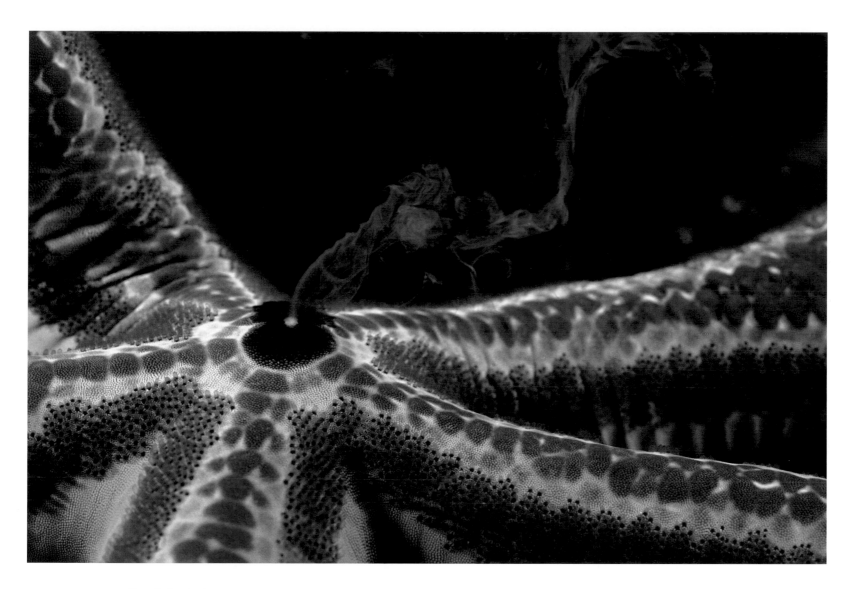

From the bowels of a seastar

It was the puffs of milky fluid exiting from the tan seastar that caught his attention.
Rather than frame the whole animal, Doug chose a graphic composition focusing
on the central point of the starfish — its anus. He was diving in a fairly heavy sea in
the Galapagos, and so it was a challenge to get into position and catch one of the
puffs. At 15 metres (nearly 50 feet) down, there was also little natural light, and it
was only in the instant of the flash that the brilliant colours became visible. Later he
realized the exhalation was a blowout of the digested remains of the animal's last
meal, making this the first and only prize-winning shot of an excreting starfish.

Doug Perrine USA 1995

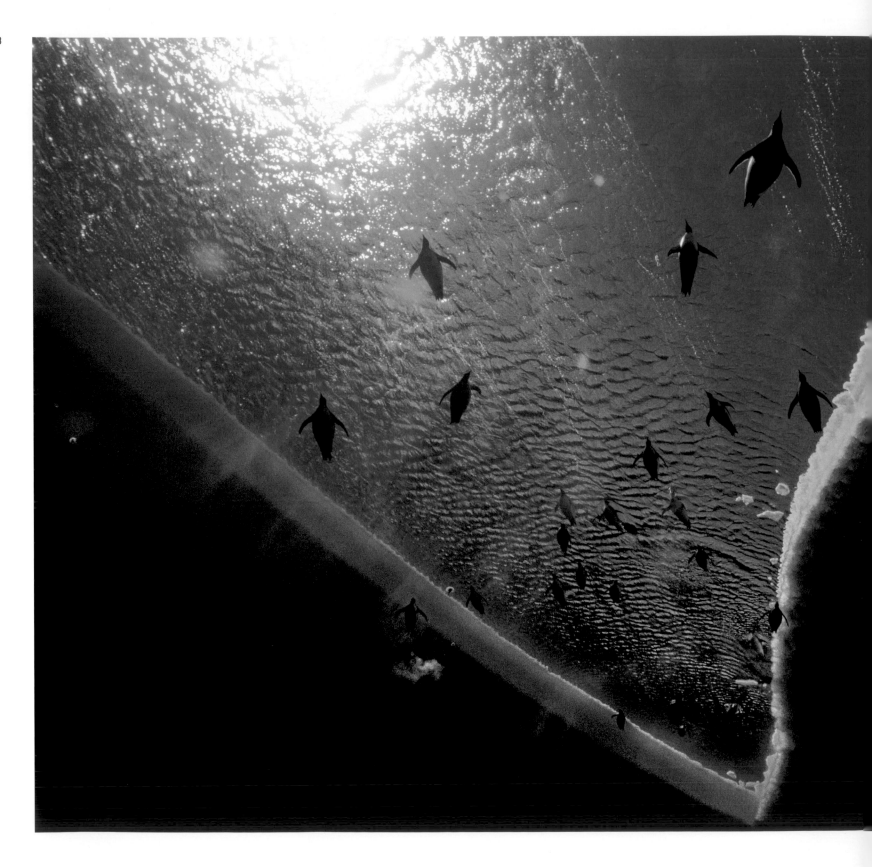

Emperors in their element

The expense of getting to Antarctica, the technological difficulties of diving there and the risks of going under the ice meant that until a decade or so ago few pictures had been taken of life below the surface and even fewer of any artistic merit. Here, the split in the ice not only provides a dramatic frame but also a diagonal lead-in that helps to create the sense of movement as a squadron of emperor penguins shoots off to hunt for fish. They exit in groups for safety, their greatest fear being the leopard seals that lurk beneath the ice, much as the photographer was doing, trying to catch an image of them in their element, flying through the water.

Norbert Wu USA 2001

Shy hamlet romance

Courtship among reef fish is rarely observed, partly as it tends to happen at dusk. But the photographer set out specifically to portray the intimate nuptials of shy hamlets, off Grand Cayman in the Caribbean. Floating motionless so not to disturb the pair, he watched them embrace, the female head down, ready to extrude eggs from her vent. Side-lighting them on low power, he caught the moment the male caressed her, his pectoral fins creating a current to draw the eggs between them to be fertilized. Shortly after, the two swapped roles, and genders, and the caresses began again. Over 20 minutes, the pair swapped sexes six times – a mating strategy as exotic as their colours.

Alexander Mustard UK 2005

Beluga watch

Light from above gently illuminates these
pure white belugas as they look up at the
photographer swimming on the surface above
them. The picture is one of the first showing
wild belugas under water, taken by
a photographer at home in polar seas.
The location was the edge of the sea ice off
northern Baffin Island in the Canadian Arctic,
where there is a short period of good underwater
visibility in June before the plankton bloom
and melting ice make the water murky.
The photographer decided that he had the
greatest chance of being close to the whales
if he avoided noisy scuba equipment and just
used a snorkel. Knowing that these highly vocal
whales are nervous of polar-bear-sized animals
but also exceptionally curious, he guessed they
wouldn't be able to resist investigating the
sound of him singing Happy Birthday into his
mouthpiece. It was an icy gamble that paid off.

Doug Allan UK 2002

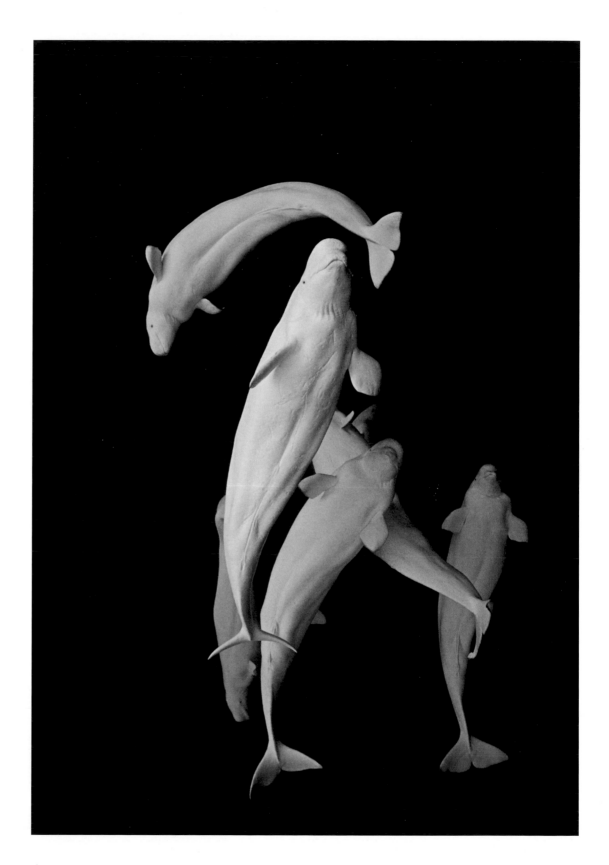

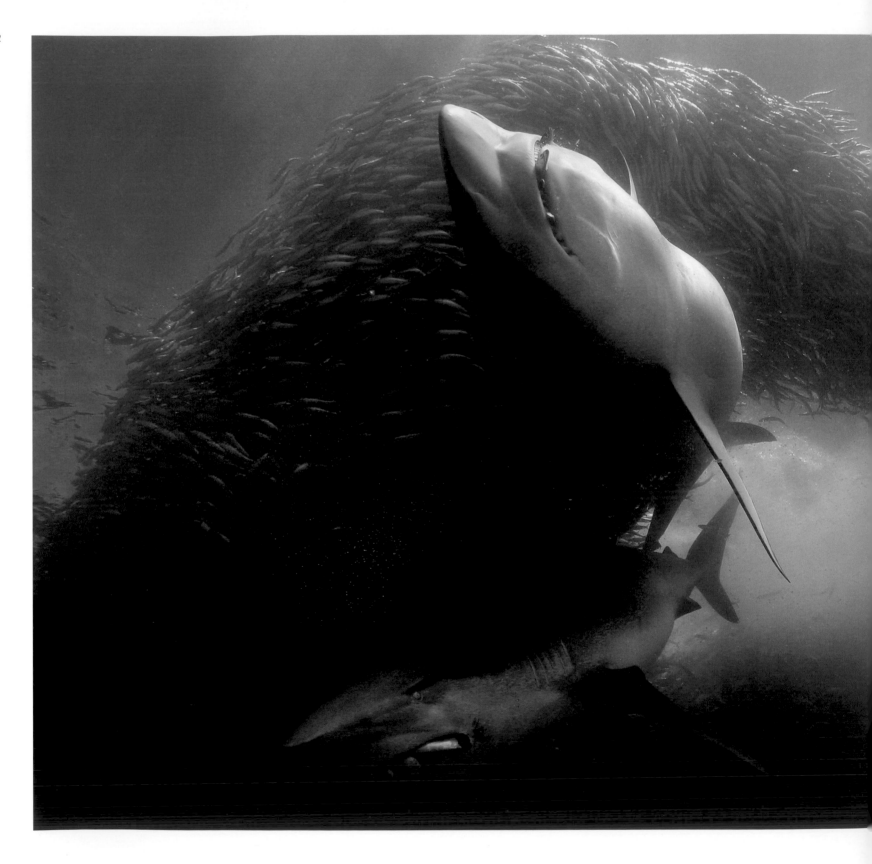

Charging sharks, swirling baitball

The first-ever underwater digital award-winner and one of the earliest digital underwater entries is a moment of pure drama. It captures the second that two bronze whalers, their mouths stuffed with fish, burst out of the swirling mass of sardines. Hundreds of sharks were attacking from all sides, and it was only possible to grab shots in between being butted by the highly charged sharks, confused by the electrical discharges from his strobes. The predator feeding frenzy that accompanies the annual sardine migration off the east coast of South Africa is an event now much photographed, but in 2004, it was still little known. Doug was using the first affordable professional digital SLR, with just a six-megapixel sensor, and so to freeze the action required great skill, with artistry displayed in the final choice of frame.

Doug Perrine USA 2004

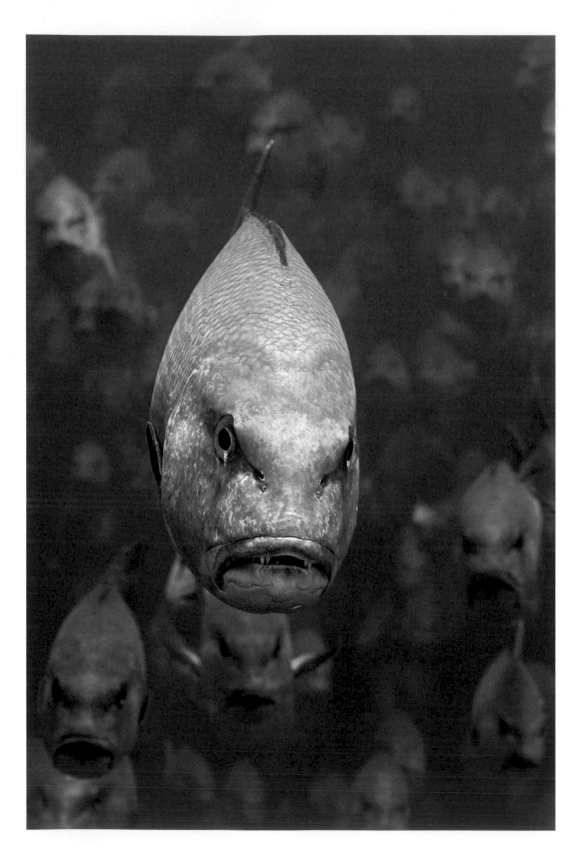

Snapper shot

Fish have character, if you look for it. Bohar snappers certainly do. In the Red Sea, they are one of the larger reef predators. What the photographer chose to do in a simple but highly effective way, with a vertical portrait, was give an impression of both their boldness and the almost menacing scale of their great courtship gatherings in preparation for their mass spawning. To pick out the single fish against a background of faces, the photographer used a novel approach at the time – two flashes extended on arms in front of the camera, allowing the use of a longer lens than normal for such a shot. But though the eye-to-eye portrait gives a sense of their predatory nature, it's the snappers themselves which are in danger. When they shoal, it is easy to catch huge numbers of them, often before they have had a chance to spawn.

Alexander Mustard UK 2005

Underworld

This otherworldly picture was taken in the shallow waters off New Zealand's Fiordland. Here tannin-stained surface water blocks out sunlight and tricks deep-water animals such as these sea pens (soft corals) into settling at shallower depths. Careful use of strobes on reduced power has illuminated the sentinel-like sea pens, their fans outstretched filtering microorganisms from the water, the blue cod seeming to stroll through them towards some great underwater gathering. The sea-bottom angle makes the picture all the more intriguing, as if the opening chapter to a story — which perhaps it is, as the government has protected the area as a marine reserve.

Brian Skerry USA 2008

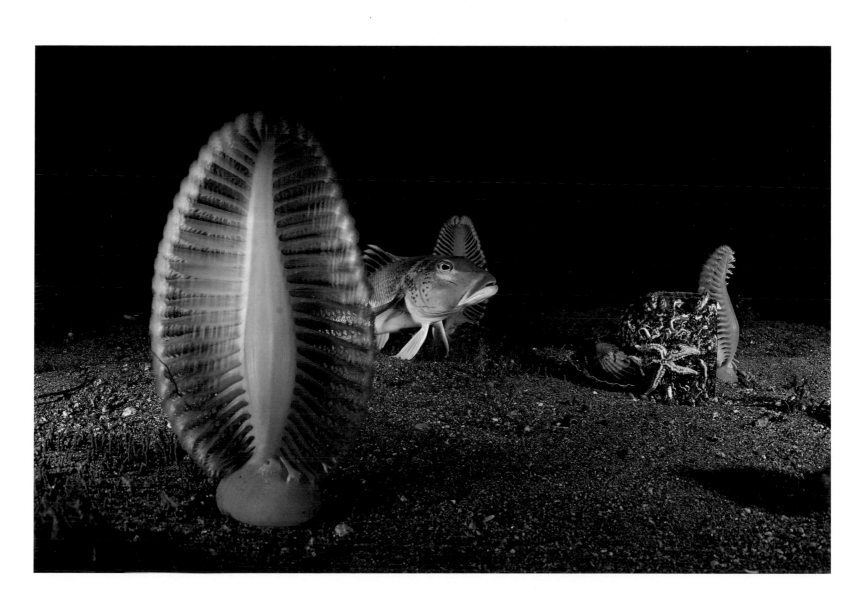

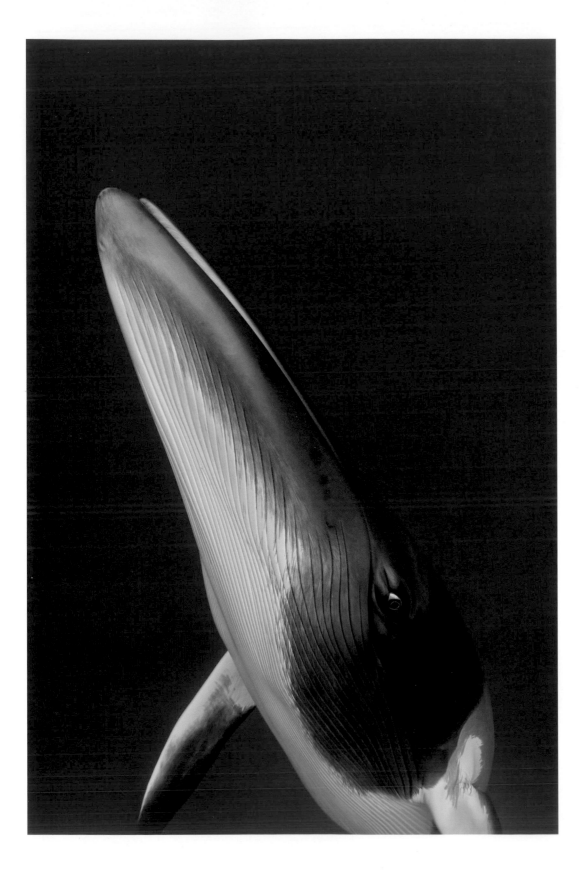

Eye of the minke

Clear, calm tropical-blue water off the northern end of Australia's Great Barrier Reef and several hours hanging on a line off a drifting boat enabled the photographer to take this unusual vertical portrait of an inquisitive dwarf minke. The clarity of the image, emphasized by the eye of the whale, makes it almost sculptural. Though it's a dwarf (a subspecies of the larger, northern-hemisphere minke), it's still nearly seven metres (23 feet) long and so longer than the photographer, who was hanging next to it in snorkelling gear. As fascinated by the human as he was by her, the whale pirouetted while keeping eye contact, displaying her distinctive and individual markings — colour patterns that enable researchers to identify the individuals that winter off Queensland.

Jürgen Freund Germany 2007

Daddy-long-legs

For curious photographers, the marine world offers a never-ending variety of strange
creatures and intriguing behaviour. Here the discovery was a pair of bizarre arrow
crabs off the southern coast of Gran Canaria in the Canary Islands. The male was
guarding a female, her maturing eggs slung below her. They were backed up by
the defence of proximity to a pair of spiny sea urchins. With such a pose and a
backdrop of blue sea studded with a sparkling shoal of silverfish, it made both
an unforgettable portrait and a fascinating bit of reportage of the behaviour of
an animal few of us will ever seen in its underwater environment.

Jordi Chias Spain 2008

First encounter

It's seldom that you see a whale and a human face to face in the marine environment and can appreciate the insignificance of the one and the scale of the other – here 70 tonnes of southern right whale, 14 metres (46 feet) long. The sheer bulk of the animal is what the photographer wanted to show when he asked his dive buddy to sink to the sandy bottom, 22 metres (72 feet) down in the clear water off the Auckland Islands, hoping that the little human would soon attract a curious whale. These subantarctic waters, far south of New Zealand, are where southern right whales come to feed, but few people have observed them under water or had such an encounter – the photographer's most memorable, ever.

Brian Skerry USA 2008

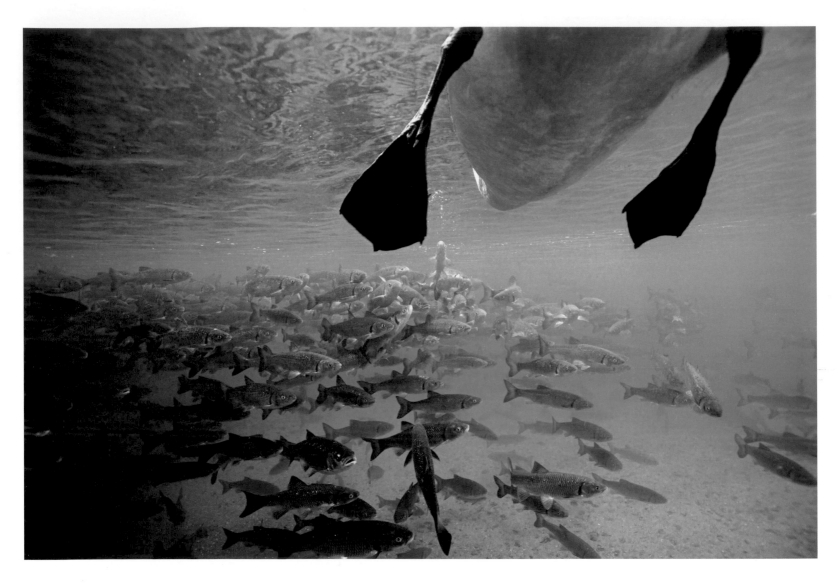

Bottom view

The unexpectedness of the viewpoint and the breakout through the frame has transformed what started as a contemplative scene into a dynamic glimpse of life below the surface. The photographer had set out to take a picture of a mass gathering of fish wintering upstream in the shallows of the River Rhine, but his visualization hadn't included a swan's bottom. When he lowered the camera into the river, the conditions were perfect — still water, a shoal of chub, sunlight filtering down to create a palette of freshwater greens — until a child started throwing bread for the swans. Frustration turned to concentration as he realized the opportunity, grabbed it and framed it.

Michel Roggo Switzerland 2010

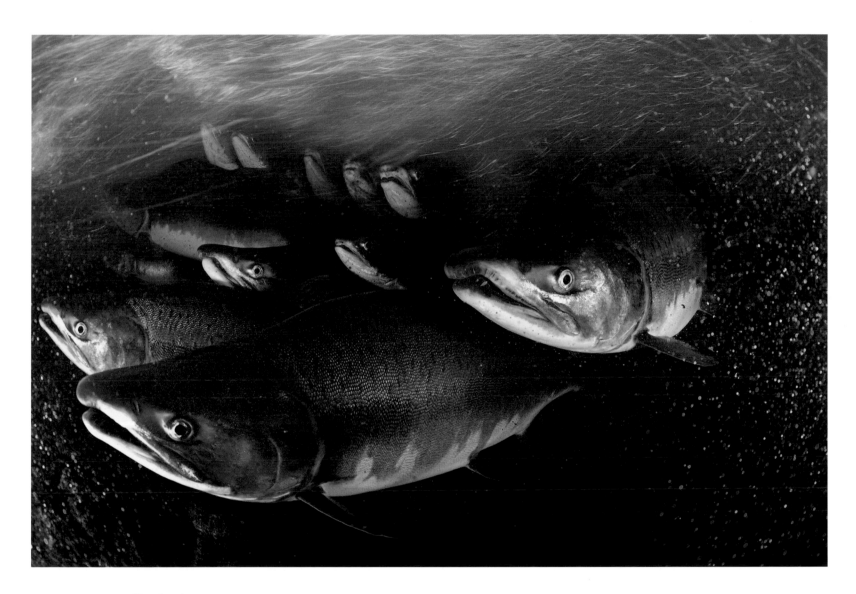

The salmon jam

There is power, movement and a sense of anxiety in this picture. The salmon are holding still against the fast-flowing water in a dark, swirling pool waiting for the right moment to power out and up the waterfall. They are united by golden light – part artificial, part natural – and their drive to get to their spawning grounds, up in the Great Bear Rainforest, in British Columbia, Canada. The photographer crouched alongside the fish for three hours, trying to compose a picture that would portray some of their power and beauty. The salmon are a vital part of the forest ecosystem, returning here to die and in the process providing a feast for other animals, which in turn leave the salmon remains in the forest, fertilizing the trees.

Thomas P Peschak Germany/South Africa 2011

Bubble-jetting emperors

Dynamism, detail and depth — it's a picture that has it all. It was also an extraordinary under-the-ice event to have witnessed, the speed of which would not have been possible to capture in such detail just a few years earlier. But though technology enabled the detail, planning, instinct and sheer determination caught the moment. With just a snorkel so he could lie motionless and not spook the penguins (on the lookout for lurking leopard seals), the photographer hooked himself under the lip of an ice hole at the edge of the frozen Ross Sea, Antarctica, and waited for the moment the emperor penguins would blast to the surface. The light was amazing, but the jet-streams of bubbles and the slush scattered it around and made the exposure almost impossible to get right. The numbing cold also meant the photographer was working almost by instinct. When an explosion happened, every hour or two, hundreds of the huge birds would rocket up and out of the ice hole in a seemingly chaotic mass. It was this chaos of bodies frozen in postures of aquadynamic grace that creates the fascination of this award-winning picture.

Paul Nicklen Canada 2012

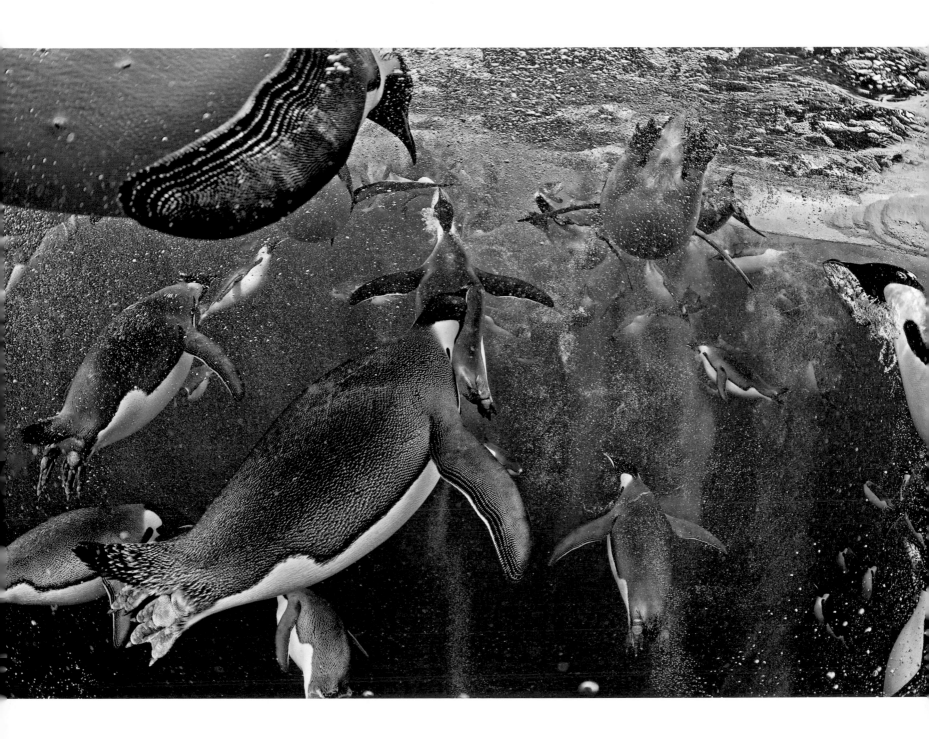

The passion of youth

It wasn't until 1981 that young photographers were given their own categories in the new Young Wildlife Photographer of the Year competition, with its own grand award. Though there were a couple of years – 1970 and 1971 – when prizes were offered for photographers aged 17 or under, there were very few entries. That was probably because lenses powerful enough to photograph wild animals were expensive, and the cameras that youngsters could afford or were given limited them to photographing either plants or stationary animals relatively close up or in zoos. To take pictures of wild animals also meant being an exceptionally good naturalist.

But there have always been keen young naturalists, and the launch in 1981 of the competition for young people coincided with the availability of more affordable equipment and the boom in wildlife tv programmes. Winning has meant not only prize money, publication and kudos but also an invitation to the awards ceremony, giving young photographers the chance meet those at the top of their profession as well as famous and prestigious presenters in the wildlife world. Winning or being placed in the competition has therefore been a major inspiration. Indeed, many of the young winners from the 1980s – Bruce Davidson, David Breed, Torsten Brehm, Ross Hoddinot, Charlie Hamilton James, Tim Martin and Warwick Sloss, to name but a few – have gone on to develop careers in wildlife photography or film-making.

To add an extra level of encouragement, the Eric Hosking Award was launched in 1990 for a portfolio of work from a photographer aged between 18 and 26. It was named after one of the UK's most famous wildlife photographers and lifetime supporter of the competition, and its aim was to give both financial and promotional backing to photographers just setting out on a career. Award-winners have included those who are now well-known names in the world of wildlife photography. Fifty years on, it would seem that that the Wildlife Photographer of the Year competition has fulfilled one of its original aims: to inspire a new generation of photographic artists.

A raft of otters

A passion for otters eventually led this young photographer, then aged 16, to Shetland, Scotland, where he spent his summer holiday tracking them. He watched a mother and her three cubs every day for three weeks. This picture was taken halfway up a cliff, looking down on the bay, his lens resting on a rock. Though he remained motionless, crouching in a rain cape, the mother – here looking straight at the camera – still sensed his presence. It's a picture resulting from determination and fieldcraft, which won him the Young Wildlife Photographer of the Year Award – for the second year running.

Charlie Hamilton James UK 1991

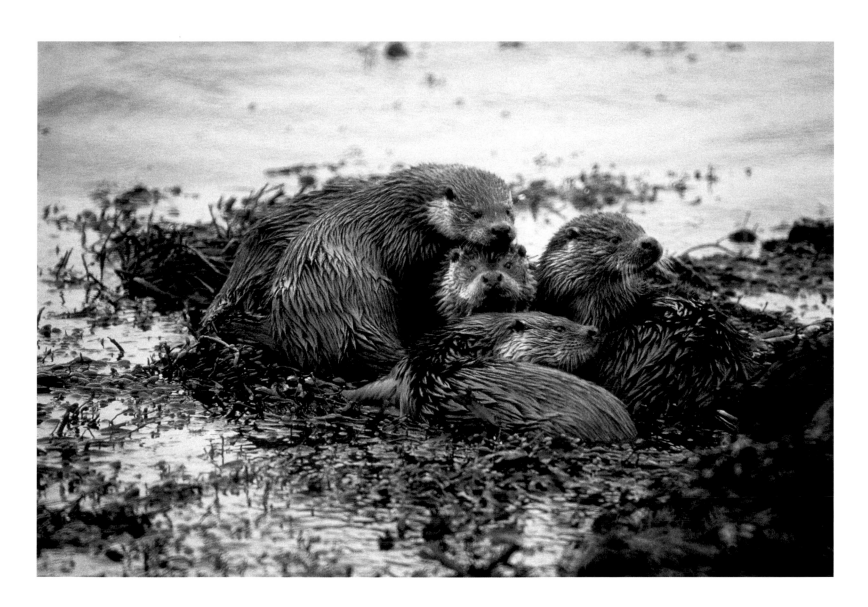

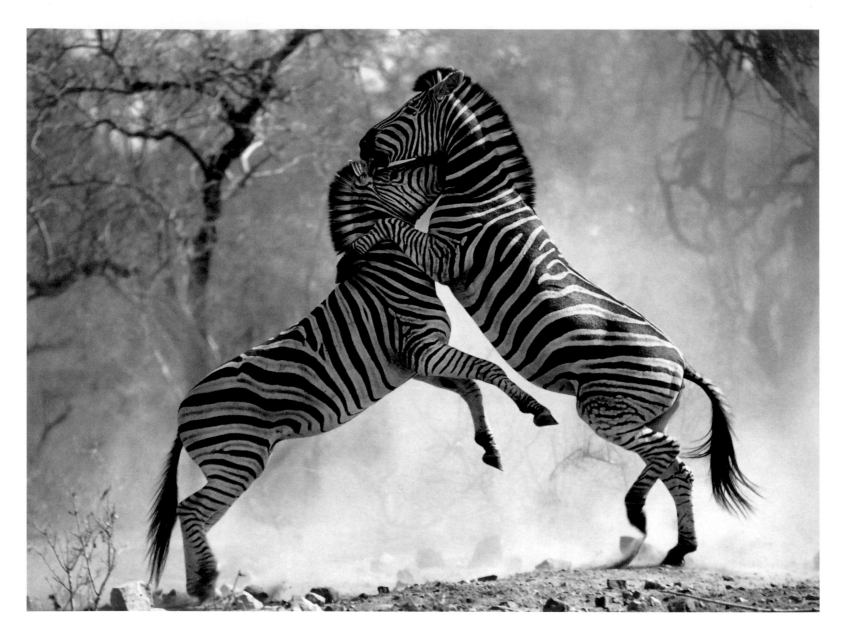

Clashing stallions

For this young photographer, the award-winner in 1996, the South African setting of Kruger National Park was effectively his local patch. The picture was taken from a car – acting as a hide – of two unequally matched stallions just when one was about to topple the other. Anticipating what would happen, he was ready for the moment and had framed and focused on the scene. It remains a classic shot of behaviour that many have photographed but few have done so well.

Nick Wilton South Africa 1996

Pool chaffinch

At 14, the photographer won the Young Wildlife Photographer of the Year Award with this poolside portrait. He had dug the pond the year before to attract subjects to photograph near to his home in Hungary. But he wanted more than just wildlife pictures – he wanted beautiful wildlife pictures. So he made sure that the pond-side against which he would shoot his subjects was attractive, adding an old boot for interest. After just six months he had counted 41 bird species coming to drink. From a simple hide where he could lie at eye-level, he watched the visitors. Here, perfectly reflected in the still water, a chaffinch pauses after having taken a sip of water.

Bence Máté Hungary 2002

Snowstorm cranes

Japanese cranes flying in a snowstorm – a picture that the photographer had dreamt of taking. In love with both snow and cranes, and having studied the work of Japanese artists, he travelled to Hokkaido, Japan – his first trip after deciding to become a professional wildlife photographer, spurred on by winning the Eric Hosking Award twice in a row. He waited eight days with the cranes at a feeding site in the east of the island before the scene materialized. More than 40cm (15 inches) of snow fell that day, and it was still snowing when the cranes, a family of three, set off for their evening roost, the pure white of their wings stark against the snow. The picture was one of a portfolio that for the third year running won him the Eric Hosking Award.

Vincent Munier France 2002

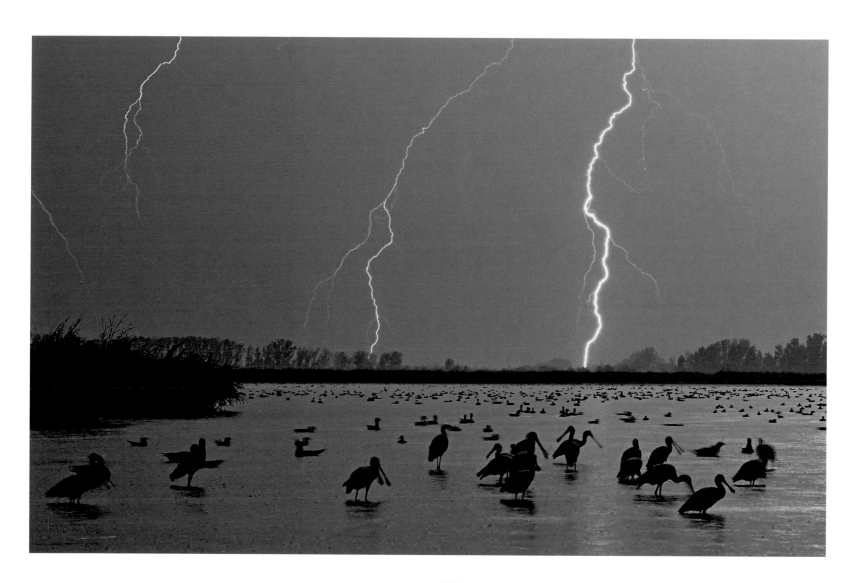

Lightning birds

Lightning is unpredictable, but that didn't stop the photographer planning to use it as the drama for his picture. He built his hide at the edge of Lake Csaj, in Kiskunság National Park, Hungary, to give him an eye-level view across the water where the waterbirds gathered to roost, and he planned for the lightning by monitoring storm patterns on the internet. The flashes were usually too high or out of the frame, but on this day they forked right in front of him, captured in a half-minute exposure. The spoonbills, ducks and gulls paid little attention as the thunder crashed overhead and the rain pelted down and certainly were unaware of the ecstatic Bence Máté in his hide. It was one of a portfolio that won him the Eric Hosking Award, for the second time.

Bence Máté Hungary 2007

The show

It's an exceptional picture of an exceptional moment, taken by one of the few young
women to carry off the top youth award. There are three layers to the story composition
that reveal themselves in turn. On the central stage — a river valley leading to
a waterhole in desert-dry Namibia — is a giraffe, trying to get to the waterhole.
It's being harassed by a young male lion, which is having fun toying with the
panicking animal (the lion would never dare to attack, as one kick could be fatal).
An audience of gemsbok has gathered, in the front row but also in the back, glimpsed
through a curtain of dust. The low evening light adds a touch of gold to the palette
of browns — a painterly scene captured through skilful use of the camera.

Catriona Parfitt UK 2008

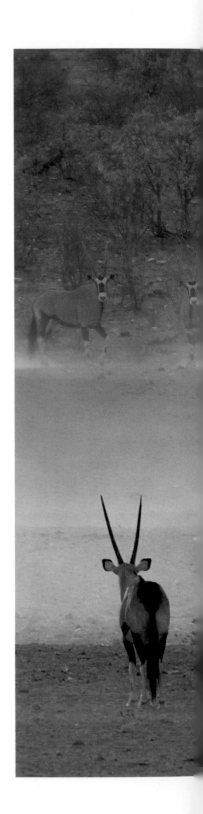

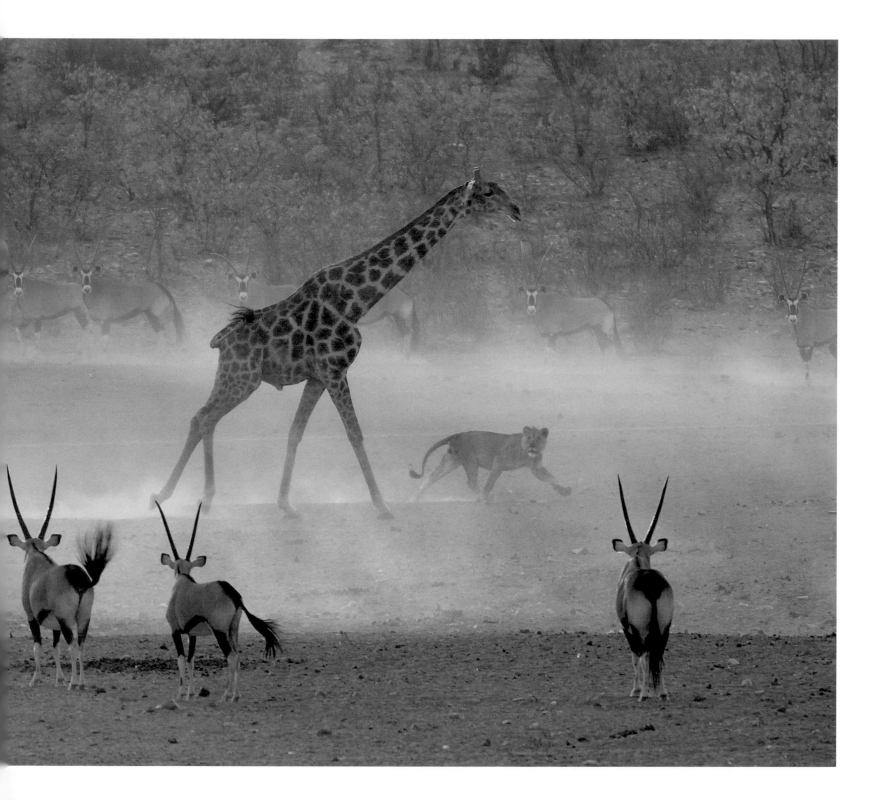

The frozen moment

Since he was nine, this young Scottish photographer has been photographing the
wildlife around his home. At 12, he won first prize, and he went on to win the top
award two years running with pictures featuring wildlife in his garden, the second time
with this shot. The subject is a fieldfare feeding on frost-covered berries on a rowan
at the bottom of the garden. The challenge was to capture the action in freezing
fog and find an angle that would allow him to isolate one bird among the throng of
desperate thrushes. The winter light was a problem, because of the speed and high
ISO needed, but it turned out to be a blessing, creating a canvas of subtle colours.

Fergus Gill UK 2010

Silent flight

This picture is an example of how bad luck can become good fortune once the beauty of the moment is recognized. The photographer's intention had been to frame a snowy owl flying towards him as it quartered a salt marsh in search of rodents. He spent a week experimenting at dawn with various settings and lighting, trying to create an impression of its ghost-like flight but never properly catching it head-on. But when he saw this picture he realized that the act of flying into rather than out of the gloom was far more atmospheric. The picture was one of a portfolio, most taken near his home in British Columbia, Canada, that won him the Eric Hosking Award.

Connor Stefanison Canada 2013

The final message

The most memorable pictures are often those that are not only aesthetically stimulating but also make you stop and think. Message-making is something the competition has championed for more than 30 years. Indeed, the exposure gained through winning has helped some pictures become powerful conservation symbols.

Photographers of nature deal with the raw elements of life. And exploring ways to convey their feelings about what is being photographed is a continual preoccupation of dedicated individuals. Many of these photographers play roles as both photojournalists and artists who develop conversations about important issues and try to connect people through their pictures.

A still picture with a message can have power more lasting than that of any moving sequence. It can do this through surprise, emotion or symbolism. Including people in the composition will convey a very specific message. Use of the photojournalism convention of the snapshot aesthetic will convey the energy of a fleeting moment. Or a composition can be created to have symbolic power.

Photo-stories are showcased in the competition through the Wildlife Photojournalist Award. To convey a narrative in just a few pictures is one of the most difficult and most time-consuming endeavours, which is why winners tend to be seasoned professionals. But whatever the status and the style of the photographer, a picture that moves the heart is a powerful tool. If it is seen by many millions, which winning pictures in this competition are, then it may effect lasting change.

Last of the golden toads

This picture has become a poignant symbol of the global loss of amphibians. When it was taken, the photographer was not aware that numbers of the golden toads were crashing nor that they would be the last of their species to be photographed. There is expectation expressed in the postures of the little males, lit in traditional portrait style against a dark backdrop, setting off their golden skin. The toads are looking out for females. The females came, but by 1989, all the golden toads had vanished, along with 40 per cent of all the amphibians in Costa Rica's Monteverde Cloud Forest Reserve. The cause? Almost certainly a chytrid fungus, its devastating effects probably exacerbated by climate change and now affecting amphibians throughout the world.

Michael and Patricia Fogden UK 1984

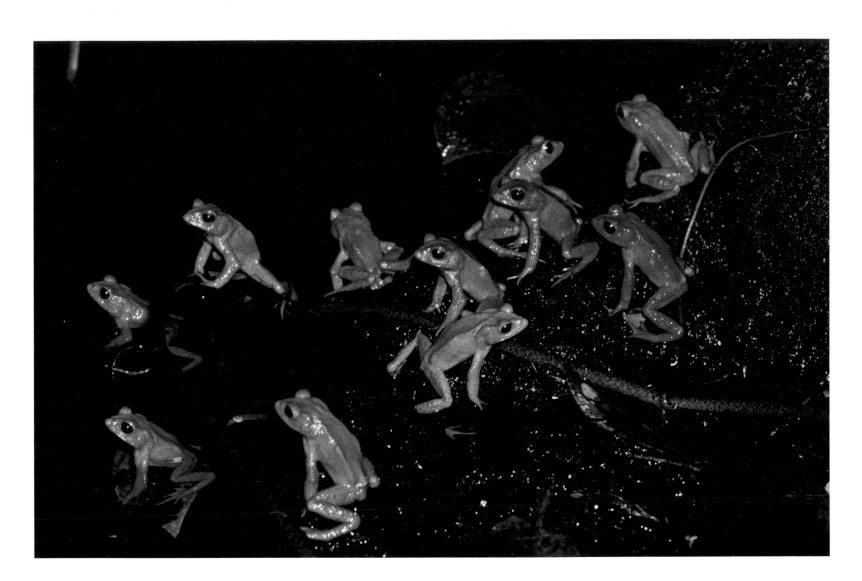

Relative values

The shock of the picture is the juxtaposition of head, bowl and bananas – and, of course, that the head is so human – being that of a fellow ape, a lowland gorilla. Bushmeat has always been part of the diet of forest people, but this gorilla – ordered for dinner by a police chief in Cameroon – represents the plunder of the forest. The kitchen tableau is as the photographer found it and is a shot taken as part of a series to expose the commercial trade in bushmeat in West Africa. The prize-winning picture resulted in complaints that it was too shocking to display. The defence? That the destruction of West Africa's forests and the linked increase in bushmeat trade and rapid decline of gorillas, chimpanzees and bonobos are even more shocking.

Karl Ammann Switzerland 1995

Survivors

It's hard to say why this picture has poignancy. Perhaps it is because the strange monkeys look so vulnerable and cold on their branch and have such naively curious human expressions. There is also a surprise in the un-monkey-like strange environment, with its cobweb lichen hangings. It is a monkey forest higher than any other, in the Yunling Mountains of China, and it's an environment that very nearly disappeared when the pines were scheduled for logging. This picture, taken by a passionate campaigner for conservation of wildlife in China and among the first ever taken of wild Yunnan snub-nosed monkeys, helped save the forest and its highly endangered lichen-eating primates.

Xi Zhinong China 2001

The sacrifice

The huge bigeye thresher shark has just died, its eyes still open, and is hanging in a drifting gillnet, its pectoral fins outstretched as if in crucifixion. The location is Mexico's Sea of Cortez, an area of massive overfishing. There's a double message here, about the tragedy of the slaughter of sharks – an estimated 100 million a year killed for their fins and as bycatch – and the enormous carnage of creatures caught indiscriminately in nets and discarded. It's a picture that the photographer had set out to make, but it had taken months to find such a pose, one that would move people rather than shock them – make them care about the needless destruction of sharks and think about the repercussions on the marine food chain.

Brian Skerry USA 2010

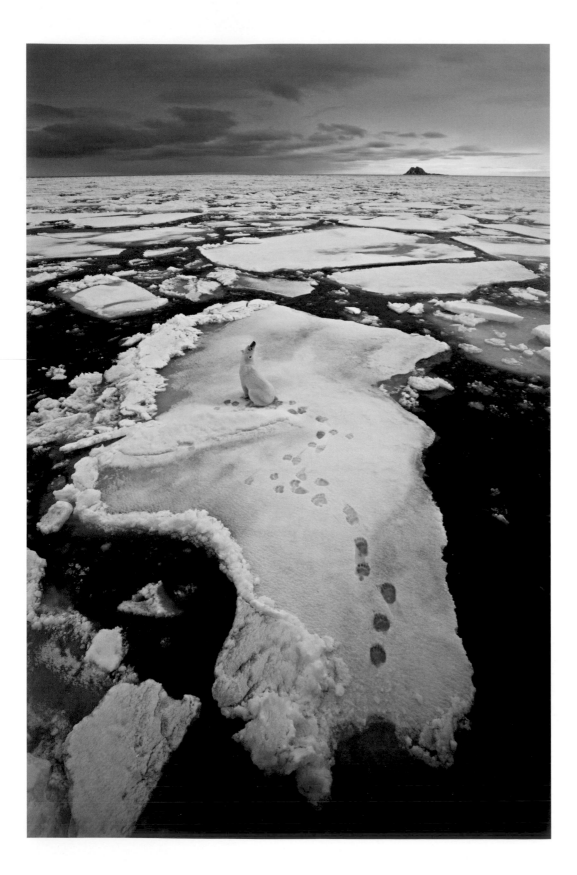

Living on thin ice

Summer around the Arctic islands of Svalbard is always a hard time for bears, with little solid ice and therefore little chance of catching seals. That's normal. But now it's normal that almost every summer the ice melts a little earlier, sometimes much earlier, and freezes later. The photographer is an Arctic specialist and has photographed polar bears over many years, but this shot represents the moment when, looking down from his boat, it all came together – the melting ice, the position of the bear, the track going nowhere and the outcrop of land far on the horizon, in line with the bear's skyward-pointing muzzle. The message? The frozen north is a fast-changing environment and the future for polar bears is an uncertain one.

Ole Jørgen Liodden Norway 2012

Last look

This could be the last portrait ever taken of a wild Sumatran tiger. Certainly it's the most poignant. The male's expression conveys apprehension, and his path in and out of darkness is symbolic of what the future holds. The 400-500 that remain are confined to those mountainous or remnant-forest regions of Sumatra that haven't been converted into oil-palm plantations. It took months and the assistance of a former tiger hunter to locate this tiger and find where to place a remote camera, and it required great skill to light him centre-stage. Hunted for its body parts for traditional Chinese medicine, this is yet another tiger subspecies that, without extreme protection, is destined for extinction.

Steve Winter USA 2012

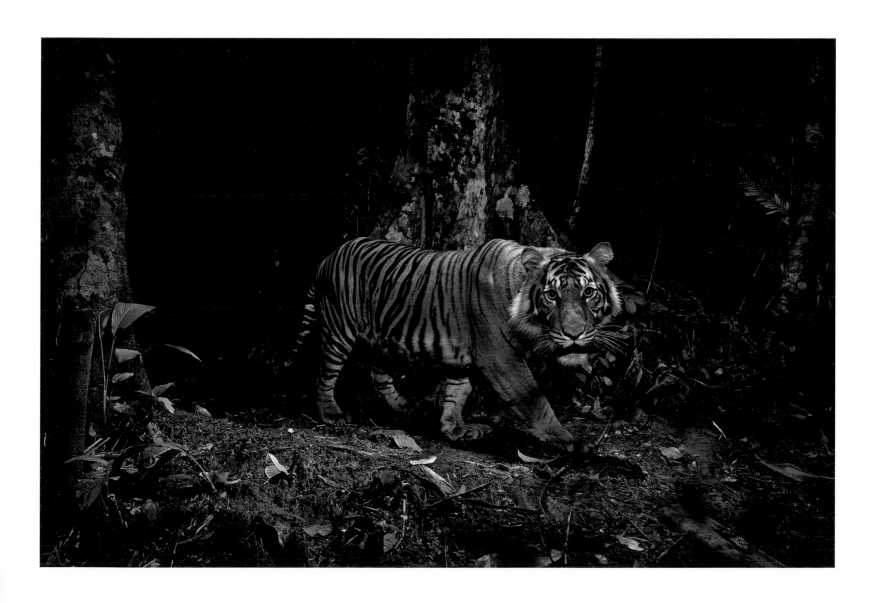

Supplying demand

It's the casualness that makes the scene especially disturbing, the bile being pumped into the precariously placed bottle, the instruments strewn around, and the contrasting clinical aspects of the Biosonic jelly and ultrasound machine. With arms and legs spread apart, the bear is almost human in its vulnerability. The picture is a 'snatched' shot at a bear farm in Vietnam of the extraction of bile from a drugged Asiatic bear – a widespread, illegal practice. It was part of the photographer's award-winning story portraying the apathy, corruption and cruelty behind the multi-billion-dollar wild-animal industry, particularly that part supplying the Chinese medicine trade.

Mark Leong USA 2010

Out of Africa

Here's a picture that truly tells a story. The expressions of the men holding the tusk, eyes down, implying respect and sadness, suggest they aren't poachers. They've been tasked by the Big Life Foundation to remove the tusks of the illegally killed elephant before the poachers get to it. But the scene, in Amboseli National Park, is symbolic of the brutality and madness of the continued slaughter of more than 25,000 African elephants a year, purely for their tusks to make ivory religious or decorative carvings. It's an award-winning picture from the photographer's three-year ivory-trade coverage, which he describes as 90 per cent investigation and 10 per cent photography.

Brent Stirton South Africa 2013

Still life in oil

There is beauty in this picture. The impression is that of an oil painting, in both colour and composition. The elegant pelicans seem posed, the colours carefully matched – the feathers of the birds, rich shades of honey, walnut and mahogany, echoed in the deep brown wood and the honey-coloured cloth – the swirls of the background picked up in the cloth of the tableau. The reality, of course, is that it's a stinking mess. The brown pelicans are oil victims of the BP Deepwater Horizon well, which blew up in the Gulf of Mexico in April 2010. They are among the 2,000 oiled birds rescued alive, awaiting cleaning by volunteers. They've already been sprayed with light oil to break up the heavy crude that's been trapped in their feathers and has turned their normally pale heads orange and the rest of them mahogany. This picture, part of a photo-story, became the photographer's 'icon of the disaster'. It also won him the Wildlife Photographer of the Year Award.

Daniel Beltrá Spain/USA 2011

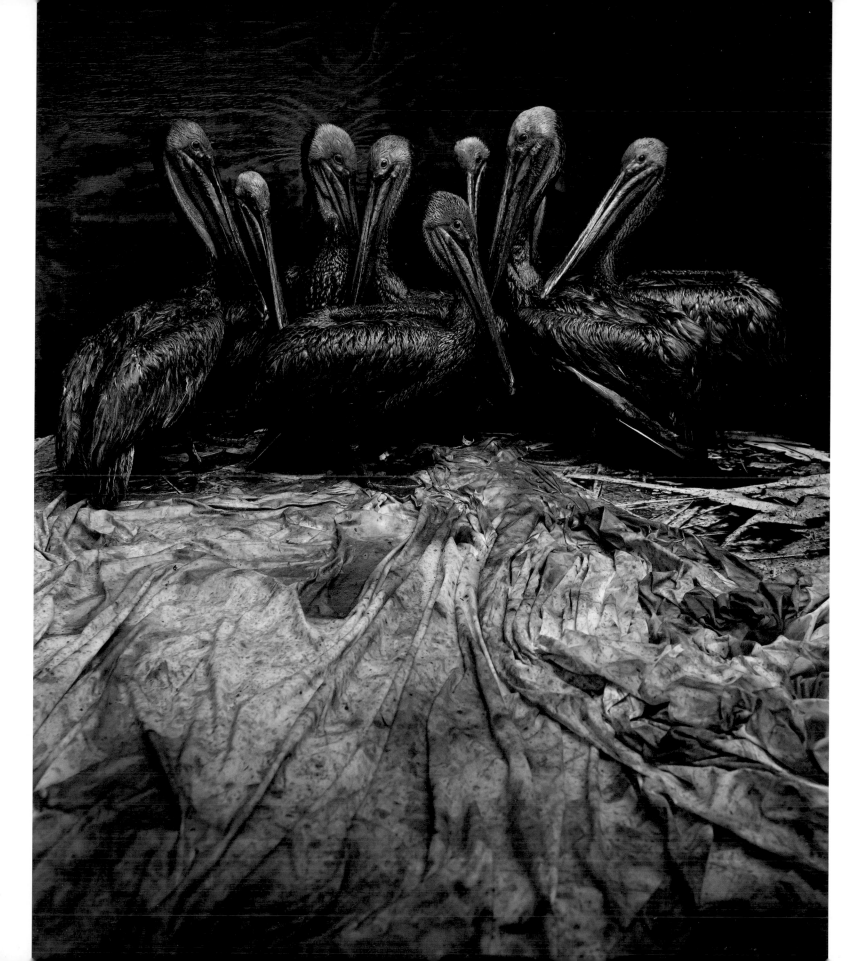

Index of photographers

4 *Canon T90 + 80-200mm lens; Kodachrome 64*
Cherry Alexander UK
www.arcticphoto.co.uk
alexander@arcticphoto.co.uk

211 *Nikonos V + 20mm lens; 1/125 sec at f5.6; Fujichrome Sensia 200*
Doug Allan UK
www.dougallan.com
dougallancamera@mac.com

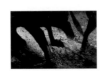

236 *Nikon F4 + 24-50mm lens; Fujichrome Velvia; flash*
Karl Ammann SWITZERLAND
www.karlammann.com
karl@karlammann.ch

131 *Minolta + 500mm lens; 1/250 sec at f5.6; Fujichrome Sensia 100; tripod*
Ingo Arndt GERMANY
www.ingoarndt.com
ingo@ingoarndt.com

103 *Hasselblad 553 ELX camera + Zeiss 500mm lens + B+W warming polarizing filter; 1/125 sec at f11; cable release; Gitzo tripod + Arca Swiss ball head*
Rob Badger USA
www.robbadger.com
rob@robbadger.com

176 *Canon EOS-1D Mark IV + EF 24-105mm lens at 35mm; 1/200 sec at f14; ISO 320; remote flashes*
Alex Badyaev USA
www.tenbestphotos.com
author@tenbestphotos.com

65 *Nikon F5 + 500mm lens; Fujichrome Velvia*
Adrian Bailey SOUTH AFRICA
www.baileyphotos.com
Agent: Aurora Photos
www.auroraphotos.com

161 *Hasselblad 500c + 80mm f2.8 Planar lens + extension tubes; electronic flash attached to power supply; bracket*
Anthony Bannister SOUTH AFRICA
www.anthonybannister.com
anthonybannister@gmail.com
Agent: Photoshot www.nhpa.co.uk

108 *Sony NEX-5 + Nikon 50mm f1.4 lens; 1/640 sec at f1.4; ISO 200; Lensbaby Tilt Transformer*
Sandra Bartocha GERMANY
www.bartocha-photography.com
info@bartocha-photography.com

30 *Nikon F4 + 400mm lens; 1/30 sec at f4; Fujichrome Velvia; tripod*
André Bärtschi LIECHTENSTEIN
www.wildtropix.com
wildtropix@gmail.com

24 William Baxter UK
wulliebaxter@ntlworld.com

72 *Nikon FM with 80-200mm zoom lens; 1/250 sec at f4.5; Kodachrome 64*
Rajesh Bedi INDIA
www.bedibrothers.co.in/Bedi
bedifilmsvisuals@gmail.com

202 *Canon EOS 5D Mark II + 100-400mm f4.5-5.6 lens; 1/1000 sec at f5.6; ISO 500*

245 *Canon EOS 5D Mark II + 35mm f1.4 lens at 35mm; 1/30 sec at f4 (-0.7 e/v); ISO 800*
Daniel Beltrá SPAIN/USA
www.danielbeltra.com
daniel@danielbeltra.com

185 *Nikon D90 + 70-300mm lens; 1/500 sec at f8; ISO 400*
Adithya Biloor INDIA
www.lensandtales.com
adithyabiloor@gmail.com

113 *Nikon D300 + 300mm f2.8 lens + teleconverter; 1/250 sec at f4.8; ISO 320; Gitzo tripod; flash*
Valter Binotto ITALY
www.valterbinotto.it
binoval@alice.it

151 *Nikon 8008s + 90mm lens + extension; f22; Fujichrome Velvia; dual strobe + diffusers*
Gerry Bishop USA
gbishop60@comcast.net

29 *Nikon F2 + 640mm Novaflex lens; 1/250 sec at f11; Kodachrome 64*

46 *Nikon F3 + 80-200mm lens; 1/125 sec at f8; Kodachrome 64*

71 *Nikon F3; 1/500 sec at f8; Kodachrome 64*

124 *Nikon F3 + 300mm lens; 1/250 sec at f2.8; Kodachrome 64*
Jim Brandenburg USA
www.jimbrandenburg.com
info@jimbrandenburg.com

188 *Nikon D3 + 70-200mm f2.8 lens; 1/125 sec at f22; ISO 320*
Antonio Busiello ITALY
www.antoniobusiello.com
antonio@antoniobusiello.com

61 *Nikon F3 + 600mm lens; 1/15 sec at f5.6; Kodachrome 200; tripod*

86 *Nikon F4 + 300mm lens + 2x teleconverter; 1/500sec at f5.6; Kodachrome 200*
Laurie Campbell UK
www.lauriecampbell.com
info@lauriecampbell.com

26 *Olympus OM2 + 300mm lens; Kodachrome 64*
David Cayless UK
david.cayless@eclipse.co.uk

217 *Canon EOS 5D + 17-40mm f4 lens at 40mm; 1/40 sec at f11; ISO 100; Sea & Sea housing; 2 Sea & Sea YS110 strobes*
Jordi Chias SPAIN
www.uwaterphoto.com
jordi@uwaterphoto.com

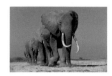

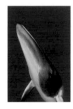

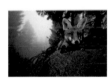

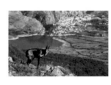
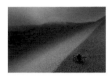

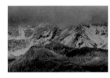

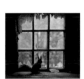

119 *Canon EOS 5D Mark II + 24mm f1.4 lens + cable release; 1/6 sec at f11; ISO 400; 2 Canon strobes + 2.5kw blonde light*

187 *Canon EOS 5D Mark II infrared converted + 24-105mm lens; 1/250 sec at f10; ISO 100*

225 *Nikon F3 + 500mm lens; 1/30 sec at f8; Kodachrome 200; beanbag*
Charlie Hamilton James UK
www.charliehamiltonjames.com

78 *Canon EOS-1N + 600mm lens; 1/500 sec; Fujichrome Velvia; beanbag*
Martin Harvey SOUTH AFRICA
www.wildimagesonline.com
martinharvey@wildimages.co.za

60 *Canon EOS-1 + 300mm lens; 1/125 sec at f11; Fujichrome Velvia; tripod*
Hannu Hautala FINLAND
www.hannuhautala.fi/en

58 *Pentax SFXn + 300mm f2.8 lens + 1.7x teleconverter; 1/125 sec at f5.6; Kodachrome 64; tripod*
Philippe Henry CANADA
www.philippe-henry.com
philippe_henry@hotmail.com

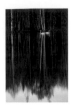

98 *Nikon F4s + 35mm lens; 4 sec at f22; Fujichrome Velvia; tripod*

177 *Canon EOS 5D Mark III + 17mm tilt/shift lens; 0.3 sec at f11; ISO 250; radio-triggered indirect flash; Hähnel Inspire LiveView Remote + monitor*
Pål Hermansen NORWAY
www.palhermansen.com
palhermansen@hotmail.com
Agent: Nature Picture Library
www.naturepl.com

99 *Nikon F + 55mm lens; 1/60 sec at f16; Fujichrome 50; strobe lights*
Richard Herrmann USA
www.richardherrmann.com
rbherrmann@cox.net

137 *Nikon D300 + 120-400mm lens at 400mm; 1/500 sec at f5.6; ISO 400*
Ross Hoddinott UK
www.rosshoddinott.co.uk
info@rosshoddinott.co.uk

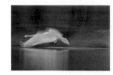

149 *Olympus OM2n + Tamron SP90mm lens mounted in reverse on Olympus bellows; f11; Kodachrome 64; tripods; 2 Mecablitz CT60 flash guns + reflector*
John A Horsfall UK
horsfall.john@mac.com

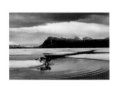

49 *Canon EOS-1 + 80-200mm lens; 1/125 sec at f4; Fujichrome 100*
Marie-Luce Hubert & Jean-Louis Klein FRANCE
www.klein-hubert-photo.com

150 *Pentax 6x7 II + 80mm lens; 1/30 sec at f16; Fujichrome Velvia; flash; tripod*
Mitsuhiko Imamori JAPAN
www.imamori-world.jp
Agent: Nature Production
www.nature-pro.com

184 *Nikon FE2 + 200mm fixed lens; 1/8 sec at f4; Kodak Tri-X-Pan 400*
Britta Jaschinski GERMANY/UK
www.brittaphotography.com
info@brittaphotography.com

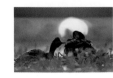

68 *Nikon F4s + 500mm lens; 1/125 sec at f4; Fujichrome Provia 100; floating hide + beanbag*

117 *Nikon F4s + 500mm f4 lens; 1/15 sec at f4; Fujichrome Provia; floating hide; beanbag*
Rob Jordan UK
www.robjordan.co.uk
robjordanphoto@btinternet.com

107 *Nikon D3S + 600mm f4 lens; 1/8 sec at f13; ISO 100*

240 *Nikon D3S + 14-24mm f2.8 lens; 1/400 sec at f11; ISO 1000*
Ole Jørgen Liodden NORWAY
www.wildphoto.com
oji@wildphoto.com

97 *Pentax 6x7 with 300mm lens; 1/5 sec at f22; Fujichrome Velvia*
Jan-Peter Lahall SWEDEN
www.lahall.com
info@lahall.com

66 *Canon EOS-1N RS + 35-350mm lens at f22; Provia 400F*
Johannes Lahti FINLAND
johannes.lahti@nettikirje.fi

104 *Canon EOS 5D Mark II + 600mm f4 lens; 1/180 sec at f5.6; ISO 800*
Tim Laman USA
www.timlaman.com
office@timlaman.com

37

38

62 *Nikon FE2 + 105mm lens; Kodachrome 64; Vivitar flash*

64 *Nikon N90 + 300mm lens; Fujichrome*

191 *Nikon + 24mm lens; Kodachrome 64*
Frans Lanting USA
www.franslanting.com

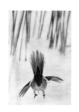

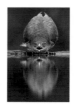

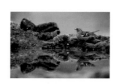

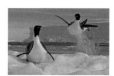

200 *Canon EOS-1Ds Mark II + 70-200mm lens; 1/2000 sec at f5; ISO 400*

222 *Canon EOS-1D Mark IV + 8-15mm f4 lens; 1/1000 sec at f7.1; ISO 500; Seacam housing*
Paul Nicklen CANADA
www.paulnicklen.com
Agent: National Geographic Creative
www.natgeocreative.com
sgold@ngs.org

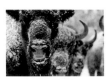

132 *Nikon D100 + 80-200mm lens; 1/90 sec at f4; ISO 200*

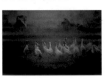

163 *Nikon F801 + 500mm lens; 3 sec at f4; Kodachrome 64; tripod*

199 *Nikon D3 + 70-200mm f2.8 lens at 200mm; 1/1600 sec at f5.6; ISO 250*
Klaus Nigge GERMANY
www.nigge-photo.de
klaus.nigge@t-online.de

111 *Canon F1 + 500mm lens; 1/30 sec at f8; Kodachrome 64*
Chris Packham UK
www.chrispackham.co.uk

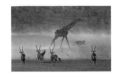

230 *Canon EOS 400D + EF 300mm f4 lens + Canon EF 1.4x extender; 1/200 sec at f5.6; ISO 100*
Catriona Parfitt UK
catriona.parfitt@btinternet.com

207 *Nikon F4s + 60mm lens; 1/125 sec at f22; Fujichrome Velvia; Aquatica housing; 2 Ikelite strobes*

212 *Canon EOS D60 + Sigma 14mm f2.8 lens; 1/800 sec at f5.6; ISO 200; UK Germany housing; Canon 550EX strobe*
Doug Perrine USA
www.seapics.com
info@seapics.com

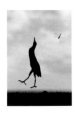

81 *Nikon D3 + 70-200mm f2.8 lens; 1/3200 sec at f6.3; ISO 400*

221 *Nikon D700 + 16mm f2.8 lens; 1/10 sec at f11; ISO 640; Subal housing; 2 Inon Z220 strobes*
Thomas P Peschak GERMANY/SOUTH AFRICA
www.thomaspeschak.com
thomas@thomaspeschak.com

43 *Canon EOS 40D + 400mm f5.6 lens; 1/800 sec at f5.6 (-1.3 e/v); ISO 400*
Mateusz Piesiak POLAND
www.mateuszpiesiak.pl

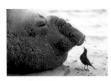

39 *Nikon F4 + 300mm lens; f4 auto; Kodachrome 64; tripod*

179 *Olympus OM-1 + 135mm Zuiko lens; Agfapan 400; tripod; hide*
Fritz Pölking GERMANY
www.poelking.com

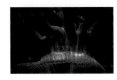

76 *Canon EOS 3 + 300mm f2.8 lens; 1/60 sec at f5.6; Fujichrome 100*
Benjam Pöntinen FINLAND
www.pontinen.fi

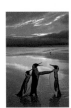

48 *Nikon F3 + 135mm f3.5 lens + skylight filter; Kodachrome 64*
Brian Rogers UK
b.m.rogers@btinternet.com
Agent: Natural Visions
www.naturalvisions.co.uk

220 *Canon EOS 5D Mark II + EF 16-35mm f2.8 lens; 1/85 sec at f5.6; ISO 400; Hugyfot housing*
Michel Roggo SWITZERLAND
www.roggo.ch
info@roggo.ch

196 *Leica R9 + 70-180mm zoom lens; gyro stabilizer; 1/500 sec at f8; Fujichrome Velvia 100*
Norbert Rosing GERMANY
www.rosing.de
rosingbear@aol.com

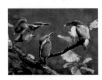

32 *Nikonos II + 28mm lens + 2:1 extension tube; f22; Kodachrome 64; flash + reflector*
Jeff Rotman USA
www.jeffrotman.com
jeffrotman@aol.com

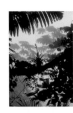

80 *Canon EOS-1Ds Mark II + 24-70mm lens; 1/60 sec at f4; ISO 200*

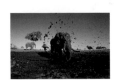

139 *Canon EOS 5 + 17-35mm lens; 1/125 sec at f11; Fujichrome Velvia rated at 40; shutter-release cable*
Andy Rouse UK
www.andyrouse.co.uk
www.foto-buzz.com

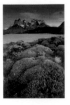

88 *Nikon F4 + 24mm lens; ¼ sec at f16; Fujichrome Velvia; tripod*
Galen Rowell USA
www.mountainlight.com

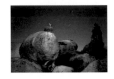

164 *Nikon FM-2 + 50mm f2 A1S lens; 6 min at f2.8; Fujichrome Velvia; tripod; teleflash system*
José B Ruiz SPAIN
www.josebruiz.com
Agent: Nature Picture Library
www.naturepl.com

57 *Nikon FM + 560mm f6.8 lens; 1/30 sec at f6.8; Kodachrome 64; tripod*
Jouni Ruuskanen FINLAND
ruuskanen.jouni@kajaani.net

126 *Nikon F4 + 80-200mm lens; 1/8 sec at f5.6; Fujichrome 100*
Carl R Sams II USA
www.carlsams.com
carlsams@carlsams.com

194 *Nikon F5 + Nikon 80-200mm AF lens; 1/250 sec at f2.8; Fujichrome Provia*
Joel Sartore USA
www.joelsartore.com
info@joelsartore.com

198 *Nikon D3X + 200-400mm f4 lens; 1/800 sec at f4.5; ISO 800*
Florian Schultz GERMANY
www.visionsofthewild.com
visionsofthewild@yahoo.com

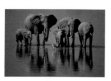

130 *Canon EOS-1V + 500mm lens + polarizing filter; image stabilizer; 1/250 sec at f4.5; Fujichrome Velvia; tripod*
Angie Scott KENYA
www.jonathanangelascott.com

73 *Canon F1 + 500mm lens; 1/60 sec at f4.5; Kodachrome 64 rated at 80*
Jonathan Scott UK
www.jonathanangelascott.com

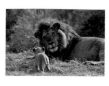

79 *Canon EOS-1N + 500mm lens; Fujichrome Sensia*

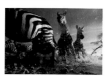

144 *Canon EOS 1V + 20mm lens; Fujichrome Velvia 100F; wireless remote control*
Anup Shah UK
www.shahrogersphotography.com

123 *Canon T90 + 800mm lens; 1/125 sec at f6.7; Fujichrome Velvia*
Wendy Shattil USA
www.dancingpelican.com
wendy@dancingpelican.com

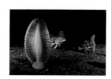

215 *Nikon D2x + 16mm lens; 1/30 sec al f9; ISO 200; Subal housing; 2 Hartenberger strobes on 1/4 power + additional strobe*

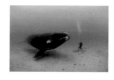

218 *Nikon D2x + 10.5mm f2.8 lens; 1/80 sec at f6.3; Subal housing*

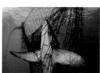

238 *Nikon D2X + 16mm lens; 1/60 sec at f8; ISO 100; Subal housing; Sea & Sea YS90 strobes*
Brian Skerry USA
www.BrianSkerry.com
brian@BrianSkerry.com
Agent: National Geographic Creative
www.natgeocreative.com

102 *Canon EOS 5D + Canon EF 35-350mm lens; 21 sec at f9.9; Manfrotto tripod*
Gary Steer AUSTRALIA
www.garysteer.com.au

233 *Canon EOS-1D Mark IV + 500mm f4 lens at 700mm + 1.4x extender; 1/15 sec at f6.3; ISO 400; Canon 580 EX II flash; Custom Brackets flash bracket; Better Beamer flash extender*
Connor Stefanison CANADA
www.connorstefanison.com
connor_stef@hotmail.com

243 *Nikon D700 + 17-35mm f2.8 lcns; 1/60 sec at f4.5; ISO 1250*
Brent Stirton SOUTH AFRICA
www.brentstirton.com
brentstirton@gmail.com

156 *Canon EOS 5D Mark II + MP-E65 f2.5 1-5x lens; 1/200 sec at f14; ISO 400; Speedlite 580EX II flash + homemade soft box*
Urmas Tartes ESTONIA
www.urmastartes.ee
urmas.tartes@hot.ee

1 *Pentax 645 + 120mm lens; 1/4 sec at f32; Fujichrome Velvia; tripod*
Jan Töve SWEDEN
www.jantove.com

25 *Canon + 300mm lens; Ektachrome X*
Peter Ugander SWEDEN
www.pugnature.com
peter@ugander.com

114 *Nikon D700 + 24-70mm lens; 1/320 sec at f16; ISO 1000*
Stefano Unterthiner ITALY
www.stefanounterthiner.com
info@stefanounterthiner.com

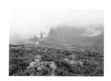

166 *Nikon D3S + 24-70mm f2.8 lens; 15 sec at f2.8; ISO 2500; Gitzo tripod + Markins ball head; cable release*
Marsel van Oosten
THE NETHERLANDS
www.squiver.com
info@squiver.com

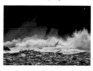

127 *Nikon F90 + 70-210mm lens; 1/60 sec at f5.6; Fujichrome Provia*
Jason Venus UK
www.jasonvenus.com
www.twitter.com/jasonvcnus

7 *Nikon D2X + 70-200mm lens + 1.4x extender; 1/640 sec at f7.1; Gitzo tripod*

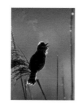

67 *Canon EOS 10D + 500mm lens + 1.4x extender; 1/500 sec at f8; 400 ISO; beanbag*
Jan Vermeer THE NETHERLANDS
www.janvermeer.nl
janvermeer.foto@planet.nl

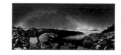

92 *Nikon D3 + 24mm f1.4 lens + Baader IR cut filter; 20 sec at f1.8; ISO 4000; Bilora C283 tripod + Ninja Nodal 5 panoramic head*
Stephane Vetter FRANCE
www.nuitsacrees.fr
stephane.vetter@wanadoo.fr

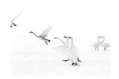

85 *Canon F1 + 28mm lens; 1/30 sec at f12; Fujichrome 50*

87 *Canon F1-N + 80-200mm lens; 1/500 sec at f5.6; Kodachrome 64*

206 *Nikonos II +18mm lens; 1/60 sec at f5.6; Ektachrome 64 rated at 100 and push-processed; Sea and Sea strobe*
Kim Westerskov NEW ZEALAND
www.kimwesterskov.com
kim.westerskov@clear.net.nz

74 *Canon EOS-1 + 600mm lens; 1/2000 sec at f4; Ektachrome EPZ 100*
Barrie Wilkins SOUTH AFRICA
www.jandbphotographers.com
bwilkins@telkomsa.net

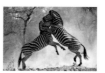

226 *Nikon N90 + 150-500mm lens; f8 at 1/250 sec; Fujichrome 100*
Nick Wilton SOUTH AFRICA
nickwilton@vodamail.co.za

146 *Canon EOS Rebel XT + 10-22mm lens at 16mm; 1/200 sec at f16; ISO 100; waterproof camera box + Plexiglass tubes for flashes; Trailmaster 1550-PS remote trigger; flashes*

208 *Nikonos V amphibious camera + 15mm lens; 1/125 sec at f11; Fujichrome Velvia rated at 100*
Norbert Wu USA
www.norbertwu.com
office@norbertwu.com

241 *Canon EOS XTi + 16mm-35mm f2.8 lens; 1/160 sec at f11; ISO 200; waterproof camera box + Plexiglas tubes for 3 Nikon flashes; Trailmaster infrared remote trigger*
Steve Winter USA
www.stevewinterphoto.com
stevewinterphoto@mac.com
Agent: National Geographic Creative
natgeocreative.com

174 *Nikon F5 + 300mm lens; 1/125 sec at f2.8; Ektachrome E100VS; tripod*
Solvin Zankl GERMANY
www.solvinzankl.com
info@solvinzankl.com

101 *Nikon N90S + 600mm lens; 1/30 sec at f16; Fujichrome Velvia*
Art Wolfe USA
www.artwolfe.com

237 *Canon EOS-1N + 400mm lens + Canon 2x extender; 1/500 sec at f5.6; Fujichrome Provia III rated at 400*
Xi Zhinong CHINA
www.wildchina.cn
mail@wildchina.cn

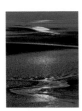

90 *Mamiya 645 + 210mm lens; 125 sec at f8; Fujichrome 100*
David Woodfall UK
www.davidwoodfallimages.co.uk
david@davidwoodfallimages.co.uk

172 *Canon EOS 1V + 100mm f2.8 macro lens; 1/100 sec; Fujichrome Velvia 50; 2 flashes*

154 *Olympus C5050Z; 1/200 sec at f8; ISO 64; Ikelite DS125 housing; Inon Z-220 strobes*
Lawrence Alex Wu CANADA
www.lawrencealexwu.com
aguapictures@gmail.com

173 *Canon EOS 5D Mark II + 17mm f2.8 lens; 1/60 sec at f22; ISO 400; 6 flashes; remote control*
Christian Ziegler GERMANY
www.naturphoto.de
zieglerphoto@yahoo.com

Additional credits

9
The J Paul Getty Museum, Los Angeles

10
Royal Photographic Society/National Media Museum/Science & Society Picture library

11
Victoria and Albert Museum, London

12
top ©Rheinisches Bildarchiv Köln, rba_c021074
bottom Cherry and Richard Kearton

13
top Frank Haes/Zoological Society of London
bottom left Reginald B Lodge
bottom right George Shiras/National Geographic Creative

14
Cherry and Richard Kearton

15
top left Royal Photographic Society/National Media Museum/Science & Society Picture library
top right Science Museum/Science & Society Picture Library

16
Royal Geographical Society (with IBG)

17
© Ansel Adams Publishing Rights Trust/CORBIS

18
top Copyright Champion family archive
bottom David Hosking/FLPA

19
David Hosking/FLPA

20
Courtesy of the Adirondack Museum id# P12910

21
David Hosking/FLPA

23
UPPA/Photoshot

First published by the Natural History Museum
Cromwell Road, London SW7 5BD
© The Trustees of the Natural History Museum, London, 2014
Photography © the individual photographers 2014

This edition published 2015
ISBN 978 0 565 09383 9

The Author has asserted her right to be identified as the Author of this work under the Copyright, Designs and Patents Act 1988.

All rights reserved. No part of this publication may be transmitted in any form or by any means without prior permission from the British Publisher.

A catalogue record for this book is available from the British Library.

Edited by Rosamund Kidman Cox
Designed by Bobby Birchall, Bobby&Co
Reproduction by Saxon Digital Services, UK
Printed by Printer Trento Srl, Italy.

10 9 8 7 6 5 4 3 2 1

WILDLIFE PHOTOGRAPHER OF THE YEAR
is the world's longest running and most prestigious competition championing the art of photography featuring wild places and wild species.
It is owned by the Natural History Museum, London.

www.wildlifephotographeroftheyear.com